NO LONGER THE PROPERTY OF
BALDWIN PUBLIC LIBRARY

W9-BDC-069
20.00

MASTERPIECES FROM THE

DAVID AND PEGGY ROCKEFELLER COLLECTION

MANET TO PICASSO

NO LONGER THE PROPERTY OF
BALDWIN PUBLIC LIBRARY

MASTERPIECES FROM

The David and Peggy Rockefeller Collection

MANET TO PICASSO

THE MUSEUM OF MODERN ART

NEW YORK

BALDWIN PUBLIC LIBRARY

PUBLISHED IN CONJUNCTION WITH THE EXHIBITION
MASTERPIECES FROM THE DAVID AND PEGGY ROCKEFELLER COLLECTION: MANET TO PICASSO
AT THE MUSEUM OF MODERN ART, NEW YORK, JUNE 9–SEPTEMBER 6, 1994
ORGANIZED BY KIRK VARNEDOE, CHIEF CURATOR, DEPARTMENT OF PAINTING AND SCULPTURE

PRODUCED BY THE DEPARTMENT OF PUBLICATIONS
THE MUSEUM OF MODERN ART, NEW YORK
OSA BROWN, DIRECTOR OF PUBLICATIONS
EDITED BY CHRISTOPHER LYON
DESIGNED BY MICHAEL HENTGES
PRODUCTION BY VICKI DRAKE AND AMANDA FREYMANN
COLOR SEPARATION BY L S GRAPHIC INC.,
NEW YORK / FOTOLITO GAMMACOLOR, MILAN
PRINTED BY L S GRAPHIC INC.,
NEW YORK / GRAPHICA COMENSE, COMO, ITALY

COPYRIGHT © 1994 BY THE MUSEUM OF MODERN ART, NEW YORK. ALL RIGHTS RESERVED

MATERIAL FROM *THE DAVID AND PEGGY ROCKEFELLER COLLECTION. VOLUME 1: EUROPEAN WORKS OF ART*,
COPYRIGHT © 1984 BY DAVID ROCKEFELLER, IS REPRINTED WITH THE PERMISSION OF
DAVID ROCKEFELLER. ALL RIGHTS RESERVED. NO PORTION OF THIS MATERIAL MAY BE REPRODUCED IN ANY FORM OR
BY ANY ELECTRONIC OR MECHANICAL MEANS INCLUDING INFORMATION STORAGE AND RETRIEVAL SYSTEMS
WITHOUT PERMISSION IN WRITING FROM DAVID ROCKEFELLER, HIS HEIRS OR ASSIGNS

CERTAIN ILLUSTRATIONS ARE COVERED BY CLAIMS TO COPYRIGHT CITED IN THE PHOTOGRAPH CREDITS, PAGE 95

LIBRARY OF CONGRESS CATALOGUE CARD NUMBER 94-76018
ISBN 0-87070-155-X (THE MUSEUM OF MODERN ART AND THAMES AND HUDSON LTD., CLOTHBOUND)
ISBN 0-8109-6126-1 (HARRY N. ABRAMS, INC., CLOTHBOUND)
ISBN 0-87070-156-8 (THE MUSEUM OF MODERN ART, PAPERBOUND)

CLOTHBOUND EDITION DISTRIBUTED IN THE UNITED STATES AND CANADA
BY HARRY N. ABRAMS, INC., NEW YORK, A TIMES MIRROR COMPANY

CLOTHBOUND EDITION DISTRIBUTED OUTSIDE THE UNITED STATES
AND CANADA BY THAMES AND HUDSON LTD., LONDON

PRINTED IN ITALY

COVER: ANDRÉ DERAIN. *CHARING CROSS BRIDGE.* 1905–6. OIL ON CANVAS, 32 ⅛ X 39 ⅝ IN. (81 X 100 CM)
THE MUSEUM OF MODERN ART, NEW YORK. FRACTIONAL GIFT OF DAVID AND PEGGY ROCKEFELLER
(THE DONORS RETAINING A LIFE INTEREST IN THE REMAINDER)

Contents

FOREWORD
David Rockefeller
7

PREFACE
Richard E. Oldenburg
10

INTRODUCTION
Kirk Varnedoe
12

MASTERPIECES FROM
THE DAVID AND PEGGY ROCKEFELLER COLLECTION
Commentaries by Kirk Varnedoe
21

CATALOGUE
66

THE GERTRUDE STEIN COLLECTION
David Rockefeller
96

GIFTS AND PROMISED GIFTS
OF DAVID AND PEGGY ROCKEFELLER
TO THE MUSEUM OF MODERN ART
98

TRUSTEES OF THE MUSEUM OF MODERN ART
100

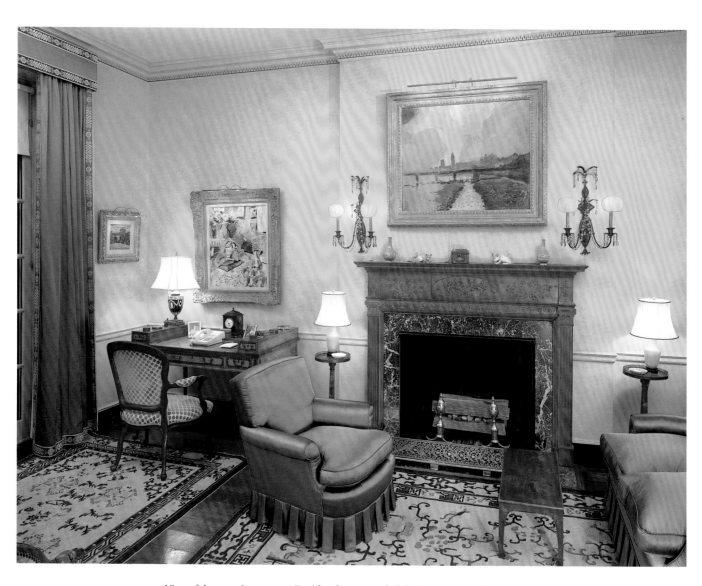

View of the morning room at David and Peggy Rockefeller's residence, New York City

∾ *Foreword*

My wife, Peggy, and I were flattered and pleased to learn that The Museum of Modern Art wished to present as a special exhibition a selection of our paintings. These works, many of which are promised gifts to the Museum, have been acquired over a period of more than forty years. Each of them was purchased because we really cared about it and because we felt there was a place for it in our home where it would give us ongoing enjoyment. We never bought a painting with a view towards "forming a collection" or to "fill out a series," but simply because, in the end, we couldn't resist it. Through this rather unscientific process, we have been fortunate to have surrounded ourselves with beautiful works of art that have given us unending and increasing pleasure as we have lived with them over time.

Neither Peggy nor I was trained in art history. My formal exposure in this field consisted of taking Fine Arts 1A and 1C, *Ancient Art* and *Western Art from the Renaissance to the Present*, as an undergraduate at Harvard in 1934–35. Probably more to the point, I was brought up amid beautiful works of art, spanning many centuries and from many different parts of the world, in the homes of my parents. My mother played a very strong role in shaping my taste and appreciation for art during my youth. She started to collect modern art in the 1920s and acquired a number of contemporary American works of art as well as prints and drawings by the great Impressionist and Post-Impressionist artists. (Her donations of drawings and prints to the Museum formed the basis of its collection in those areas.)

My father was not fond of modern art, so in order to have a place to display her many new acquisitions, Mother had a gallery built on the seventh floor of our home on West Fifty-fourth Street in New York. I often visited it with her and well remember the meetings she had there with Lillie Bliss, Conger Goodyear, and Mary Quinn Sullivan, when they were laying plans for what became The Museum of Modern Art. Alfred H. Barr, Jr., visited our home frequently during this period and after the founding of the Museum, of which he was the first director, and was very kind to me as a young man. Mother enjoyed entertaining her favorite artists there as well. I can vividly recall being introduced to Henri Matisse, Diego Rivera, Arthur Davies, Charles Sheeler, and many others, when they came to see my mother.

In a certain sense, Peggy and I learned about art together. During more than half a century of married life, we have always enjoyed visiting museums and galleries on our travels throughout the world. Until well after World War II, however, we had neither the time nor the financial resources to acquire important paintings of our own. Although my academic knowledge of painting may still be marginally greater than hers, Peggy shares some of

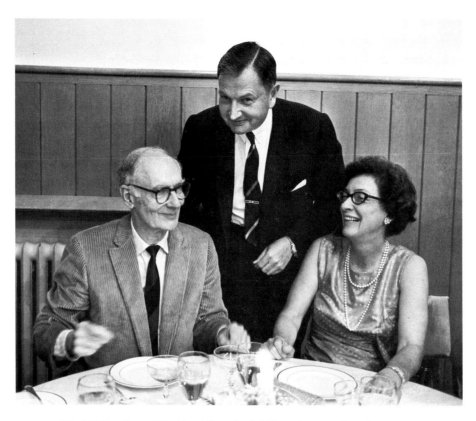

Alfred H. Barr, Jr., and David and Peggy Rockefeller at the party given for Mr. Barr,
on his retirement as Director of Museum Collections, by Mr. and Mrs. Rockefeller at the
Rockefeller Estate, in Pocantico Hills, New York, June 22, 1967.

my mother's ability to intuitively recognize quality, and it was Peggy who first saw and instantly appreciated some of the best pictures we own, including Paul Gauguin's *The Wave* and Paul Signac's portrait of Félix Fénéon (see pages 41 and 39).

We started to take a serious interest in more contemporary art only after 1948, when my mother died and I succeeded her as a trustee of The Museum of Modern Art. The first important Impressionist work we bought was Pierre Renoir's *Gabrielle at the Mirror* (page 35). Since then, we have acquired the paintings in our collection from a number of different sources. Some we purchased at auction and others through dealers in New York, London, and Paris. For instance, through the good offices of Alfred Barr, we acquired, in one memorable morning in 1955, Paul Cézanne's *Boy in a Red Vest*, Georges Seurat's *The Roadstead at Grandcamp*, and Édouard Manet's *The Brioche* (pages 31, 37, and 23) from Paul Rosenberg, who had bought a major portion of the Chester Beattie Collection. In fact, Peggy convinced me that this magnificent Manet was far superior to the one I had selected—another example of her intuitive appreciation of excellence.

Before making a decision to buy any painting of substantial value, we always sought professional advice concerning its authenticity and quality, but the final and determining consideration was invariably whether we both liked it. Among our many mentors, three individuals, all intimately associated with the Museum, stand out: Alfred H. Barr, Jr.; Monroe Wheeler, for many years the Museum's director of publications and exhibitions; and William S. Rubin, now Director Emeritus of the Department of Painting and Sculpture.

With the benefit of hindsight, the worst mistakes we made were in not buying a number of exquisite paintings when presented with the opportunity. For example, through Alfred Barr we were offered Paul Gauguin's *Still Life with Three Puppies* (1888), Henri Rousseau's *The Dream* (1910), and Pablo Picasso's *Girl with a Mandolin* (1910). Fortunately, they all found their way to the Museum—two were bought by my brother Nelson and later donated—but every time we see them, we wish that we had immediately recognized their extraordinary qualities and that they might have tarried with us a while.

In a few instances we were fortunate to be among those connected with the Museum who participated in the acquisition of an important collection. The most exciting occasion was the purchase of the Gertrude Stein Collection in the late 1960s, in association with Jock Whitney, André Meyer, Bill Paley, and my brother Nelson. The details of that fascinating acquisition are described herein on pages 96 and 97. Four paintings in the exhibition accompanied by this publication are among the ones we acquired from the Stein collection.

Although many of the works we have enjoyed most are exhibited here, our taste in art is by no means limited to French and other European painting of the late nineteenth and early twentieth centuries. We have bought a good many American paintings, from various periods and schools, and we also own a scattering of works by Latin American and Asian artists, which give us great pleasure. The one common denominator that we have tried to sustain in the acquisition of all of our works of art is high quality.

I mention all this because I believe it is relevant to an understanding of our motivation in the selection of the works shown in this exhibition. We hope those viewing it will share some of the pleasure we have had in living with these paintings for so many years.

David Rockefeller
Life Trustee and Chairman Emeritus
The Museum of Modern Art

✍ *Preface*

The Museum of Modern Art has been blessed throughout its history by the inspired patronage of distinguished collectors. Within that lineage of benefaction, from the time of this institution's founding until today, the continuing commitment of the Rockefeller family constitutes an especially remarkable, virtually unrivaled record of public-spirited dedication and generosity. David Rockefeller, recently retired from his second term as Chairman of the Museum's Board of Trustees and elected to the post of Chairman Emeritus, has sustained the high tradition of leadership established by his mother, Abby Aldrich Rockefeller, who joined with a small circle of associates to create the Museum in 1929. He has also, with his wife Peggy, given an extraordinary group of works to the Museum; some of those already reside in our galleries and others are pledged for the future. Peggy and David Rockefeller have now been kind enough to allow us to mount this select exhibition of their gifts in the area of early modern painting and to include in it other masterworks from their private collection. The word "private" is especially applicable in this case, as the Rockefellers have never sought public recognition for their superb collections of paintings, drawings, and decorative art objects, but have always acquired and conserved these works in the spirit of a quiet, personal love of beauty. We are therefore especially grateful for their willingness to accede to the Museum's request to share this group of great modern paintings with our public.

Kirk Varnedoe, Chief Curator, Painting and Sculpture, has been responsible for the selection of the exhibition and has written the informative introduction and commentaries on individual works in this catalogue. He joins with me in expressing our very warm thanks to Bertha Saunders, Curator of the David and Peggy Rockefeller Collection, for all the help she has given in the preparation of both the show and this publication. We are also most grateful to two Associates of David Rockefeller, Marnie Pillsbury and Peter Johnson, for their valued assistance in the realization of this project. In Mr. Varnedoe's office, Victoria Garvin, Administrator/Assistant to the Chief Curator, has played a key role in keeping all parties in proper communication, and in furthering all phases of the effort.

The Museum was extremely fortunate to have as a resource the extensive scholarly entries written by Margaret Potter for the privately published catalogue of David and Peggy Rockefeller's collection. In order to review these writings in the light of the most recent scholarly literature, we enlisted the aid of Jodi Hauptman, doctoral candidate at Yale University, whose admirable research contributed new insights and information. We are most appreciative of her excellent work, which resulted in the revised and expanded versions

of almost all of Ms. Potter's entries published here. She received valuable help from Pepe Karmel and, in the Department of Painting and Sculpture, Judith Cousins, Curator, Research, and Lynn Zelevansky, Curatorial Assistant. In the Museum Library, Janis Ekdahl, Assistant Director; Eumie Imm, Associate Librarian, Reference; and John Trause, Associate Librarian, Reference/Periodicals, are also owed a debt of thanks for their assistance. The editing of those entries, and of the other texts in the book, was the task of Christopher Lyon, Editor, Department of Publications; his sensitive and astute attention to that assignment is evident throughout. The handsome design of the publication is due to Michael Hentges, Director, Department of Graphics; and the quality of its production was very capably overseen by Vicki Drake, Associate Production Manager, and Amanda Freymann, Production Manager, Department of Publications. Mikki Carpenter, Director, Photographic Services and Permissions, helped with the photographic needs of the project. Osa Brown, Director, Department of Publications, has supervised these and other aspects of the catalogue's preparation, and we thank her for her careful overview.

In the mounting of the exhibition, Mr. Varnedoe was able to rely on the highly professional skills of several members of the Museum staff. Anne Umland, Curatorial Assistant, Painting and Sculpture, guided the overall organization of the project with care and intelligence, and Richard Palmer, Coordinator of Exhibitions, helped to ensure that all aspects moved ahead smoothly. Cora Rosevear, Associate Curator, Painting and Sculpture, was as always invaluable in helping to coordinate loans. The staff of the Department of Conservation, and particularly James Coddington, Conservator, provided expert assistance. Ramona Bannayan, Associate Registrar, supervised the collection, transport, and installation of the works. The final layout and installation of the exhibition itself were the work of Jerome Neuner, Director of Exhibition Production and Design. For the dedication of these staff members and their colleagues, Kirk Varnedoe and I are deeply appreciative.

In conclusion, I wish to express our immense gratitude to Peggy and David Rockefeller for their extraordinary graciousness in parting with these works for several months to make this presentation possible. This is a particular privilege for the Museum and a great gift of pleasure to our public. In very modest return, we hope that this exhibition and publication will represent worthy tributes to their exemplary generosity, connoisseurship, and love of art.

Richard E. Oldenburg
Director
The Museum of Modern Art

∿ *Introduction*

This presentation of twenty-one paintings cannot pretend to suggest the full scope of David and Peggy Rockefeller's collection, nor does it convey the breadth of interests reflected by their many gifts to The Museum of Modern Art. Many of the painters whose works grace their residences are not represented; and the Rockefellers have given to this museum numerous works in the fields of Latin American, Asian, and contemporary American art that are not featured here. There is, however, a logic to this narrowed selection. As the exhibition honors Mr. and Mrs. Rockefeller *and* their association with The Museum of Modern Art, we have decided to concentrate on the area where the Museum's special focus as an institution most completely overlaps with a central area of their activity as collectors. That happy coincidence of interests occurs in the field of early modern European painting. Thus, working with the Rockefellers, we have chosen an exhibition whose core is a magnificent group of their gifts to the Museum, chronologically anchored at one end by Paul Cézanne's *Still Life with Fruit Dish* of 1879–80 (p. 29) and at the other by Pablo Picasso's Cubism, in his 1914 *Woman with a Guitar* (p. 63). Especially notable among these donations are the glowing canvases by André Derain, Georges Braque, and Henri Matisse that reflect the Rockefellers' longstanding love of the brilliantly colored work of the Parisian Fauve painters of 1906–7.

To show these donations in a somewhat broader historical context, and to give a more representative idea of the Rockefeller collection's depth in this area, we asked to include a few paintings which fall outside our Museum's purview. Some of these the Rockefellers have generously pledged elsewhere; a few others are presently slated to remain in the family collection. This enhanced grouping offers a testament to the Rockefellers' acumen as connoisseurs and to their generosity as patrons of public institutions; but it also provides for our visitors an exceptional schematic survey—by way of some particularly high peaks—of the early flowering of the modern spirit in painting.

Though they are catalogued here in historical order according to artist, these masterworks from the Rockefeller collection might profitably be studied as examples of landscape, cityscape, still life, and figure painting in the late nineteenth and early twentieth centuries. A series of contrasts fundamental to early modern painting may be established, for example, by comparing Georges Seurat's *The Roadstead at Grandcamp* of 1885 (p. 37) and the seaside view Paul Gauguin painted three years later, *The Wave* (p. 41). One opposition would lie in the topological shift from the grass lawns of Normandy—which, with its tourist towns and sail harbors, had been one of the areas favored by the Impressionists in the 1860s

and 1870s—to the rocky bays of Brittany, which attracted later painters for the "savagery" of its craggier, less developed coasts. Another contrast is offered by the soft envelope of misty luminosity that Seurat created to unify his vista and Gauguin's flattened planes of unified hue, which have a sharper decorative impact. A still more profound difference, however, marks the basic approaches of the artists. Seurat, though driven to order his work along mathematical, semiscientific lines, remained committed to capturing the nuances of perceptual experience in an atomized atmosphere of light. Gauguin wanted to work with more emphatic contours, more evidently artificial abstract patterns, and bolder local colors, which spoke, he felt, not solely to the retina, as he claimed Impressionism had, but to the inner eye and the imagination.

These kinds of concerns, over how art might be reshaped to answer new notions of the relationship between the data of the senses and the work of the mind, continued to dominate the rhetoric of artistic debate well into the new century. The supposed opposition between the cognitive and the merely perceptual was still very much at stake in the supplanting of Fauve painting by Cubism, and it is exemplified in the contrast here between Braque's *The Large Trees* (1906–7; p. 53) and Picasso's *Landscape* (1908; p. 59). In the fall and winter of 1906–7, Braque, like Matisse and Derain a little earlier, had sought the stronger light of the south of France to help form a more vividly colorful imagery of nature. Yet for all the "unnatural" iridescence of their colors—derived to a great extent from Gauguin's innovations—Fauve paintings such as *The Large Trees* were shortly to be seen by the innovators of Cubism (including Braque himself!) as still tied to the disorganized rendering of optical sensation that they believed had characterized Impressionism.

The Picasso *Landscape,* which dates from from less than two years later, reflects Picasso's willful attempt to put art more evidently under the dominion of the mind. In contrast to the undulating softness of Braque's contoured zones of soft hills, vegetation, and gently blunted architecture, Picasso's picture presents a denuded vista of rocks, spiky bare branches, and sharply angular architectural masses; and in order to concentrate more insistently on volume and spatial structure—as opposed to effects of light and atmosphere—the artist imposed a somber, near-monochrome color scheme. Picasso was never a painter much concerned with landscape; in works of the Blue and Rose periods, and again in the beach scenes of the 1920s, natural settings tended to be nothing more than barren metaphysical vistas. As he moved toward Cubism's fusions of foregrounds and backgrounds, though, this emotionally neutral motif of a conjoined tree and house—a screen of forms fanning out across the canvas to occlude deep space—must have seemed especially apt.

In this and other landscapes of 1908, Picasso, guided in part by Braque's investigations of Cézanne's construction of volume and space, drew from the older master a vocabulary of chiselled weightiness that borders on the clumsy. Yet within two years he would move closer to another aspect of Cézanne, seen in the more airy, floating, transparent construction of watercolors such as the superb *Mont Sainte-Victoire* (1902–6; p. 33) in the pre-

13

sent exhibition. The delicate choreography of broken contour and overlapping touches of color in such watercolors provided both Braque and Picasso with inspiration for their sophisticated dissolution of form in the Analytic Cubist works of 1910–11.

It would be a misleading simplification, however, to describe the advent of Cubism or the changing modern image of landscape only in the narrow terms of formal influences and experiments. New languages of form frequently arise, not just from internal variations on inherited conventions, but also from the interaction of those conventions with fresh observations of familiar things. Inevitably, too, early modern artists' efforts to impose new orders on the vision of nature have metaphoric resonance as well. Among the Rockefeller pictures, both Pissarro's *Landscape at Les Pâtis, Pontoise* (1868; p. 25) and Picasso's *The Reservoir, Horta de Ebro* (1909; p. 61) bear out these points in parallel fashion: their styles and their subjects seem fused in two different images of a "naturally" constructed community.

By collapsing the middle ground, Pissarro's view of Pontoise emphasizes the organizing structure provided by the horizontal bands of fields and hill and the tectonically erect verticals of the recurrent slender trees. This formal pictorial organization accords in turn with the organization of the subject: land measured, segmented, and striped by agriculture, from the small garden plot close by to the distant hillside's alternation of newly tilled and ripening or fallow strips. Without romanticizing rural life, the picture constructs a thoroughly modernized Arcadian vision of a world ennobled by human labor—the earth plotted and made fruitful under a benign sky. Pissarro's lifelong ideals of social harmony were rooted in just such an idealized vision of interlocking humanity and nature.

In Picasso's view of the hillside town of Horta de Ebro, by contrast, spatial recession and the solid grounding of things have become deeply problematic matters, called into question in every facet of the scene. Yet there seems a sense in which Picasso, too, like Pissarro before him, draws from a vista not just formal order but metaphorical meaning. The ascending aggregation of simplified masses and narrow interstices provided a ready-made Cubist motif, a shallow massing of related angles perfectly suited to nurture an "architecture" of systematically faceted forms that could then be transported to Paris to treat still lifes and portraits, as well as cityscapes, in the following year. But the patterns of accretion by which the small hill town had grown, like the orderliness of the plots dividing the land in Pissarro's picture, also convey the sense of a community rooted in time.

In the anonymous vernacular architecture of Horta de Ebro, plain façades and roofs having an almost modular similarity were interlocked in a variety of seemingly illogical ways. Doubtlessly, this made an attractive model for Cubism's semiregular but consistently confounding dissolution of the conventional unities of forms. If so, then this view shows one of the foundations of modern painting being formed on a very prototype of the higgledy-piggledy, "organic" community that would later be cited by architects and urbanists as the saving alternative to the too-severe tectonic regularity that modern art and architecture had spawned.

Early modern painting's direct concern with the nature of modern urban communities is more evidently at issue, though, in the three city views by Monet, Derain, and Bonnard in the present exhibition. In Monet's 1877 view *The Gare St.-Lazare: Sunlight Effect* (p. 27), the railway revolution that was but a tiny footnote in Pissarro's view of Pontoise less than a decade before has come front and center as the principal subject. More specifically, it is in the volatile, all-confounding effect of steam that Monet finds his keynote theme; the scene is a spectacle of ephemerality and dissolution as fundamentally opposite to the grounded regularity of the countryside that Pissarro celebrated as the traditions of village life were to the new mobilities of city society. As other modern artists would, Monet here sought out the face of the new, not in the familiar physiognomies of great urban monuments or postcard vistas, but in the seemingly featureless zones of emptiness—such as railroad switchyards—spawned within the patterns of modern development. He tried, too, to wrest a new aesthetics from the raw material of industrialism that others ignored or spurned as inherently ugly. The very shapelessness of industrial vapor and smoke was thus as logical a focus of his developing Impressionism as fog, mist, and snow had been before.

In later decades, when the Impressionist vision became more finely aestheticized and mingled with the moody reveries of Symbolism—as in Monet's own cityscapes of London in the early 1900s—it was a younger generation of painters who resuscitated the bolder energies of these initial 1870s confrontations with the modern city. Against the grain of the *fin-de-siècle* taste for harmony, the Fauve artists pointedly revived both the early Impressionists' motifs of clamorous public life and their more boldly juxtaposed hues as a springboard for a brash embrace of the new century. With that in mind, Derain's *Charing Cross Bridge* (1905–6; p. 51) can be seen to epitomize a complex Oedipal relation—at once indebted, admirative, and hostile—with Monet. Even though Derain's dealer sent him to London to capitalize on the success of the recent Monet vistas, the young Derain more frequently dwelled on bustling traffic and the commercial, industrial pulse of the city on the Thames; and in place of the near-monochrome tonal harmonies that the aging Monet favored, he laid down slabs of bright, contrasting hues—as if to emphasize his love of the dissonant energies that his elder had muffled in the fog. The Rockefellers' *Charing Cross Bridge* is one of the rare canvases in which Derain's choice of motif is almost identical to the older master's; but the contrast in realization is only the more apparent. Sunset in the city is here not a moody time of waning half-light which evokes the decline of time, but a pyrotechnical display of fiery energies where even the encroaching blues of evening are intensified to suggest lit-up nights and incandescent tomorrows.

The wonderful Bonnard folding screen *The Promenade* (1894; pp. 46–47) descends, on the other hand, from a different vein of Impressionism—from the fascination of artists such as Édouard Manet and Edgar Degas with the thousand little dramas and comedies of manners that unfold on the boulevards and in the cafés of the modern city. Here was a domain where the sharp observation of particulars—as opposed to the generalized evoca-

tion of buzzing crowds and wide avenues—was most tellingly required; and where the physiognomy of line counted for more than weather and light. Bonnard's screen fused this demand for succinct encapsulation of the foibles of the day—caricatural and journalistic in the best sense—with the exotic and abstracting aesthetics of then-fashionable Japanese design. In so doing, he created an object that embodies some of the ambivalence of the artistic mileu to which he belonged—the Impressionist *flâneur*, or wandering sampler of urban experience, now becomes a *pantouflard*, or cozily slippered homebody, as the socially acute observation of street life is transformed into the comfortable accoutrement of a well-padded private interior.

Bonnard's later *Basket of Fruit Reflected in a Mirror* (ca. 1944–46; p. 49) reinforces this sense of his pleasure in the closure of the private interior—his enjoyment, in a domain of intimist comforts, of what Schiller called the "poetry of possession." In this still life (which we have included because of its close ties to Bonnard's early aesthetics, though it was painted after the period we are examining), the decorative finesse of Japonist flatness has been replaced by a far more complex spatial organization whose ambiguities and order alike reflect the intervening experience of Cubism and abstract art. *Basket of Fruit* seems a "late" work in a double sense, within Bonnard's long career of gently celebrating the rooms, gardens, companions, and cherished objects that surrounded him, and within the modern tradition as well. About seventy-five years separate Bonnard's still life from Manet's *The Brioche* (1870; p. 23)—not much less time than separated Manet from his source of inspiration in the late-eighteenth-century still lifes of Chardin. Yet Manet literally recast the elements of that older master in a new light, with freshly clarified color and confident boldness of conception. Bonnard here refined and attenuated the diverse heritage of the modern tradition—the hues of Gauguin and the Fauves, as well as the structures of later Cubism such as that of Braque—into a tender poetry that has the warmth of the hearth but also the glow of a sunset.

Juxtaposed with such a delicate structure of visual conundrums in thin spatial layers, Cézanne's *Still Life with Fruit Dish* (1879–80; p. 29), painted a lifetime earlier, assumes an archaic power akin to that of early Doric architecture. Its basic elements are not radically different from those of Manet's *The Brioche*, and indeed there are echoing devices, such as the inward-pointing knife at the edge of the table, which suggest a shared attention to the still lifes of Chardin. Yet in the short decade that separates these two works, a radical set of differences had intervened. The ways in which Cézanne points toward a decisively altered future are everywhere evident: in the tenser play of sharp asymmetries and monumental stasis; in the sculptural color modelling of the white cloth, which merges into the standing dish and, still more radically than in the Manet, cancels the leading edge of the table; in the compression of the ellipses of the dish and glass, which seem to align themselves with the assertive horizon of the table's rear edge; and in the organized rhythm of parallel, regularized brushstrokes throughout, building volumes, such as those of the apples, in a shadowless masonry of hues.

Cézanne's composition is built in part on symmetries. The two stacks of fruit, inside the bowl and on the table, are each composed in a crosslike fashion: a central vertical pair of apples flanked by a horizontal pair. Floral motifs in the wallpaper, seen in the upper corners of the picture, supply balanced brackets. But these pairings and symmetries are not allowed to remain stable. Each side of the ostensibly symmetrical pairs differs from the other. In this unpredictable, inch-by-inch negotiation between observation and construction, the imposed rationality of the artist has an altogether different physical expression in the picture—more hesitant, but also more raw with the tensions of invention—than the corresponding evidence of the mind in the more assertively geometric, but more refined and stable, *Musician's Table* (1914; p. 65) Juan Gris painted over three decades later.

Gris's still life is not an array of flowers or fruit, but something closer to a traditional depiction of the attributes of the arts. The subject of music, composing beauty by controlled interval and meter, may have had special appeal for him, concerned as he was with the measured geometry of art; and the empty musical score here, as well as the violin without strings, may be meant to suggest visual art's silent orchestration. Traditionally, though, still lifes that feature musical instruments (or other tools of creative ambition) speak of silence in a more tragic vein. An air of melancholy *vanitas* surrounds them as they bear witness to the ephemerality of human pleasures and to the poignancy of efforts to cheat mortality by artistic striving. Gris's arrangement, by contrast, is an instance of the general proliferation of musical instruments in Cubist imagery, and, more specifically, it refers to the merger of creativity and conviviality in café life: the wine glasses and newspaper headline represent that convergence of arts, amusements, and the events of the day which was the implied subject of so many paintings and collages by Picasso and Braque after 1912. Standing between the elemental force of 1870s Cézanne and the more Alexandrian pleasures of late Bonnard, Gris's table represents the moment of Cubist collage when the private language of the avant-garde first sought direct intersection with the rough clamor of the modern urban world.

Taken alone, the apples in Gauguin's *Portrait of Jacob Meyer de Haan* (1889; p. 43) obviously belong to this tradition of modern still life and descend directly from the apples in Cézanne's *Still Life with Fruit Dish* (which Gauguin owned). Their role in this picture, however, is to serve as attributes of the sitter and as elements (very likely denoting mankind's Fall through the sin of Adam and Eve) within a complex symbolic program. In a fashion that recalls other Gauguin scenes of religious revelation, the field of de Haan's portrait seems divided between a dreamer and his dream. Does he see these apples, this lamp, these books? Or is Gauguin showing us, as if in a giant comic-strip "thought balloon," symbolic items that exist only in de Haan's imagination?

The challenge Gauguin's split image addresses is closely related to questions about the sensations of the retina and the work of the mind, which we discussed in relation to his landscape *The Wave*: how were the gains of Impressionist naturalism—and here we would

add the lessons of Cézanne—to be subsumed within an art that addresses meanings not evident in the visible surfaces of the world? That problem is closely related to the one that prompted the (stylistically quite different) portrait of Félix Fénéon painted by Signac just a year later in 1890 (p. 39): how can one depict simultaneously the worldly appearance of a person *and* his or her ideas? The odd conjunctions and hybrid styles in the two works—splicing caricatural specificity and radically flattened abstract pattern, and combining clarity of depiction with the opacity of coded meaning—are indices of this unresolved dilemma.

Gauguin, in keeping with his primitivist bent, put his faith in synthesis and simplification as routes to the universal fundaments of art's language. Signac, the adept of modern science, chose the path of analytic division and mathematics. In each case, however, a crucial ingredient seems to have been humor: in the barb of caricature that informs both likenesses, but also in the whole idea of a portrait as a privileged communication between friends, who take pleasure in making it opaque to non-initiates. Both pictures—and especially the Signac, with its devotion to scientific system—belong to the world from which Marcel Duchamp came, and to which we cannot easily return—one where the clubby jokes of avant-garde hermeticism could be played in terms as yet untainted by disillusioned irony.

In concluding, if we looked within the Rockefellers' collection for one group of works which might add further dimensions to the issues raised in discussing these themes of landscape, cityscape, and still life, we could look beyond the portraits of de Haan and Fénéon to the broader field of paintings of the human figure, where the collection provides a series of stepping-stones from Impressionism and Post-Impressionism through the early 1900s to Cubism on the eve of World War I.

The pairing of Renoir's *Gabrielle at the Mirror* (1910; p. 35) with Cézanne's *Boy in a Red Vest* (1888–90; p. 31), for example, would allow us to contrast later works by two artists—and friends—who participated in Impressionism and then moved beyond its innovations. Solid sculptural volumes and a concern for the physiognomy of edges in the Cézanne sharply contrast with the softer, more generalized forms that Renoir swaths in a thick, perfumed atmosphere. Similarly, Renoir's costume-trunk orientalism seems absolutely alien to Cézanne's lanky young model, despite his picturesque attire. In Cézanne's depiction of the model, as in many of his still lifes, naturalism's imperatives are still felt in the undisguised evidence of the studio setting, with its demystifying clutter and props. Renoir, by contrast, creates a hybrid realm of realism and artifice, where the overtones of harem romance color the everyday tasks of the *toilette*, and the invitation to voyeurism mingles with the recognition that the subject is a model posing.

In both cases, we can divine some of the reasons why each artist eventually came to be seen as an emblem of consolidation and conservatism. Cézanne's concern for structure, and the stable probity of his deliberately constructed volumes—along with his rural life in Aix, far from the capital—helped make him a hero to many early twentieth-century

artists and thinkers, who despaired of what we would now call the "hype" of new art and who sought a more solid, reasonable ground on which to anchor modern French aesthetics. In the years around his death in 1906, Cézanne appealed not only to an artist like Braque, who sought to move art beyond the permissiveness of Fauvism toward the discipline of the mind, but also to more openly conservative, politically right-wing ideologues, who wanted to consolidate the gains of later nineteenth century art as a buttress against progress and change and who advocated a return to the enduring French verities of Reason and rural life.

In similar fashion, after the crisis of World War I, in a political climate familiarly known as the "return to order," many in France evoked the reassuring appeal of an ideal of classical stability vested in the Mediterranean tradition. Again, the call went out to consolidate the gains of the avant-garde in a style that would reaffirm the singular virtues and pleasures of French culture. In these circumstances, the recently deceased Renoir served somewhat as Cézanne had around 1906, as the grand old man of the modern tradition. Despite the radical flair of his youth, he had survived to produce a canon of female beauty that translated the ideal rigor of the classical heritage into the sensual pleasures of the present. Pictures such as *Gabrielle at the Mirror* found their echo in these postwar years both in the odalisques of Matisse's Nice period and in the ample proportions of Picasso's neoclassical figures of the early 1920s.

If we have any doubt, however, that Picasso retained his connection with a Spanish heritage despite his attachment to such French styles and traditions, we need only compare Renoir's *Gabrielle at the Mirror* to a picture the young Picasso painted just a few years before, the Rockefellers' memorable *Girl with a Basket of Flowers* (1905; p. 57). The generalized forms of her body seem to belong with the relatively sweet and emotionally passive nudes of Picasso's Rose period; but the unsettlingly specific, prematurely seasoned face of the girl retains something of the expressions of the predatory cabaret whores who stare out of Picasso's first paintings of Parisian night life. The odd fusion of ecclesiastical idealism (the picture was originally conceived to show a girl at her first communion) and corrosive realism belongs to a heritage of Catholicism that is distinctly Spanish; and the added overtones of precocious, confrontational sexuality could not be more distant from the self-absorbed boudoir nudity of Renoir's model.

Complementing—and often as vehicle for—his consistent attention to matters of sexuality, however, Picasso was also one of the major form-givers in modern art in the area of humor and high spirits; and while we think of his later years as focused strongly on inner life and private *amours*, we should never forget the wit and openness with which the young Picasso embraced the public commerce and amusements of modern Paris. The Rockefellers' *Woman with a Guitar* (1914; p. 63) perfectly personifies the playful jauntiness, worldly yet earthy, of Cubism just before the war. The everyday slang of headlines and posters and the weekly quotient of punning, farcical cabaret humor seemed to Picasso useful accomplices as he nimbly cobbled together the ephemeral snippets that make up his collages. Of course,

the radical fragmentation of the body into disparate abstract planes, and the incursion of cheap wallpapers, crass tabloid ads, and headlines of war's atrocities, did communicate the conditions of urban life with an edge that was not reassuring. Yet the lively incongruity, mobility, and radical insubstantiality of images such as *Woman with a Guitar* respond to modern life with a world of form where the attempt to assign categories, such as "serious" or "funny," "critical" or "positive," "radical" or "complicitous," only invites us to impose closures and reductive readings on open-ended and richly ambiguous inventions.

It is this kind of contradictory complexity, and confounding blend of the conservative and radical impulses in modern art, that marks one of the greatest and also one of the most beautiful pictures in the Rockefeller collection, Matisse's *Interior with a Young Girl/Girl Reading* (1905–6; p. 55). It was painted in Matisse's apartment on the Quai St. Michel; but anyone who has experienced a small urban flat in winter will see that Matisse was already residing in a tropics of the imagination that prefigures the environments infused with light and color he would create for himself decades later. In the *art nouveau* milieu Matisse knew as a young man, there were currents of thought which held that the décor of a room should surround a person like an emanation of the vital energies of his or her psyche, which, in that period, meant a continuous web of dark, plasmic curvilinearity. What seems remarkable here, however, is the apparent disparity between the inner state of the subject—quietly absorbed in reading—and the riotous, pyrotechnical remaking of the room around her. Coming unbottled in this picture is the genie that would continue to attend Matisse throughout his life, allowing him to summon radical art from the stuff of a conservative life—not just by fantasies of escape from it, such as the nude frolic of the 1909 *Dance*, but from deeper probing into the heart of its embrace, in such pictures as *The Piano Lesson* (1916) or *The Red Studio* (1911), to choose a set of familiar examples from the Museum's collection. The apparently simple sight of a daughter reading, the embodiment of proper domestic interiority, becomes the occasion for an aggressively untidy eruption of color which is not—as in the paintings by Gauguin or Signac discussed here—simply the ulterior manifestation of the sitter's ideas, but something more complex: the merger of the artist's empathetic response with the perception of the subject at hand. A central part of what we value in modern art resides here, in the seemingly inappropriate and perpetually fascinating conjunction of the ordinary and the fantastic. Our wonder lies not simply in the radical innovation itself, but in the power of that innovation to make us see anew, by unexpected means, the transforming discovery latent in the simplest of our daily experiences.

Kirk Varnedoe
Chief Curator
Department of Painting and Sculpture

MASTERPIECES FROM THE

DAVID AND PEGGY ROCKEFELLER COLLECTION

Édouard Manet

FRENCH, 1832–1883

The Brioche

La Brioche
1870

The Brioche, like many of Manet's most original paintings, "quotes" from earlier art. The central motif of a flower stuck into a bakery puff pays homage to the eighteenth-century French master J.-B.-S. Chardin, whose still life featuring a similar splice of blossom and bread (*Un Dessert*, 1763) entered the Louvre the year before Manet painted this still life. However, the fancy furniture and bright panache of Manet's execution belie the sober simplicity that had been Chardin's retort to the courtly frivolity of his day. The snow-pure brilliance of white petals and crisp linen, and the fresh clarity of local color—in the velvety peaches and hot red lacquer, or in the limpid green grapes and deep purple plums—are set against profoundly somber shadow. In parallel fashion, the spontaneous casual-ness of the improvised floral display and just-unfolded napkin contrasts with the ornate elegance of the antique table: kitchen goods in a salon setting. Such affections for disarming immediacy and elegant formality mark Manet's persona as both iconoclast and epicure. They may also be taken to say something about this moment in history, between the hothouse revival of Rococo style under the Second Empire in the 1860s and the open-air aesthetics of the democratizing, Impressionist decade ahead.

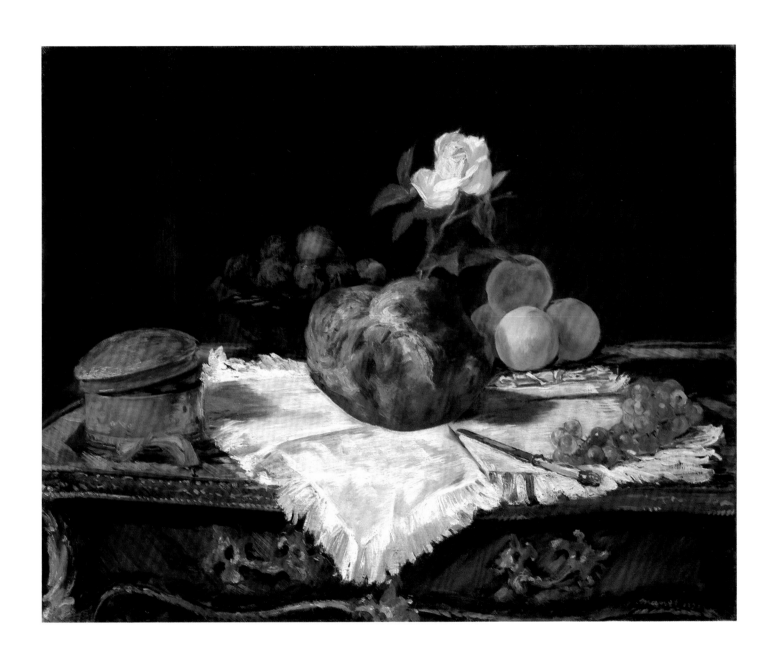

Camille-Jacob Pissarro

FRENCH (BORN ST. THOMAS, DANISH WEST INDIES), 1830–1903

Landscape at Les Pâtis, Pontoise

Paysage aux Pâtis, Pontoise

1868

The village of Pontoise, near Paris, was one of the favored locales of Pissarro's early career. Though he would later paint its industrial aspects, here he shows it as a peaceable farming community in which the intrusion of the railroad—the tiny black engine sending up a puff of smoke by the quarry at the base of the hill, near the center of the canvas—offers the only note of advancing modernization. The high horizon, compressed spatial structure, and solid, masonry-like construction of the painting remind us of the lessons Paul Cézanne would draw from his close association with Pissarro, while the high-key greens and overall luminosity recall Pissarro's own debt to Camille Corot. That brightness also might be taken as a harbinger of the Impressionism of the next decade; but the painting's agrarian subject and large scale, and a denser, more controlled application of paint than Pissarro later adopted, point to an epoch when these young painters still sought their public through the official Salon exhibitions.

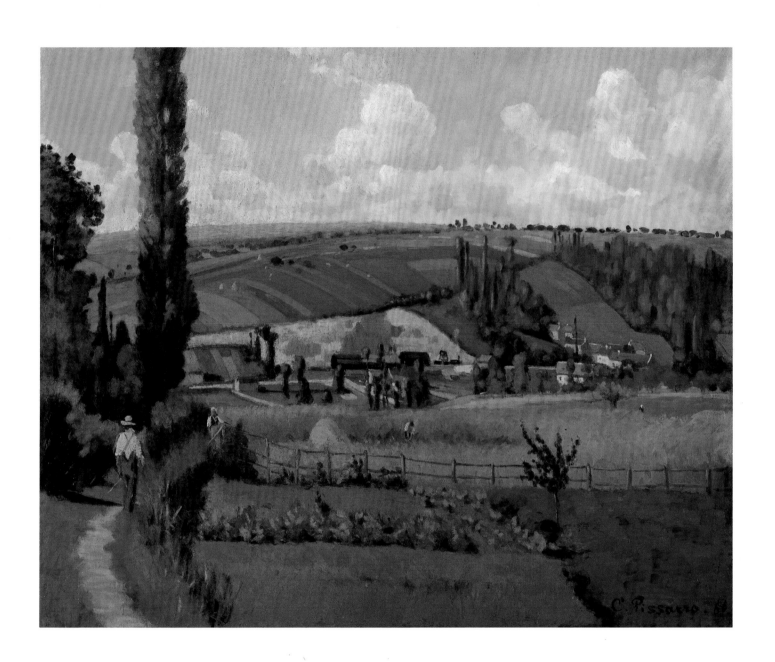

Claude-Oscar Monet
FRENCH, 1840–1926

The Gare St.-Lazare: Sunlight Effect
Extérieur de la Gare St.-Lazare: Effet de soleil
1877

In 1876 and early 1877, when he painted a number of views of Paris's St.-Lazare train station, Monet took on a boldly modern subject in a singularly oblique way. The English Romantic painter William Turner had shown a speeding locomotive in the countryside as if it were a fire-breathing apparition; others—including later the Italian Futurist painter Umberto Boccioni—depicted railroad station halls as scenes of turbulent human drama. Monet, however, found the poetry of modernity in more prosaic locales, choosing to paint the engines "at ease," slowly shuttling in and out of the shed or idling on the unpromising terrain of the switchyard. For many Parisians, this site would have been only a hellish no-man's land of grime and clatter; but for Monet it was the modern equivalent of a great harbor, where the city opened onto the countryside and lost its insularity in its newly swift connections to its suburbs, other cities, and nations beyond. Above all, for a painter who repeatedly challenged himself to give form to the most ephemeral and elusive of visual experiences, this was a spectacle of dissolving form and shifting light, with the buildings at street level apparently floating on volumes of vapor that reach up the canvas to merge with the clouds in the sky above. As in other scenes of snow and fog, which risk becoming colorlessly uniform, Monet selected one point of focus—here the red signal panel right of center—to key up the color and activate the spatial structure of the painting.

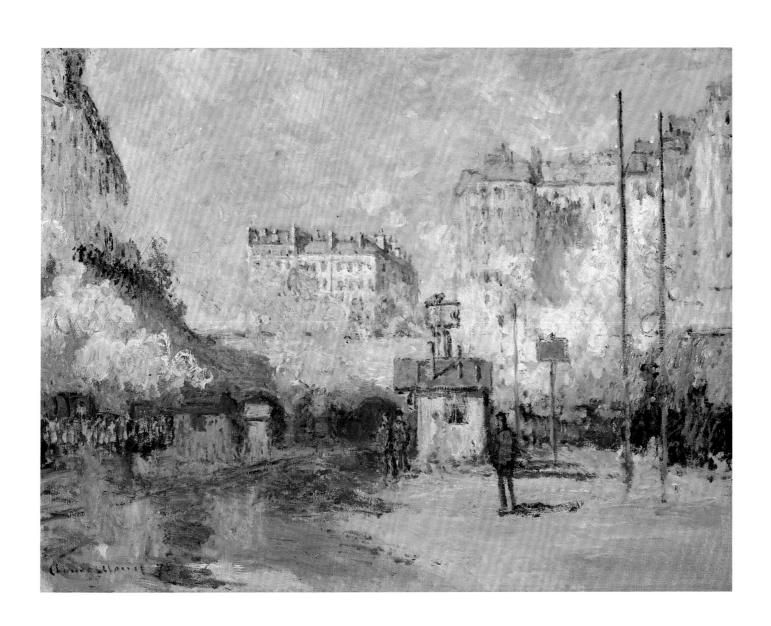

Paul Cézanne

FRENCH, 1839–1906

Still Life with Fruit Dish
Nature morte au compotier
1879–80

For a generation of early modern artists, this painting was a very special embodiment of Cézanne's genius. It belonged to Paul Gauguin, who struggled to keep it even when in dire financial straits; and it was later copied by Maurice Denis, who set it as an object of veneration in his *Homage to Cézanne* (1900; see page 69). Though certain artists may have borrowed from it specific elements—such as the flowered wallpaper, which seems to echo in several Gauguin paintings—the painting was more important for its whole manner of conception, which seemed to sum up all that Cézanne had learned from Impressionism and all that he had invented to surpass it. If we compare it to Manet's grander *Brioche* (p. 23) of just ten years earlier, we can see that the intervening experience of open-air Impressionism has thoroughly banished the shadows on which Manet's sense of space and modelling still depended. Color has become not just a matter of local tones but an all-pervasive fabric: black is almost wholly eliminated, white areas are rendered in complex passages of tinted light, and volume is conveyed solely by the juxtaposition of hues. Yet the animated, variegated brushstrokes and the sense of spontaneity common to Monet's and Renoir's Impressionist canvases of this same date are rejected in favor of what have been called Cézanne's "constructive" strokes—regular, parallel units of paint from which the image is built brick by brick into something redolent of patience, reflection, and never-wavering, inch-by-inch concentration. Add to this the tense rigor of Cézanne's willful deformations of perspective in the volumes of dish and glass, and the monumentality that results from the play of sculptural masses in this shallow and compressed space, and we begin to comprehend the immense authority that made this work the talisman of a new vision.

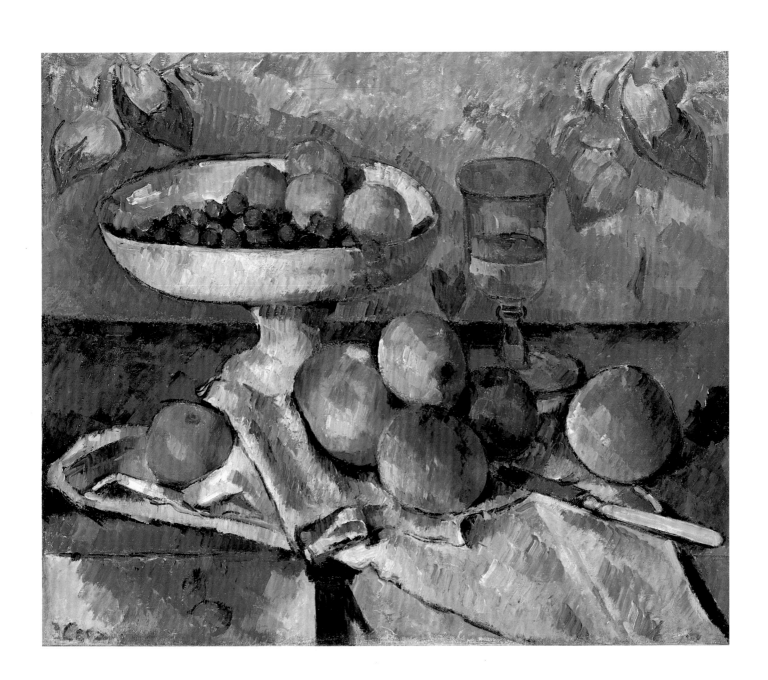

Paul Cézanne

Boy in a Red Vest
Garçon au gilet rouge
1888–90

This painting, which once belonged to Cézanne's friend Claude Monet, is one of four showing the same subject in slightly varying poses. The young Italian who posed was, unusually for Cézanne, a professional model; but nothing is known that would convincingly explain the meaning of the costume or shed light on the particular conjunction of grandly draped setting and relatively casual posture. Here, as in the great Cézanne *Bather* (ca. 1885) already in the Museum's collection, an undramatized confrontation with an apparently stock studio subject results in a painting of deep fascination and beauty. Slightly hunched, inert, and passively inexpressive in terms of conventional cues, the sitter still seems endowed with a complex inner life. The device of the dark drape gives the light sleeves great volumetric presence, allowing them to set off the note of clear red in the protruding vest; similarly, the dark shadow in the drape sets off the boy's profile. Yet the life of the work lies not so much in the major elements of the composition—such as the large interlocking reverse sweeps of that drapery, which move in nascent pinwheel fashion around the bent body of the youth—as in smaller moments: the subtle parallelisms and rhymes of large and small contours; the specific physiognomy of minor moments such as the folds in the shirt or the notching angles of the vest and sleeves; and the constant, unpredictable dialogue of sharply drawn and gently constructed passages of painting.

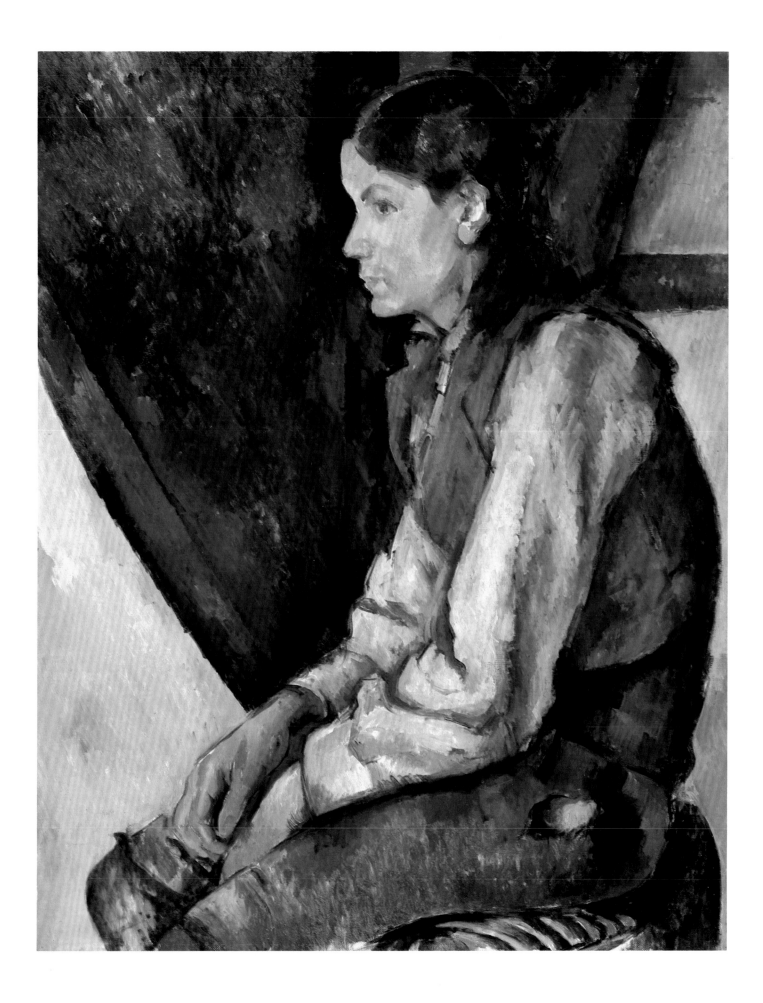

∾ Paul Cézanne

Mont Sainte-Victoire
1902–6

To many artists in the nineteenth century, watercolor was a secondary medium, for spontaneous sketching. Cézanne, however, used it in a deliberate, even painstaking way, which wrested from it a new complexity and depth. As the Rockefellers' *Mont Sainte-Victoire* shows, he created overlapping networks of separate strokes by working with patches of a color all over the field, allowing each color to dry before superimposing the next array of strokes. To augment the airy translucency of these multiple overlays of color, Cézanne deliberately left a considerable amount of pristine paper in all parts of the image, increasing its luminosity. (The influence of this approach is often held to account for the "unfinished" look of later oil paintings in which bare canvas plays a prominent role.) In this fashion, the regular, "constructive" strokes, which brought such powerful solidity to earlier works such as the *Still Life with Fruit Dish* (p. 29), became the foundation elements of a shimmering tapestry of transparencies.

In the final years of his life, Cézanne made numerous watercolors of Mont Sainte-Victoire, and almost always from this same vantage point, where the craggy physiognomy of the mountain rises on the horizon beyond an extended middle distance of trees and hills. The telescoped space here yields an ennobling, idealized view in which a cool, organically rendered rock mass is set above the myriad overlapping facets of a warmer landscape in the intervening valley.

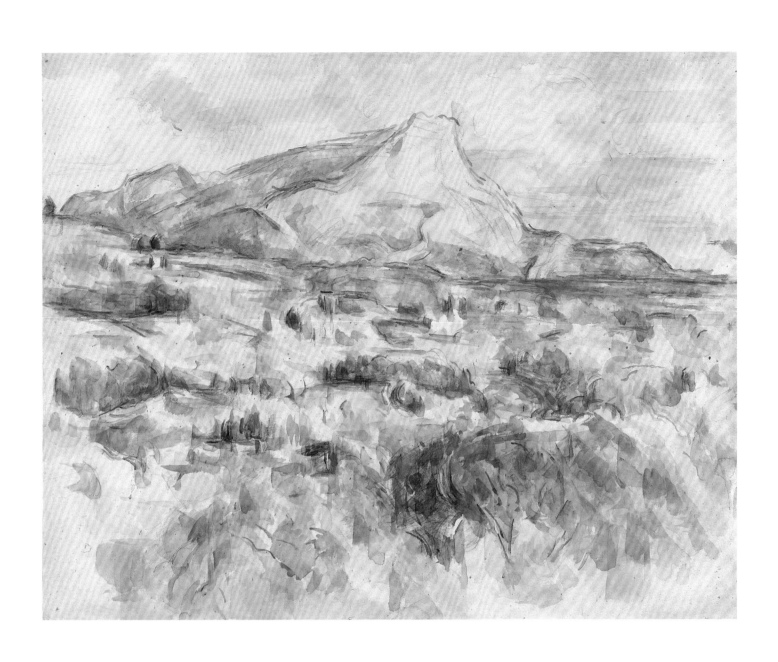

Pierre-Auguste Renoir

FRENCH, 1841–1919

Gabrielle at the Mirror

Gabrielle au miroir

1910

As a young man, Renoir pursued the Impressionist program of showing the dazzle of sunlight, the flair of fashion, and the often nervous public life of modern society; but in later life he dwelt on what he felt were more timeless forms of beauty, particularly the female form. As early as the 1880s, he had begun to refer to older art for a treatment of the nude in which substantial volumes would communicate a stable, assuring grace. Here, one of his favorite models shows that anatomical ideal more fully evolved and personalized—a body roundly ample but wholly unponderous, peeking through the gauzy patterns of a half-opened negligee and swathed in a vaporous atmosphere of ruddy interior warmth.

Painted a year after the early Cubism of Picasso's *The Reservoir, Horta de Ebro* (see page 61), the picture might seem simply *retardataire*; but in fact it looks forward as well. Both Matisse and Picasso paid homage to the aging Renoir, whose canon of female beauty seemed—especially in the crisis years surrounding World War I—to embody a special marriage between classicizing idealism and a distinctly modern, specifically French sense of sophisticated pleasure. The thick-limbed women in Renoir's later works were important sources for Picasso's neoclassical figures of the 1920s (see the Museum's *Three Women at the Source* [1921]); and, with its softly exoticized boudoir eroticism, *Gabrielle at the Mirror* also anticipated the 1920s odalisques of Matisse in their harem costumes.

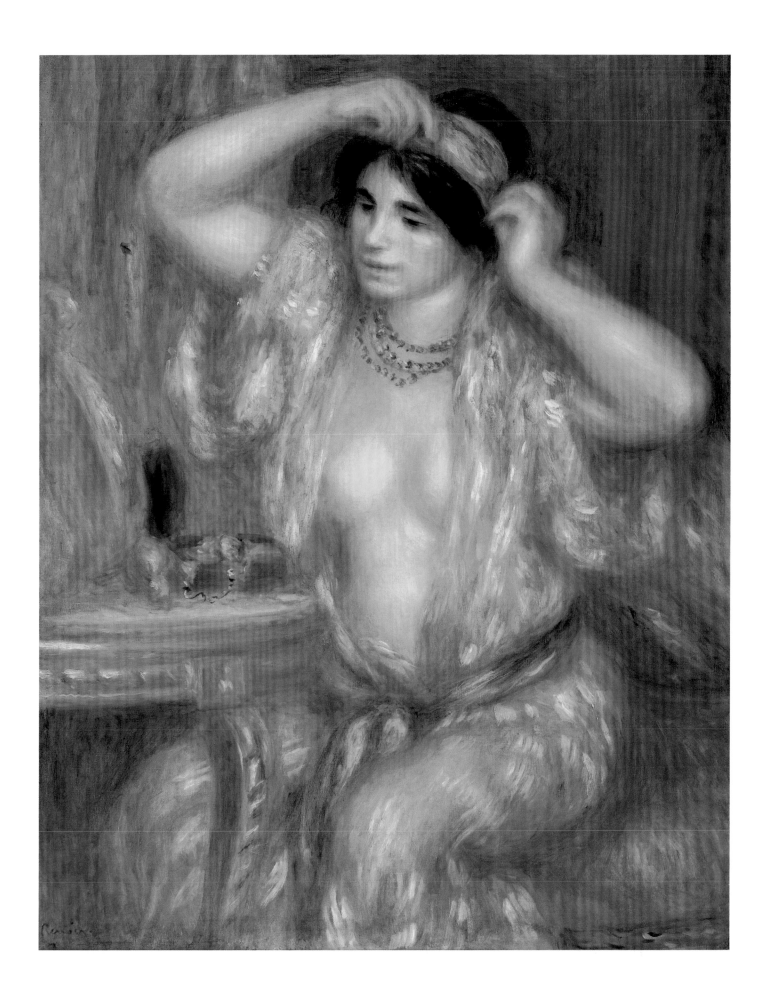

Georges-Pierre Seurat

FRENCH, 1859–1891

The Roadstead at Grandcamp
La Rade de Grandcamp
1885

Seurat followed his Impressionist elders in their love of the Normandy coast; but he ignored the gaiety of vacation crinolines on the sands and turned his back on the picturesque motifs of laboring fisher folk or windy tempests. His Normandy was typically a depopulated zone of still noons, silent sails, and misty twilights; his painting of peaceful summer landscapes there provided a yearly counterpoint to his attempts to capture, in larger, more "constructed" pictures, the conflicted rhythms of public life in Paris.

The Rockefellers' painting, among the first of Seurat's views of the Channel coast, was made shortly after his immense effort to complete *A Sunday Afternoon on the Island of La Grande-Jatte* (The Art Institute of Chicago). In that canvas, he had begun to bring to maturity his signature manner of pointillism—building a painting by the systematic application of countless small, regular (though never mechanically identical) dots of paint. Here, the handling remains more in line with the variegated touch of Impressionist painting, and he abandons the hard-fought color complexity, geometric organization, and linear stylizations of *A Sunday Afternoon.* The domesticized foreground of a manicured lawn, tended hedge, and fence gives on to leisure boats riding at anchor in a gently rippling current. Only the slightly odd animism of an unclipped bush, so central and prominent, and the dark triangle of shadow from an unseen source at the right gently remind us of what Giorgio de Chirico would see in Seurat: that he could distill from the least remarkable intervals of daily life not only a rational order but a mysterious poetry.

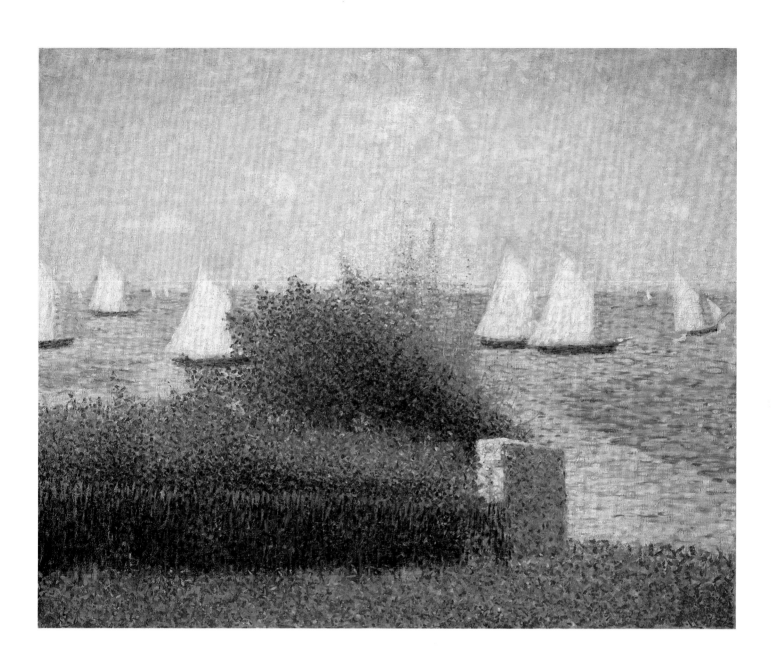

Paul Signac

FRENCH, 1863–1935

Opus 217. Against the Enamel of a Background Rhythmic with Beats and Angles, Tones, and Tints, Portrait of M. Félix Fénéon in 1890

Opus 217. Sur l'émail d'un fond rhythmique de mesures et d'angles, de tons et de teintes, portrait de M. Félix Fénéon en 1890
1890

In the hands of Seurat, the myriad dots of pointillist painting had proved especially well-attuned to conjuring the tint of sunsets, the half-light of gas lamps, and afternoon shadows. Yet here Seurat's younger cohort Paul Signac deploys pointillism in the service of a giddy carnival of colors and a boldly flattened pinwheeling pattern; and sets in its midst, sternly reserved and decorous, a caricaturally sharp profile of the art critic Félix Fénéon, one of the prime supporters of Seurat's and Signac's Neo-Impressionism.

Fénéon (whose resemblance to the archetypal Yankee, "Uncle Sam," is here played up) shared with Signac the belief that a new aesthetics could be based on hidden mathematical laws of relationship between the hues and vectors of visual experience and the viewer's emotional response. As a believer in the doctrines of anarchism, he felt these universal laws would serve the broad projects of educating the working classes and promoting new orders of social harmony. Accordingly, the wheel of color and pattern behind his figure was intended in part to demonstrate the ideas of Charles Henry, one of the prime theorists of the new "scientific" aesthetics. The precise meanings of the demonstration and of the various symbols—the lily in Fénéon's hand or the stars behind him—are often debated. What is unmistakably clear, in any event, is that the elaborately titled picture has the coded references, not just of esoteric theory, but of an elaborately staged in-joke. Conceived in a spirit of subversive conspiracy by its author and its subject, the portrait was designed from the outset to be both shocking and mystifying. It suggests a lost moment in the early modern era when it could be imagined that art might reconcile science, beauty, and social reform, and all in high spirits.

38

Paul Gauguin

FRENCH (DIED ATUANA, HIVA-OA, MARQUESAS ISLANDS), 1848–1903

The Wave
La Vague
1888

In the remarkably abstract design of this seascape, it is only the sliver of beach curving down the canvas's right edge that gives orientation to the spatial expanse of the sea's green-white plane. Similarly, the scale of the vista is established only by the tiny figures at the right—apparently recreational bathers rather than the working seaweed gatherers we might expect to see at the point where Brittany's rural farms met its rocky coast. While it is larger and more consistently naturalistic, the vista recalls the interest in flattened, decorative design that informed Gauguin's nearly contemporaneous portrait of Jacob Meyer de Haan (p. 43), painted on the walls of the inn at Le Pouldu, not far from this site.

Those who have written about *The Wave* have consistently pointed to the influence on it of Japanese art. The linear treatment of the wave crests echoes woodblock prints such as those of Hiroshige, as does the plunging overhead perspective, which Edgar Degas, whom Gauguin admired, employed in his theater and dance scenes of the 1880s. The most direct and relevant precedent for this picture, though, may be the views of craggy rocks in foaming oceans that Monet painted on the island of Belle-Ile off the Brittany coast in 1886.

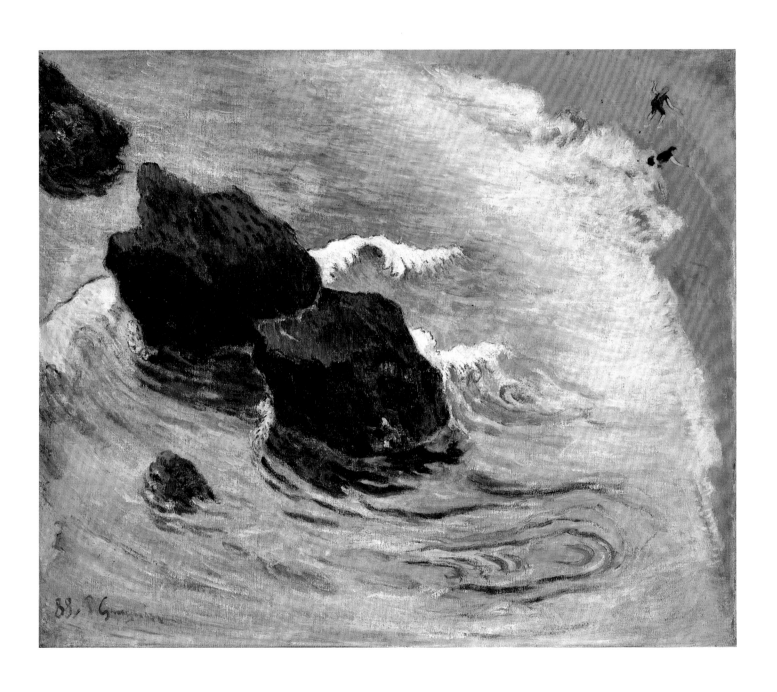

~ Paul Gauguin

Portrait of Jacob Meyer de Haan
1889

This striking portrait, of a Dutch painter who was one of Gauguin's closest friends, stems from the same period in Brittany when the artist created *The Wave* (p. 41) and also the *Still Life with Three Puppies* (1888), one of the most distinctive and popular early paintings in the Museum's collection. Like *Three Puppies*, the portrait combines a severely flattened pictorial space and attention to pattern with an apparently symbolic program of meaningful details—whose meaning has yet to be conclusively decoded. The work was originally painted as part of a decorative ensemble on the panel of a door in an inn at Le Pouldu, where both artists stayed and where de Haan had an affair with the proprietor, Marie Henry. A Gauguin self-portrait, similarly flat and with an even more insistent symbolic program (see page 81), graced the corresponding door on the other side of a fireplace. The snake and apples in Gauguin's self-depiction and the apples in this portrait may refer to the temptation of Eve in Eden, and hence, obliquely, to de Haan's sexual liaison. Gauguin has given de Haan the pose of a thinker and has included two books that denote de Haan's preoccupations with religion and philosophy: Milton's *Paradise Lost* and Thomas Carlyle's *Sartor Resartus*. (Since Carlyle's central character is called "Diogenes," after the Greek philosopher who searched by lamplight for an honest man, the prominent lamp here may extend this reference.) Yet Gauguin, who was de Haan's rival for Marie Henry's favors, also has endowed his friend with a predatory, almost diabolical presence, in the intensity of his hovering gaze and in the suggestion of a cloven hoof for a hand.

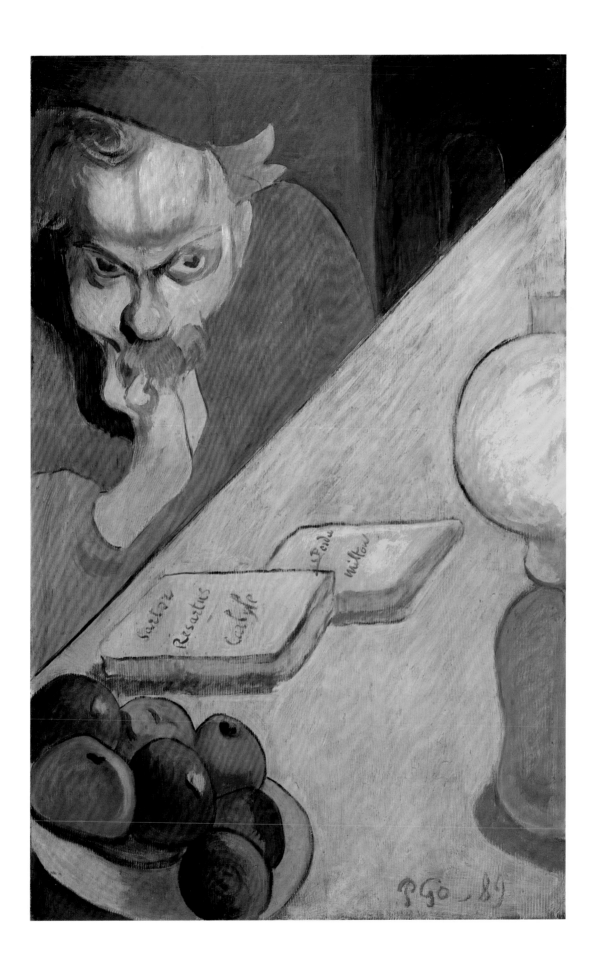

Pierre Bonnard

FRENCH, 1867–1947

The Promenade
Promenade des nourrices, frise des fiacres
1894

Bonnard shows us a collision between puerile mischief and cautious propriety, as a fashionable mother shelters her white-frocked little girl from two rambunctious boys chasing their rolling hoops. Even the family whippet cringes, in contrast to the heartier, independent mutts in the background. Given the suggestion of vegetation at the outside edges, we might guess that this little comedy of public manners is set in a sandy Parisian park such as the Tuileries; that the balustrade at the left, along which the bonneted nannies sit with their prams, is the edge of that park; and that the horsedrawn cabs beyond are lined up in front of a regularly planted row of urban trees.

This screen, which Bonnard later remade in the form of a four-part lithograph, has its ancestry in Impressionist social observation such as Edgar Degas's (similarly class-conscious) view of *The Place de la Concorde* (ca. 1873). But the marked interest in more drastically flattened and repetitive motifs—and the format of the screen itself, for which Bonnard designed the frame—bespeak a more delicately aestheticized interest in drying and pressing the varieties of public life into the patterned decor of the private interior. Here the pithy, economical slang of caricatural illustration is inflected with the sophisticated silhouetting and asymmetries of Japonist taste, to refine the hurdy-gurdy of anecdotal street life into the gentler amusements of chamber music.

THE SCREEN IS ILLUSTRATED ON THE NEXT PAGES

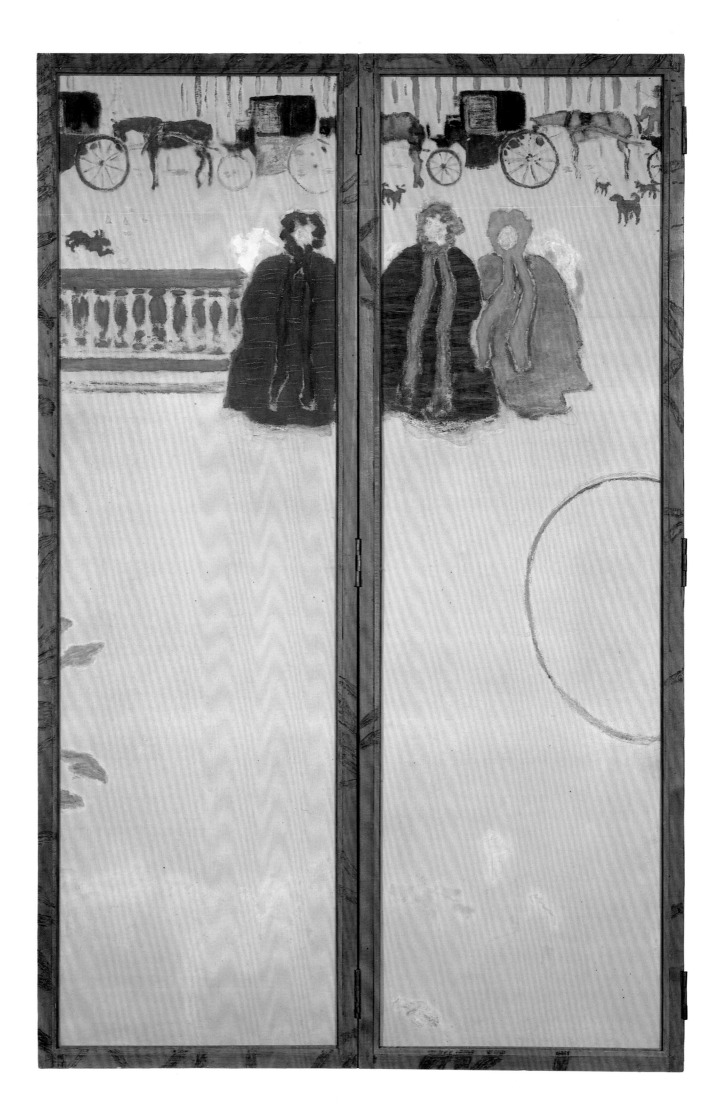

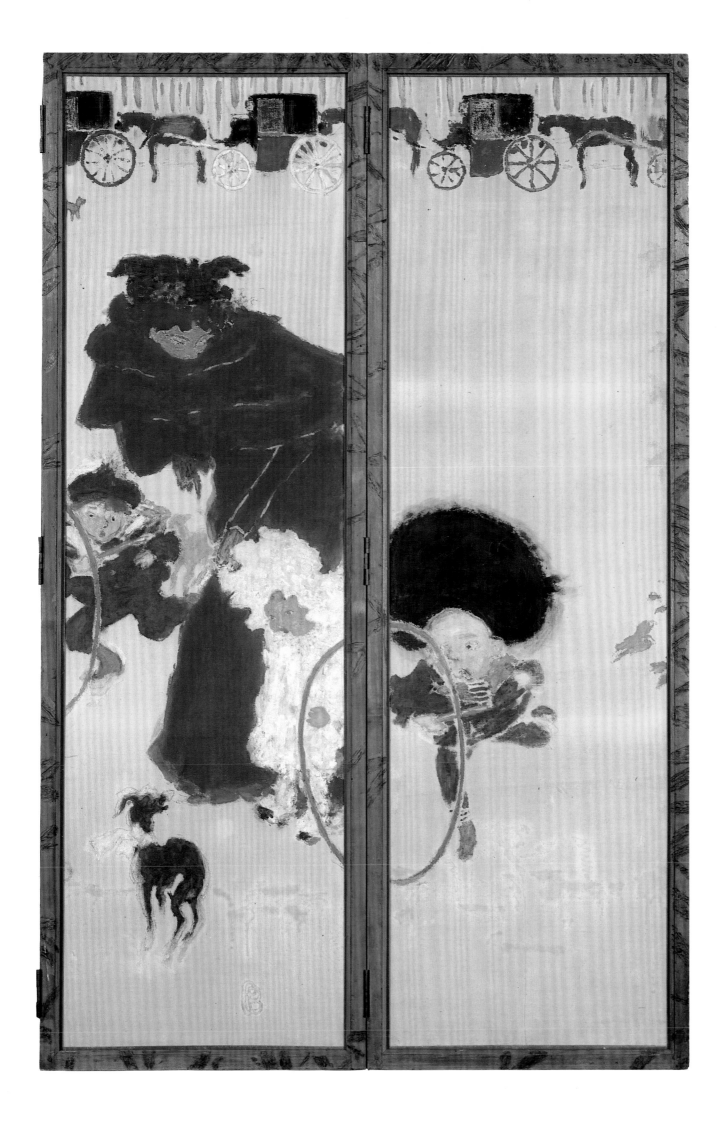

Pierre Bonnard

Basket of Fruit Reflected in a Mirror
Corbeille de fruits se reflétant dans une glace de buffet
Ca. 1944–46

This late still life obviously falls outside the early modern period that is the focus of our exhibition, but it is included because of its strong continuity with the aesthetic Bonnard formed near the turn of the century. Its rich color, domestic subject matter, and use of reflection (the central image is a mirror, and the surrounding panels appear to be a wall and frame), are all elements typical of Bonnard's work throughout his mature career. What is particularly striking here, however, is the rigorous *order* of the picture—a rectilinear structure that is used to balance the ambiguous space within the mirror image. This blend of pattern and observation, strict flatness and spatial conundrum, is unthinkable without the experience of Cubism and abstract art.

By some standards this picture might be seen as "regressive" for its date, too obviously pleasing and softly discrete. With tremulous rendering and the lambent glow of gently corrosive, perfumed colors, Bonnard relieves modern art's abstract geometry of its confident certitude and dissolves from the Cubist heritage both its austerity and its punning, nimble wit. It is, however, precisely in this compromise between rigor and relaxation that the picture may have its particular integrity, or even its own quiet heroism. It was painted near the moment of France's liberation in World War II, when Bonnard was in his late seventies and approaching the end of his life; in this context, his attempt here to link avant-garde rigor and domestic satisfactions poignantly bespeaks a faith that cannot have been merely easy or pleasant to maintain.

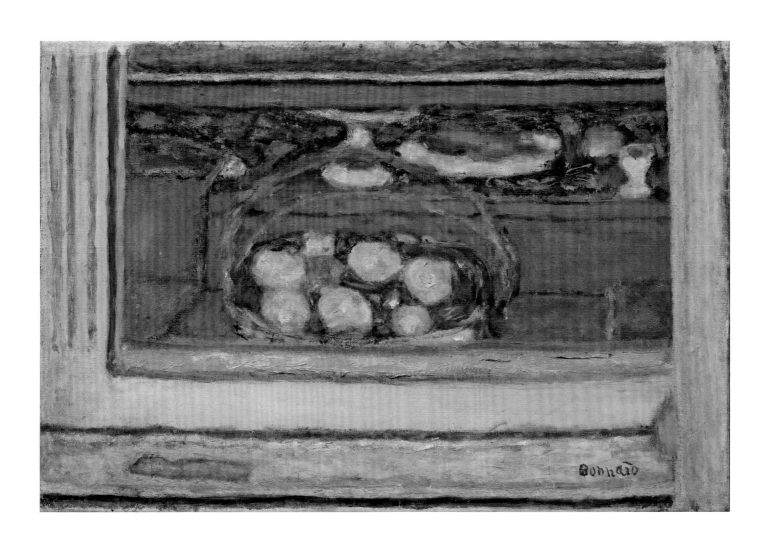

André Derain

FRENCH, 1880–1954

Charing Cross Bridge
1905–6

Claude Monet's 1904 exhibition of paintings of London was well-received by the Parisian public; and Derain's dealer, apparently thinking to mine further the same vein, sent him across the Channel to bring home vistas of the English capital. But where Monet's views—including one of this bridge—are typically moody and fog-shrouded even when the sun is high, Derain's more youthful outlook yielded a consistent sense of exuberance, evident even in this sunset theme. Not since William Turner painted *The Burning of the Houses of Lords and Commons* (1835) had the Thames been similarly set ablaze in paint.

The Museum already owns a Derain *London Bridge* from this same period, but it is far more structured and busy, with the traffic-filled bridge plunging inward toward a crowded embankment over a river alive with barges and boats. The Rockefellers' *Charing Cross Bridge,* with only its thin band of silhouetted architecture dividing the sweep of the sky from the shimmering river, is far more abstract. It is one of the most explosive of all Derain's views of London, and indeed one of the most opulently freewheeling of all Fauve vistas. The loose, planar array of color suggests the spreading washes of a giant watercolor, and the picture seems as yet innocent of the influence of Cézanne that would soon begin to inflect Derain's and Matisse's canvases with a more regular structure of stroke and composition.

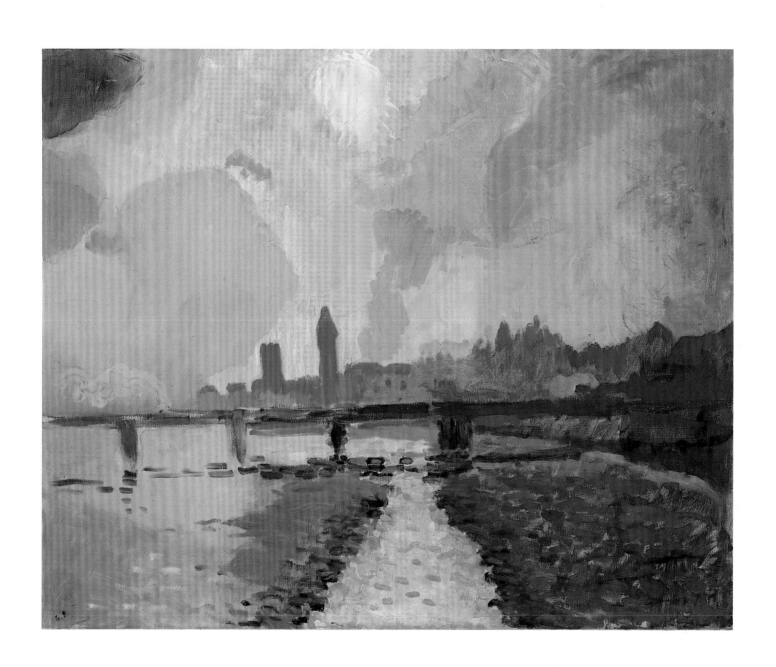

ᘐ Georges Braque
FRENCH, 1882–1963

The Large Trees
Les Gros Arbres
1906–7

Matisse and Derain once looked on Braque as a promising young conscript to the cause of Fauvist painting; but as others have noted, Braque came late to Fauvism and left early. *The Large Trees* makes clear, too, that he stood somewhat apart even within the period of his fullest engagement. Its relatively sober mood and softly controlled language of hue and contour is leagues away from the splashiness of a work like Derain's *Charing Cross Bridge* (p. 51).

The area around L'Estaque, near the Bay of Marseilles, had been one of the favored sites of Cézanne, and Braque certainly knew this when he chose to paint there—just as Derain would when he painted *The Turning Road, L'Estaque* (The Museum of Fine Arts, Houston) in this same period (the William S. Paley bequest to the Museum includes one version of this picture, as well as a L'Estaque landscape by Cézanne). In retrospect, we can see—in the choice of climbing hillside and high horizon, and especially in the attention to the structuring elements of rocks and houses—how Braque had already begun to interpret the Cézannian legacy in a way that belied the unsystematic and loosely disciplined approach of the Fauves. The canvases he would paint the following year suppress color and address volume and spatial structure in a way that not only announced his personal abandonment of the Fauve aesthetic—a painful blow from a prize initiate—but opened a principal path toward the Cubist revolution that would decisively close off Fauvism's future.

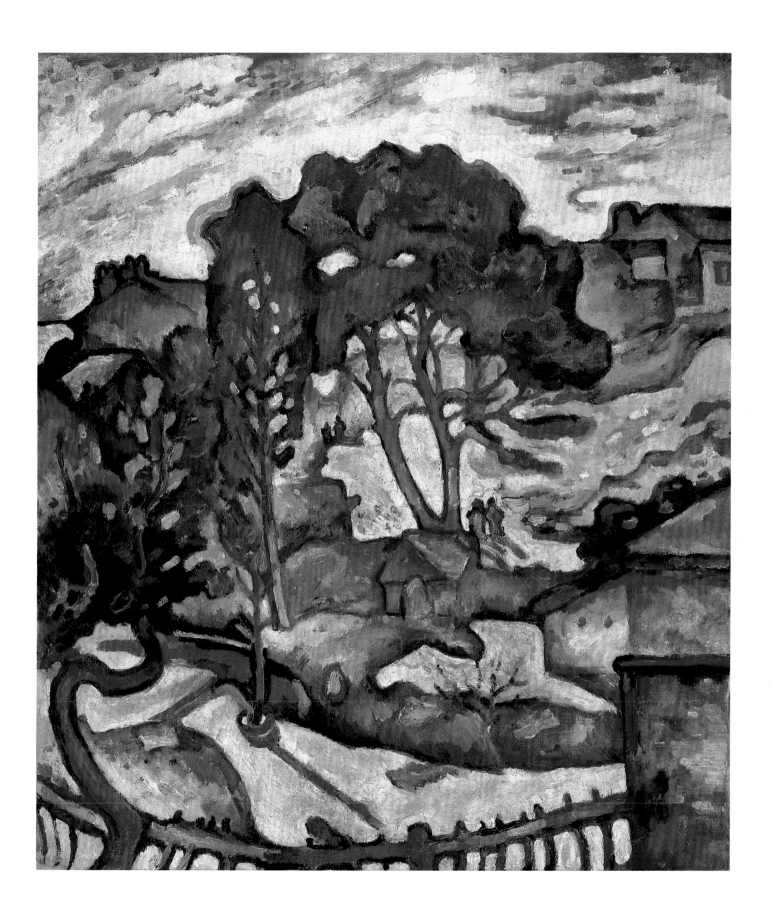

Henri-Émile-Benoît Matisse

FRENCH, 1869–1954

Interior with a Young Girl / Girl Reading
Intérieur à la fillette / La Lecture
1905–6

With the spread of literacy and the growth of the novel's popularity in the nineteenth century, painters often showed women with books as a pleasant motif of distracted reverie or daydreaming, typically with implications of melancholy or licentious fantasy. To Matisse, private intellectual life was a far more profound subject; here he literally celebrates close concentration, as his daughter, Marguerite, embracing the book and bending with absorption into the task, is rendered in a fireworks display of color.

This has been called a "mixed-technique" Fauve painting since different areas are handled in different ways: with sweeping flattened planes, a scattered confetti of strokes, isolated daubs of pure hue, and with some forms bounded by thick dark outlines and others by no lines at all. The result is an unlikely but endlessly fascinating conjunction of subject and effect: a domestic interior, typically the emblem of protected security and tidily ordered propriety, is treated in the terms of an intense, virtually Dionysian joy, and in a way that prefigures later Matisse canvases such as *Harmony in Red* (1908), where the simple act of setting a table and arranging fruit is the motif which anchors riotous linear energy and all-consuming color intensity. Expanding what is arguably the greatest group of Matisse paintings in any museum, this picture also will be the centerpiece of The Museum of Modern Art's Fauve holdings.

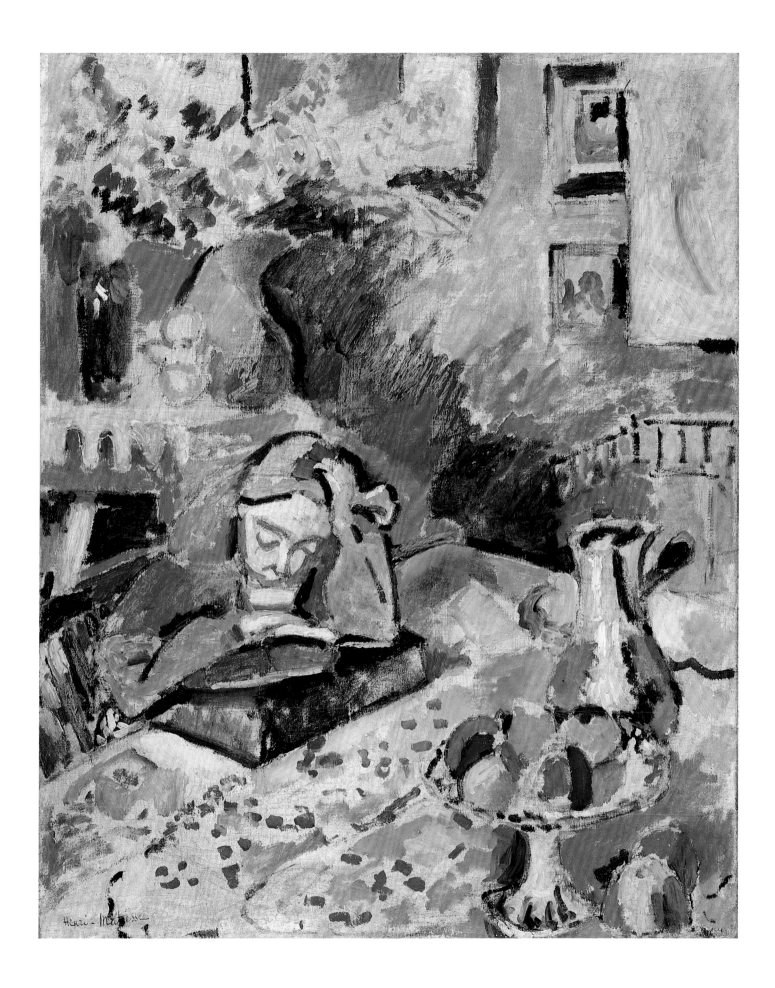

Pablo Picasso

SPANISH (DIED MOUGINS, FRANCE), 1881–1973

Girl with a Basket of Flowers
Jeune Fille à corbeille des fleurs
1905

With the trappings of innocence but the gaze of experience, this singular flower girl stands at the wedding of some memorably disturbing contradictions. Her figure, in a profile pose of stiff, almost Egyptian formality, is modelled in general, abstracted volumes; but its oddly proportioned anatomy of thin legs and high incipient breasts seems pointedly, specifically pubescent. Atop that body, modelled with a harsher naturalism and set off by a commandingly dark mass of hair, sits a head whose precociously older eyes and hard, wary stare seem jarringly at odds with the first-communion primness around it. The functional explanation of these disjunctions—that Picasso "disrobed" his young model by painting her face from life and then inventing the nude body—does nothing to diminish their unsettling effect. While the body type might be seen as an anticipation of the heavier physiques of the women of Picasso's later Rose period (see the Museum's *Two Nudes* of 1906), it is the ambiguous, slightly perverse air of sexuality here that conveys a more intangible emotional premonition—not just of Picasso's own future work, but also of the provocative adolescents of Balthus.

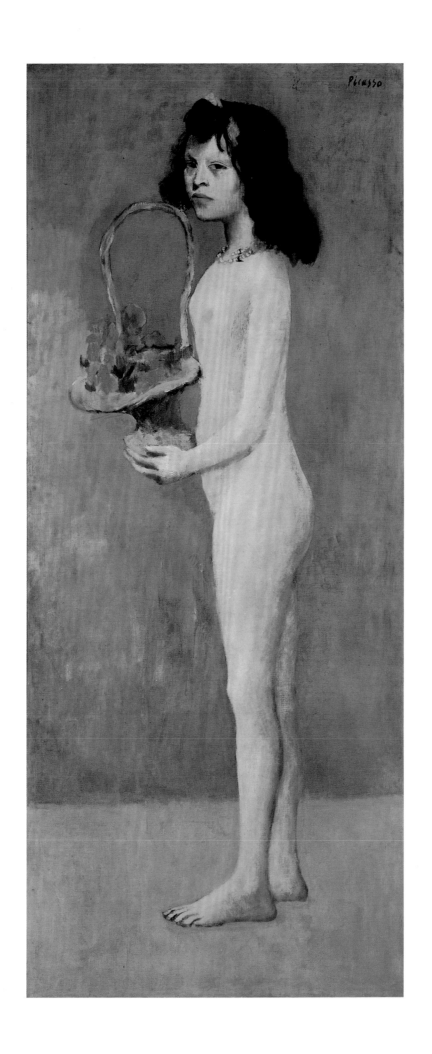

ॐ Pablo Picasso

Landscape
1908

In the summer of 1907, Picasso's art had been shaped by the explosively fragmenting, psychosexually charged energies of *Les Demoiselles d'Avignon* (in the Museum's collection). A year later, in the more subdued emotional tone of this work, we find him building the formal vocabulary of earthbound, monumentally faceted volumes that would mark his large canvas *Three Women* (The Hermitage Museum, Saint Petersburg), completed in the autumn of 1908, and would eventually lead to the more refined architecture of Analytic Cubism. We also find him, in this and several of the other works he painted in the small town of La Rue-des-Bois, outside Paris, engaged in the unlikely and even perverse project of trying to combine the formulaic simplicity and particularity of the "naive" painter Henri Rousseau with the sophisticated structures of Cézanne.

This picture's distinctive green palette as well as its schematic linear style and the shaded modelling of the tree branches owe a debt to the jungle fantasies of Rousseau, whose hauntingly earnest, slapstick-simple violations of academic conventions Picasso so treasured. The ambiguously fractured planes and inconsistently shaded masonry of creases and angles in the picture present, however, a creative mistranslation of the device of *passage* by which Cézanne, especially in his later work, elided adjacent planes to confound consistent readings of spatial advance and recession.

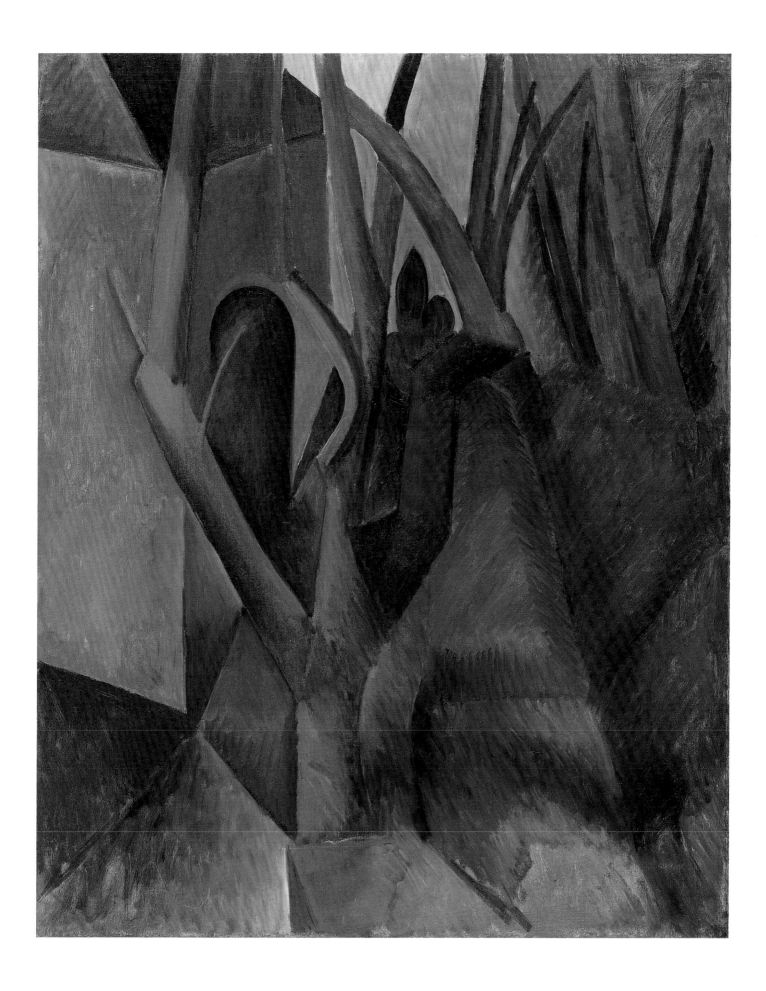

Pablo Picasso

The Reservoir, Horta de Ebro
L'Abreuvoir
1909

Painted one year later than *Landscape* (p. 59), this view of the Spanish town where Picasso spent the summer of 1909 shows him moving beyond the cruder, heavier volumes and somber modelling of his work at La Rue-des-Bois. He is beginning to master the complex effects of inconsistently shaded planes, with tilted and elided angles of intersection between volumes, which would lead within a year to the ethereal scaffolding of pictorial architecture in Cubism's most abstract phase.

 The Reservoir, Horta de Ebro offers the ideal companion piece for *Houses on the Hill, Horta de Ebro*, painted in the same summer and previously given to the Museum by David Rockefeller's brother, Nelson A. Rockefeller. In both paintings, the prospect of the village itself seemed to offer a kind of "found Cubism" in the stacked-up hillside aggregation of irregularly juxtaposed façades and roofs. In this particular view, though, Picasso focused not just on the play of volumetric structures, but also, exceptionally, on an insubstantial optical phenomenon: the reflection of the buildings in a large cistern used to water cattle. This flattened and inverted vertical "doubling" of the town's upper architecture created the illusion of an even more precipitous, clifflike flattening of the village's ascent, bringing the top and bottom of the vista into the same shallow spatial plane.

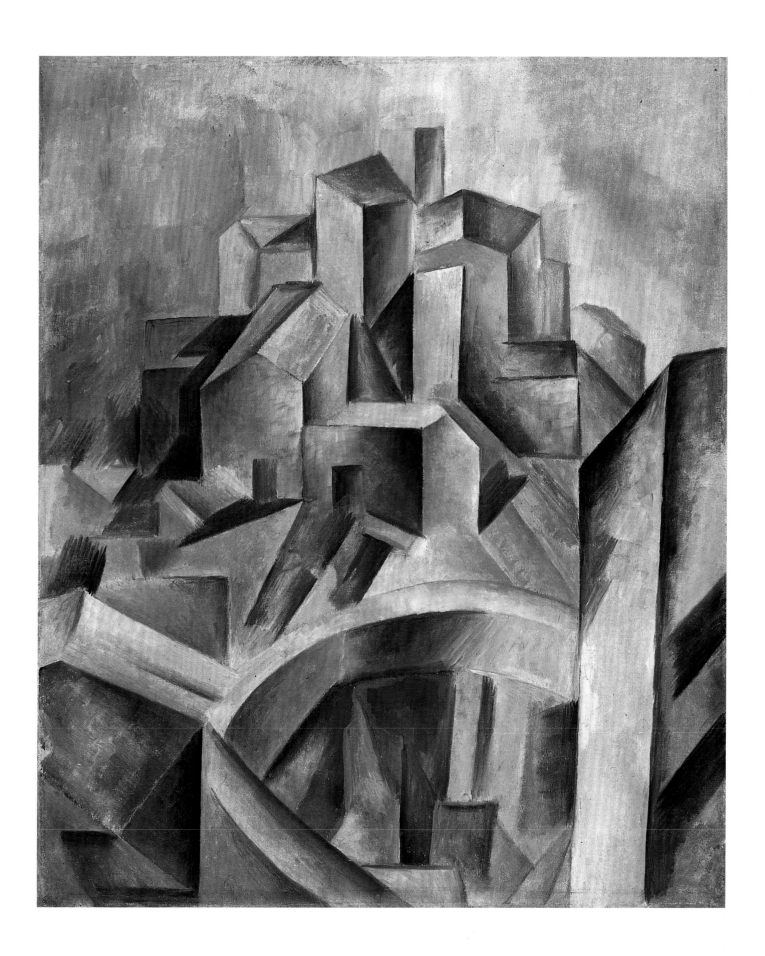

Pablo Picasso

Woman with a Guitar
Femme à la guitare
1914

Earlier Cubist Picassos in the Museum's collection, such as *Girl with a Mandolin* of 1910 or *"Ma Jolie"* of 1911, maintain the tradition of the woman with a musical instrument as a motif of quiet studio contemplation. Here, however, that same tune is replayed in the jaunty rhythms of street entertainment, in a picture with a smiling face and the bold stripes and dotted patterns of upbeat decorative playfulness. The legacy of Picasso's work with collage and of the constructed sculptures that began with the sheet-metal *Guitar* (1912–13) in the Museum's collection is evident in the patterned pieces that make this figure a kind of Cubist playing card. In typical Picasso fashion, the guitar shape has multiple uses here: the same double curves represent the instrument itself at bottom, the ears beside the rectangular head above, and also what appears to be a type of puffed beret (which also makes a second face) atop that head.

The Russian letters visible here translate as a fragment of the phrase "Grand Concert," and the numbers may suggest the price of admission and hour for the performance. It is unclear where Picasso might have seen such Russian publicity, but in this period culture flowed efficiently between Paris and Russia, with major patrons from Moscow for the paintings of both Matisse and Picasso, and Paris performances by Russian musicians and dancers. In the age of Diaghilev and Nijinsky, the duet of energies between Parisian Cubism and Russian lettering would not have seemed at all off key.

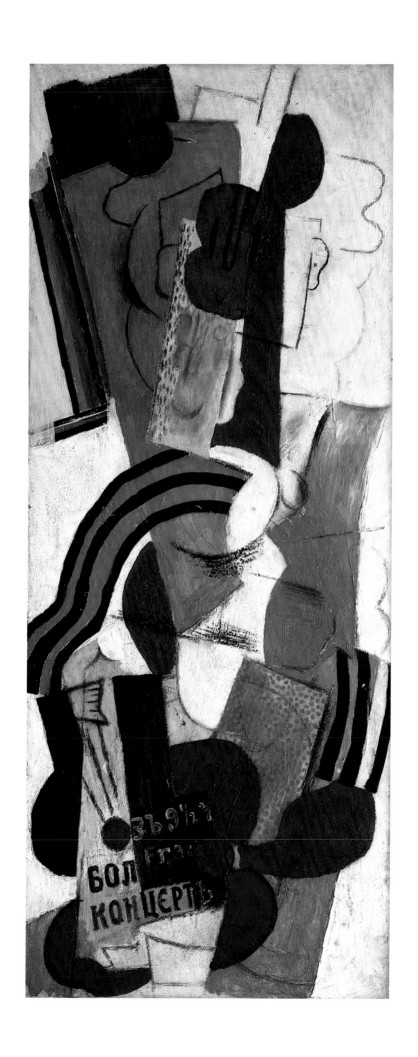

∾ Juan Gris (José Victoriano González)
SPANISH (DIED BOULOGNE-SUR-SEINE, FRANCE), 1887–1927

The Musician's Table
La Table du musicien
1914

Juan Gris actually exhibited paintings with pasted-in collage elements before the collages of Picasso and Braque had been shown; but it was not until 1914, the year of this still life, that Gris focused extensively on work in cut and pasted papers. The results, as *The Musician's Table* demonstrates, are works of high sophistication and complexity, but they are also marked by a certain conservative spirit of order. The materials here are themselves decoratively diverse, and their interlocking arrangement is calculatedly complex. Taken altogether, however, the carefully scissored passages of implied transparency and double-use elements do not present the more freewheeling kinds of ambiguities and formal puns that had been characteristic of Picasso's collages especially. Gris's classicizing temperament comes through in the suave precision of the drawing, the essentially stereometric rendering of the table, and the separately defined color areas of background and table. Moreover, the composition is an exercise in stable geometry: a balanced compositional diamond poises the table corner at the mid-point of the paper's lower edge, just as the wood-grain paper appears to touch the midpoint of the table's upper edge, and the circular opening of a glass seems to define the exact center of the field. The resulting image has an elegant beauty, but that beauty is based in part on its more traditional pictorial character. (One might compare the "music" of this composition, for example, with the aggressively disjunctive, collagelike rhythms of Picasso's *Woman with a Guitar* of 1914 [p. 63].) Gris's increasing differences with Picasso and Braque, the other two principal pioneers of Cubism, may also lie behind his choice of the snipped headline "Explorateurs en désaccord" (Explorers in disagreement).

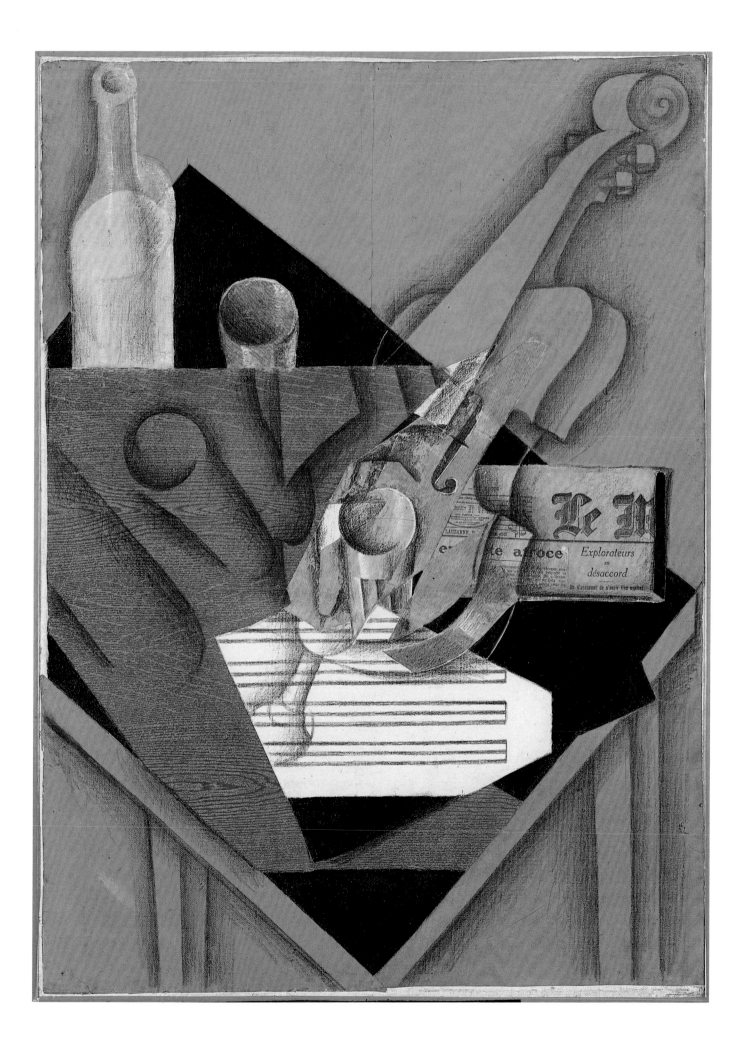

Catalogue

EXPLANATORY NOTE

The order of the preceding plates and the following catalogue is approximately chronological. Instead of arranging the artists according to date of birth or period of activity, however, artists working in related styles have been grouped together. If there is more than one work by a particular artist, the works are listed chronologically.

The title of a work is given first in English, followed by other titles by which the work has been known. The date assigned to a work is in accord with recent scholarship; in two instances, Cézanne's *Boy in a Red Vest* and *Still Life with Fruit Dish*, the author of these entries has proposed a date different from the date given in the entry head.

The entries, originally published in 1984, were written by Margaret Potter, a former associate curator in the Department of Painting and Sculpture of The Museum of Modern Art, who died in 1992. Jodi Hauptman revised almost all of the entries (with the sole exceptions of those treating the Manet and Bonnard still-life paintings) to take into account recent scholarship, and she updated the listings of exhibitions and references at the end of each entry.

∾ Édouard Manet. French, 1832–1883
The Brioche (*La Brioche*). 1870

Oil on canvas, 25⅝ x 32 in. (65 x 81 cm.). Signed and dated lower right: *Manet 1870*. The Metropolitan Museum of Art, New York. Fractional gift of David and Peggy Rockefeller (the donors retaining a life interest in the remainder).

Manet turned to still life repeatedly throughout his career, but he rarely dated his work in this genre. This sumptuous example is one of the few exceptions. According to Adolphe Tabarant (1947, pp. 178–79), it was painted early in the summer of 1870, shortly after Manet had moved his studio to 8, rue des Beaux-Arts, in the house owned by Henri Fantin-Latour. For the preceding few years, his still-life subjects had been influenced by those of Jean-Baptiste Chardin, as was first rather querulously observed by the critic Josephin Péledan in his review of the Manet memorial exhibition in 1884. Commenting on Manet's use of precedents in Spanish art, Péledan wrote: "No critic has remarked on this flagrant pastiche, not even M. Gérôme, whose standards of taste must be so upset by his own painting that he cannot appreciate Manet's *Les Dessertes*, which is as good as the finest Chardin . . ." (1884, p. 102). Subsequent scholars have noted that the central motif of this work—a brioche decorated with a flower—derives specifically from the older master's *Un Dessert* of 1763 (G. Wildenstein, *Chardin*, Paris, 1933, no. 1090), one of twelve Chardins that entered the Louvre with the LaCaze Bequest in 1869.

While he borrowed Chardin's motif, replacing the earlier artist's orange blossom with a rose, Manet retained none of the straightforward domestic sobriety of that work, nor even the casual composition and bold simplifications of his own earlier still lifes. The forms are softly modeled, the colors rich but subtle, and the composition singularly graceful; the dessert has been removed from a prosaic kitchen setting to that of an elegant salon. Both in style and choice of accessories, Manet's adaptation seems to pay tribute to other aspects of eighteenth-century art—the formal grace and sensuous refinement of the Rococo.[1]

The first owner of *The Brioche* was the noted baritone of the French opera, Jean-Baptiste Faure, an impulsive collector of contemporary painting and one of the earliest to acquire pictures by Manet, from whom he bought five works in 1873. Four years later he commissioned Manet to portray him in his famous role as Hamlet in Ambroise Thomas's opera of that name, but he was never wholly satisfied with the several drawings and three paintings that resulted. In 1906, shortly before its dispersal, Faure's collection of twenty-four paintings and watercolors by Manet was shown to great acclaim in Paris, Berlin, and London, and *The Brioche* was frequently mentioned in the reviews. The London *Times* reported: "The Faure Collection of Manets has been famous in Paris for many years, and the owner's house has long been a place of pilgrimage to admirers of the great realist. The pictures have been chosen with great taste, and they include nearly all the best works of the painter . . . note especially the celebrated *La Brioche*" (1906, cited by D. Sutton, 1954, p. 293). Recording public reaction, the London *Athenaeum* noted: "It is strange to find that the average frequenter of picture exhibitions still gets something of a shock from the sight of these pictures. Yet even *he* will admit . . . the mastery of the great still life *La Brioche*, with its marvelous rendering of some blue plums, its tactless insistence on the light contour of some peaches" (1906, p. 805).

When shown in the memorial exhibition of 1884, the painting was erroneously dated 1877, an error repeated by Théodore Duret, who in his monograph (1902) listed it under the years 1875–76–77. Faure may have acquired the work in 1877, when Manet painted his portrait, or confusion may have arisen with a smaller variant of the subject with a light, patterned background dating from 1876 (D. Rouart and D. Wildenstein, 1975, no. 251). Another small painting of a brioche decorated with a rose was discovered at the dental school of the University of Pennsylvania and published by Anne Coffin Hanson (1979, repr. in color, p. 68, no. 25; J. Bareau, *Manet: By Himself*, London, 1991, no. 222).

PROVENANCE: Jean-Baptiste Faure, Paris;[2] Durand-Ruel, Paris, 1907, New York, 1909; Carl O. Neilsen, Oslo, 1918; Etienne Bignou, Paris; Durand-Ruel, New York; Alexander Reid, Glasgow, 1923; Leonard Gow, Craigendorran (Glasgow), by 1932; Mrs. A. Chester Beatty, London, by 1936; Paul Rosenberg, New York, 1955; David and Peggy Rockefeller, 1955; fractional gift to The Metropolitan Museum of Art, New York (the donors retaining a life interest in the remainder).

EXHIBITIONS: Paris, Ecole Nationale des Beaux-Arts, *Oeuvres d'Edouard Manet*, Jan. 1884, no. 85; Paris, Durand-Ruel, *24 Tableaux et aquarelles de Manet formant la collection Faure*, Mar. 1–31,

1906, no. 12, also shown in Berlin, Galerie Paul Cassirer; London, Sulley & Co., *Paintings and Water-Colors by Manet (Faure Collection)*, June 11–30, 1906, no. 10; Manchester, City Art Gallery, *Modern French Paintings*, 1907–8, no. 66; London, Fine Art Palace, *Franco-British Exhibition*, 1908, no. 331; Copenhagen, Ny Carlsberg Glyptotek, *Föreningen Fransk Kunst, Fjerde Udstilling: Edouard Manet: Udstilling af Hans Arbejder i Skandinavisk Fje*, Jan. 27–Feb. 17, 1922, no. 15, also shown in Stockholm and Oslo; Alexander Reid with Thomas Agnew and Sons, *Masterpieces of French Art*, London, June 1923, no. 15, and Glasgow, Aug. 1923; London, Royal Academy of Arts, Burlington House, *Exhibition of French Art: 1200–1900*, Jan. 4–Mar. 5, 1932, no. 395; Paris, Musée de l'Orangerie, *Manet: 1832–1883*, June 16–Oct. 9, 1932, no. 43; Brussels, Palais des Beaux-Arts, *L'Impressionnisme*, June 15–Sept. 29, 1935, no. 35; Paris, Paul Rosenberg, *Le Grand Siècle*, June 15–July 11, 1936, no. 35; London, Anglo-French Art and Travel Society, New Burlington Galleries, *Masters of French 19th Century Painting*, Oct. 1–31, 1936, no. 37; New York, The Museum of Modern Art, *Paintings from Private Collections*, May–Sept. 1955, no. 79; Washington, D.C., National Gallery of Art, *Masterpieces of Impressionist and Post-Impressionist Painting*, Apr. 25–May 24, 1959, repr. p. 15; Cambridge, Mass., The Fogg Art Museum, Harvard University, *Works of Art from the Collections of the Harvard Class of 1936*, June 11–Aug. 25, 1961, no. 16; New York, The Metropolitan Museum of Art, *Summer Loan Exhibition*, July 12–Sept. 3, 1963, no. 28; New York, Harvard Club, *Harvard Club Centennial*, May 1–14, 1965; Philadelphia Museum of Art, *Edouard Manet: 1832–1883*, Nov. 3–Dec. 11, 1966, pp. 117–19, repr., no. 102, traveled to The Art Institute of Chicago, Jan. 13–Feb. 19, 1967; Minneapolis Institute of Arts, *The Past Rediscovered*, July 1–Sept. 7, 1969, no. 55, repr.

REFERENCES: J. Péledan, "Le Procédé de Manet," *L'Artiste*, vol. LIV, Feb. 1884, p. 102; *Notice sur la Collection J.-B. Faure, suivie du catalogue des tableaux formant cette collection*, Paris, 1902, no. 34; T. Duret, *Histoire d'Edouard Manet et de son oeuvre*, Paris, 1902, no. 223; E. Moreau-Nélaton, ms. cat. of Manet's oeuvre, Paris, Bibliothèque Nationale, 1906; *Times* (London), June 10, 1906 (cited by D. Sutton, *Burlington Magazine*, vol. XCVI, Sept. 1954, p. 293); *Athenaeum* (London), June 30, 1906, p. 805; *Art Journal* (London), Aug. 1906, p. 241; *Die Kunst für Alle*, vol. XXII, Nov. 1, 1906, p. 72; *Die Kunst unserer Zeit*, vol. XIX, 1908, repr. p. 48; *Die Kunst für Alle*, vol. XXVI, 1910–11, repr. p. 168; J. Meier-Graefe, *Edouard Manet*, Munich, 1912, pp. 282 ff., fig. 83; G. Severini, *Edouard Manet*, Rome, 1924, pl. XXIII; E. Moreau-Nélaton, *Manet raconté par lui-même*, Paris, 1926, vol. II, p. 44, figs. 227, 347; A. Tabarant, *Manet: Histoire catalographique*, Paris, 1931, p. 203, no. 154; C. Léger, *Edouard Manet*, Paris, 1931, no. 13, repr.; *Cahiers d'art*, vol. VII, 1932, repr. p. 321; P. Jamot and G. Wildenstein, *Manet*, Paris, 1932, vol. I, no. 181; vol. II, fig. 407; L. Venturi, *Cézanne: Son Art, son oeuvre*, Paris, 1936, vol. I, pp. 24, 109; R. Rey, *Manet*, Paris, 1938, no. 157, repr.; G. Jedlicka, *Edouard Manet*, Erlenbach and Zürich, 1941, pp. 195, 198, repr. p. 199; A. Tabarant, *Manet et ses oeuvres*, Paris, 1947, pp. 178–79, no. 161, repr. p. 607; B. Reifenberg, *Manet*, Bern, 1947, no. 20, repr.; H. Florisoone, *Manet*, Monaco, 1947, pp. xv, xvii, pl. 46; G. Bazin, *L'Epoque Impressionniste*, Paris, 1947, pl. 45; C. Sterling, *La Nature morte de l'antiquité à nos jours*, Paris, 1952, pp. 88, 92; *The Museum of Modern Art Bulletin*, Summer 1955, repr. p. 10; *Vogue* (New York), Feb. 1, 1956, repr. in color, p. 173; J. Rewald, *The History of Impressionism*, 2nd ed., New York, 1961, repr. in color, p. 219; J. Mathey, *Graphisme de Manet*, Paris, 1963, vol. II, pl. 110 (detail); G. H. Hamilton, "Is Manet Still Modern?" *Art News Annual*, vol. XXXI, 1966, repr. p. 126; M. Venturi and S. Orienti, *L'opera pittorica di Edouard Manet*, Milan, 1967, no. 137, repr. p. 98; French ed., Paris, 1970, no. 137, repr. p. 99; *A Man of Influence: Alex Reid 1854–1928*, exh. cat., Scottish Arts Council, Glasgow, Oct. 1967, pp. 10, 14; D. Rouart and D. Wildenstein, *Edouard Manet: Catalogue raisonné*, Lausanne and Paris, 1975, no. 157, repr.; A. C. Hanson, "A Tale of Two Manets," *Art in America*, vol. LXVII, Dec. 1979, p.66, repr. p. 62; Charles F. Stuckey, "What's Wrong with This Picture?" *Art in America*, vol. LXIX, no. 7, Sept. 1981, pp. 96–107.

1. As observed by L. Venturi (*Cézanne: Son Art, son oeuvre*, Paris, 1936, vol. I, p. 24), this work may have influenced Cézanne's choice of an ormolu-mounted eighteenth-century table as the setting for his own still life, *Un Dessert*, which was probably painted in the home of its first owner, Dr. Chocquet, in 1875–77 (Philadelphia Museum of Art, Mr. and Mrs. Carroll Tyson Collection; Venturi no. 197).

2. According to A. Tabarant, Faure acquired the work directly from the artist, although it is not mentioned in the records of Faure's purchases; cf. A. Callen, "Faure and Manet," *Gazette des Beaux-Arts*, vol. LXXXIII, Mar. 1974, pp. 157 ff.

This was one of three paintings acquired from Mrs. A. Chester Beatty's collection.

This magnificent still life is one of the finest paintings in this genre that I have ever seen. It reminds one a little bit of Chardin, but in many ways I think it is more beautiful than Chardin's still lifes, which I love as well.

DAVID ROCKEFELLER

∾ Camille-Jacob Pissarro
French (born St. Thomas, Danish West Indies), 1830–1903
Landscape at Les Pâtis, Pontoise
(*Paysage aux Pâtis, Pontoise*). 1868

Oil on canvas, 32 x 39 ½ in. (81 x 100 cm.). Signed and dated lower right: *C. Pissarro 68*. National Gallery of Art, Washington, D.C. Fractional gift of David and Peggy Rockefeller (the donors retaining a life interest in the remainder).

This view shows the sloping pastures on the outskirts of Pontoise, a town

twenty-seven miles from Paris, near the confluence of the Seine and the Oise, where Pissarro lived from 1866 to 1868 and where he settled again after the Franco-Prussian War during the decade 1872–82. Richard Brettell has explained that "the picture was painted from the hillside near the village of Cernay overlooking the Voisne Valley with its hamlet, Les Pâtis" (1990, p. 147). A quarry is depicted in the center of the painting (exh. cat., 1981, p. 78). This canvas and another of the same region, *Le Moulin du Pâtis*, are two of a group of seven large horizontal landscapes painted in 1867–68 (L.-R. Pissarro and L. Venturi, 1939, nos. 52, 55–58, 61, and 62); two were exhibited at the Salon in the spring of 1868. Even with the strong vertical emphasis of path and trees at the left—which offer the sole point of entrance into the picture—the horizontally structured vista of fields stretching to a distant horizon makes this work the most panoramic of the group. Brettell also noted that in paintings from what he terms the "first Pontoise period," like this example from the Rockefeller collection, Pissarro explored the structure of landscape, "the nature of nature" (1990, pp. 145, 202). Thus Pissarro's *pictorial* ordering reveals a conception of the natural environment as something that also can be ordered and improved. Pissarro's carefully planned composition, typical of the landscapes from the Pontoise period, is based on the banding of farms, hills, and meadows into parallels (Brettell, 1990, pp. 145–46). Brettell's understanding of Pissarro's artistic production echoes that of Emile Zola, who described one of Pissarro's Pontoise landscapes as "truly a modern countryside. One feels that man has passed through it turning the soil and harrowing it, delimiting the horizons" (quoted in C. Lloyd, 1981, p. 31). Despite its carefully contrived structure, the broad, free brushstroke and careful observation of tonal values suggest that the work may have been painted outdoors on a slightly overcast summer day. At this time "Pissarro chose to enlarge what had been appropriate forms for plein-air oil sketches to the scale of a Salon landscape" (exh. cat., 1991, p. 157). Unusual for an agricultural landscape, traditionally depicted at harvest time in yellows, browns, and golds, Pissarro's almost monochromatic use of green allows him to concentrate, like Corot, an artist whom he admired, on value rather than hue. As for subject matter, Pissarro paid little attention to Pontoise's commerce, preferring the quieter views of the plowed landscapes. It is for this reason that Brettell concluded that during this first trip to Pontoise, Pissarro painted "'modern' pictures of pre-modern subjects" (1990, p. 144).

When war broke out in 1870, Pissarro fled first to friends in Brittany and then on to England, leaving his accumulated work in his studio in Montmartre and in a house he had rented in Louveciennes in 1869, which was subsequently occupied by German soldiers. Upon his return, he wrote to Théodore Duret, "I have lost everything; only forty paintings remain out of fifteen hundred" (Pissarro and Venturi, 1939, vol. I, p. 24); however, surviving works indicate that he was unduly pessimistic about his losses. Special precautions by his landlady at Louveciennes saved from destruction this group of salon-size canvases, Pissarro's most ambitious work to date.

The year following his return to Pontoise in 1872, having been exposed to the work of Claude Monet and having acquired a better sense of the history of landscape painting, Pissarro returned to the same cluster of buildings set amid the pastures, from a vantage point to the right of the present view (Pissarro and Venturi no. 235). A lithograph entitled *Une Rue aux Pâtis, Pontoise*, is dated 1874 (L. Delteil, *Le Peintre-graveur illustré [XIXe et XXe siècles]*, Paris, 1923, vol. 17, no. 130, repr.).

References in his letters to his son Lucien, who settled in London in 1883, reveal that in spite of material hardship, Pissarro consistently set aside for his wife and family paintings that he especially valued (cf. letters dated Jan. 21, 1886; Jan. 18, 1887; Mar. 17 and 24, 1896; Mar. 10, 1897; Apr. 21 and 26, 1897; and May 23, 1899, in J. Rewald, ed., *Camille Pissarro: Letters to His Son Lucien,* New York, 1943). The present painting, which was inherited by his daughter Jeanne, may have been part of that family collection,

to which Pissarro often referred when writing to his son: "I am keeping the picture for us." This painting was also important for Paul Cézanne, who executed a remarkably similar picture, *La Côte de Galet, Pontoise*, ca. 1879–82 (Brettell, 1980, p. 78). Pissarro, known as a supportive teacher, attracted many artists to Pontoise, and although Pissarro was a mentor for Cézanne, in many ways their creative relationship was reciprocal.

PROVENANCE: Mme Alexandre Bonin (Jeanne Pissarro, the artist's second daughter), Paris; Emile Lernoud, Buenos Aires; Dr. Carlos Zubizarreta, Buenos Aires; Wildenstein and Co., New York; David and Peggy Rockefeller, 1955, fractional gift to The National Gallery of Art, Washington, D.C. (the donors retaining a life interest in the remainder).

EXHIBITIONS: Buenos Aires, *Amigos del Arte*, 1932, no. 39; Hanover, N.H., Hopkins Art Center Galleries, Dartmouth College, *Impressionism 1865–1885*, Nov.–Dec. 1962; London, Hayward Gallery (organized by The Arts Council of Great Britain), *Pissarro 1830–1903*, Oct. 1980–Jan. 1981, traveled to Paris, Grand Palais, Jan.–Apr. 1981, and to Boston, Museum of Fine Arts, May 19–Aug. 9, 1981, no. 12, repr. (work shown only in Boston); Washington, D.C., National Gallery of Art, *Art for the Nation: Gifts in Honor of the Fiftieth Anniversary of the National Gallery of Art*, Mar. 17–June 16, 1991, p. 157.

REFERENCES: *Catalogue de la collection Emile Lernoud*, Buenos Aires, repr.; L.-R. Pissarro and L. Venturi, *Camille Pissarro: Son Art, son oeuvre*, Paris, 1939, vol. I, p. 86, no. 61; vol. II, pl. 11; J. Rewald, *The History of Impressionism*, 4th rev. ed., New York, 1973, repr. in color, p. 145; C. Kunstler, *Camille Pissarro*, Paris, 1974, p. 75; R. Brettell, F. Cachin, et al., *Pissarro 1830–1903*, London, 1980, p. 78; C. Lloyd, *Camille Pissarro*, New York, 1981, repr. p. 35; R. Brettell, *Pissarro and Pontoise: The Painter in a Landscape*, New Haven, 1990, repr. p. 146; J. Pissarro, *Camille Pissarro*, New York, 1993, fig. 49, p. 57, disc. p. 51.

This painting, which we bought from Wildenstein, remains among our favorites. The Metropolitan Museum of Art owns a somewhat smaller painting of the same landscape. Our picture has been in the living room at 65th Street ever since its purchase more than twenty-five years ago. We feel we were very lucky to have found it. D.R.

❧ Claude-Oscar Monet. French, 1840–1926
The Gare St.-Lazare: Sunlight Effect
(*Extérieur de la Gare St.-Lazare: Effet de soleil*). (1877)

Oil on canvas, 24 x 31¾ in. (61 x 80.5 cm.). Signed and dated lower left: *Claude Monet 78*. David and Peggy Rockefeller Collection.

In January 1877 Monet wrote from Argenteuil to a friend regarding his continuing efforts to obtain permission to paint in the Gare St.-Lazare; in the previous year he had taken a small pied-à-terre in Paris near the depot, in a neighborhood already home to Edouard Manet, Stéphane Mallarmé, and Gustave Caillebotte. In April 1877 Monet exhibited eight views of the station at the Third Impressionist Exhibition. Although this group of paintings cannot really be called a series like the artist's later views of Rouen Cathedral or of haystacks, it is the first time that Monet focused so intently on a single motif (P. Tucker, 1989, pp. 26–27).

This particular train station may have held special significance for Monet and his fellow Impressionist painters because it was the station from which they departed for most of the landscape sites they frequented, including Argenteuil, Bougival, Chatou, and Le Havre (Tucker, 1982, p. 169; R. Brettell, 1987, p. 43). Not only was the train seen as a mode of transport to their favorite destinations in the countryside, but the railroad itself came to epitomize for Monet, and for so many of these artists, the energy and force of modern life. In 1873 Monet's close friend Manet had used the Gare St.-Lazare as the background in his painting of a woman and child in a garden (National Gallery of Art, Washington, D.C.; D. Rouart and D. Wildenstein, *Edouard Manet: Catalogue raisonné*, Lausanne and Paris, 1975, no. 207). Manet, and also Caillebotte, had painted numerous scenes of the railroad; however, unlike these two artists, Monet went down to the level of the tracks and into the train yard.

While Monet probably got closer to the trains than his fellow painters, in the entire "ensemble" of paintings it was less the machine that interested him than the interaction of light and steam (Brettell, 1986, p. 198). Legend has it that Monet persuaded the stationmaster to keep the trains running so that he could get a better sense of the engines' billowing smoke (Brettell, 1987, p. 43). The effects of smoke and steam in sunlight that Monet rendered in these paintings may have been inspired by Joseph Turner's *Rain, Steam, and Speed: The Great Western Railway* of 1844 (National Gallery, London; A. Wilton, *J. M. W. Turner: His Art and Life*, New York, 1979, repr. p. 217), which Monet must have seen during his stay in London in 1870 and which he probably remembered long after. In an entry of September 5, 1892, Theodore Robinson recorded in his diary that Monet "spoke of Turner with admiration—the railway one—and many of the watercolor studies from nature" (vol. I of Robinson diaries; photocopy of ms. in Frick Art Reference Library).

Daniel Wildenstein has catalogued twelve paintings of the station and its surroundings (1974, nos. 438–49); he believes that the present work, like the rest of the series, was painted in 1877 but signed later, perhaps when Monet sold it. Wildenstein has identified the site shown here as a spot between the Pont de l'Europe and the former Batignolles tunnel, of which the arcaded entrance can be seen in the middle distance. He cites a drawing for this work in the Monet bequest of 1966 to the Musée Marmottan (inv. 5130, fol. 12, recto), as well as a smaller, sketchier oil version of the same view, but with an arriving train at the right (Wildenstein no. 444). According to L. E. Rowe (1934, p. 50), the home and place of business of Durand-Ruel, who subsequently owned the painting, was at that time in the nearby rue de Rome, which appears in the background of the picture.

PROVENANCE: Baron Franchetti, Paris; Durand-Ruel, Paris, 1897; Durand-Ruel, New York; Museum of the Rhode Island School of Design, Providence, R. I., 1934–44; Wildenstein and Co., New York, 1944; Mr. and Mrs. Leigh B. Block, Chicago, by 1952; Sam Salz, New York; David and Peggy Rockefeller, 1958.

EXHIBITIONS: Paris, Durand-Ruel, *Monet, Pissarro, Renoir et Sisley*, Apr. 1899, no. 7; Weimar, *Monet, Manet, Renoir et Cézanne*, 1904, no. 15; London, Grafton Galleries, *Pictures by Boudin, Cézanne, Degas, Manet, Monet, Morisot, Pissarro, Renoir and Sisley*, Jan.–Feb. 1905, no. 145, picture book pl. 21; Zürich, Kunsthaus, *Französische Kunst des XIX. und XX. Jahrhunderts*, Oct. 5–Nov. 14, 1917, no. 131, repr.; New York, Durand-Ruel, *Claude Monet*, Mar. 1923, no. 8; Paris, Galerie Georges Petit, *Claude Monet*, Jan. 4–18, 1924, no. 40; New York, Durand-Ruel, *Masterpieces by Claude Monet*, Mar. 20–Apr. 16, 1933, no. 13; New York, Durand-Ruel, *Great French Masters of the 19th Century*, Feb. 12–Mar. 10, 1934, no. 35; Boston, Museum of Fine Arts, *Independent Painters of 19th Century Paris*, Mar. 15–Apr. 28, 1935, no. 33, repr. p. 69; New York, M. Knoedler and Co., *Views of Paris*, Jan. 9–28, 1939, no. 31, repr.; St. Louis, City Art Museum, *Claude Monet*, Sept. 25–Oct. 22, 1957, no. 33, traveled to the Minneapolis Institute of Arts, Nov. 1–Dec. 1, 1957; New York, The Museum of Modern Art, *Claude Monet: Seasons and Moments*, Mar. 9–May 15, 1960, no. 18, traveled to the Los Angeles County Museum of Art, June 14–Aug. 7, 1960.

REFERENCES: A. Fontainas, "Art Moderne," *Mercure de France*, May 1899, p. 530; V. Pica, *Gli Impressionisti francesi*, Bergamo, 1908, repr. p. 74; G. Grappe, *Claude Monet*, Berlin, 1909, repr. p. 8; R. Koechlin, "Claude Monet," *Art et décoration*, vol. LI, Feb. 1927, p. 41, repr. p. 38; C. Léger, *Claude Monet*, Paris, 1930, pl. 21; L. E. Rowe, "A Painting by Monet," *Bulletin of the Rhode Island School of Design*, vol. XXII, Oct. 1934, pp. 49–51, repr.; J. Rewald, "Paysages de Paris de Corot à Utrillo," *Le Renaissance*, XX année, Jan.–Feb. 1937, unpaged, repr.; J. Wilhelm, *Les Peintres du paysage parisien du XVᵉ siècle à nos jours*, Paris, 1944, no. 47, repr.; C. Reuterswärd, *Monet*, Stockholm, 1948, p. 281; C. Roger-Marx, *Monet*, Lausanne, 1949, no. 29, repr.; M. and G. Blunden, *Impressionists and Impressionism*, Lausanne, 1972, repr. in color, p. 141; D. Rouart and J.-D. Rey, *Claude Monet—Nymphéas, ou les miroirs du temps, suivi d'un catalogue raisonné par R. Maillard*, Paris, 1972, unpaged, repr.; D. Wildenstein, *Claude Monet: Biographie et catalogue raisonné, vol. I: 1840-1881*, Lausanne and Paris, 1974, no. 443, repr.; cf. pp. 83 ff, 431; R. Walter, "Saint Lazare l'impressioniste," *L'Oeil*, no. 292, Nov. 1979, pp. 48–55; S. Levine, "Monet, Lumière and Cinematic Time," *Journal of Aesthetics and Art Criticism*, vol. XXXVI, no. 4, Summer 1978, p. 444; P. Tucker, *Monet at Argenteuil*, New Haven, 1982, p. 169; R. Brettell et al., *A Day in the Country: Impressionism and the French Landscape*, Los Angeles, 1984, pp. 115–16; R. Brettell, "The 'First' Exhibition of Impressionist Painters," in *The New Painting: Impressionism 1874–1886*, exh. cat., San Francisco, 1986, pp. 196–99; R. Brettell, *French Impressionists*, Chicago and New York, 1987, p. 43; P. Tucker, *Monet in the 90s: The Series Paintings*, Boston and New Haven, 1989, pp. 26–27; V. Spate, *The Colour of Time: Claude Monet*, London, 1992, pp. 120–25.

In 1958 we visited Sam Salz's gallery-home and found that he had two paintings on consignment belonging to our friends Mr. and Mrs. Leigh Block of Chicago. We had known the Blocks from my days as a trustee of the University of Chicago, and I had visited their magnificent collection. Mr. Salz said that they were planning to sell 'The Gare St.-Lazare' by Monet and

a Matisse 'Odalisque.' The prices they were asking seemed high, but we thought they were both such outstandingly beautiful paintings that we bought them without much hesitation. We have been increasingly glad that we did so, as they are two of the pictures we enjoy most particularly.

D.R.

∾ Paul Cézanne. French, 1839–1906
Still Life with Fruit Dish (*Nature morte au compotier*). (1879–80)
Oil on canvas, 18 ¼ x 21 ½ in. (46.4 x 54.6 cm.). Partial signature lower left: *P Cez.*[1] Not dated. The Museum of Modern Art, New York. Fractional gift of David and Peggy Rockefeller (the donors retaining a life interest in the remainder).

This famous still life was perhaps the first work by Cézanne to achieve wide recognition during the artist's own lifetime. Probably shortly after it was painted, it was acquired by Paul Gauguin, who, as a prosperous broker and part-time artist, formed a substantial collection of Impressionist works between 1879 and 1883; it remained in his possession until 1898 (M. Bodelsen, 1970, p. 606). Undoubtedly Gauguin took this work to Copenhagen when he traveled there with his Danish wife and family in the fall of 1884; and probably he was referring to this painting when, back in Paris the following year, he wrote to his wife in Denmark, "I'm keeping my two Cézannes; they're rare of their kind, because he finished so little of his work, and one day they'll be worth a good deal" (M. Malingue, 1946, p. 75). As Gauguin owned at least five works by Cézanne by that time, it is supposed by Merete Bodelsen that the artist and his wife had an informal understanding on a division of his collection, which served as a chief source of family support now that Gauguin was devoting himself to painting full-time. As his wife continued to sell paintings to meet family needs, early in 1888 Gauguin prepared a list of works he had left in Copenhagen, including this one (*Album Briant*, Louvre RF 30273, p. 5; Bodelsen, 1962, pp. 207–8; 1970, p. 606). Apparently his wife sent this painting back to him in Paris, for in June of that year he wrote from Pont-Aven refusing the offer of his artist friend Emile Schuffenecker to buy it: "The Cézanne you ask me for is a pearl of exceptional quality, and I have already refused 300 francs for it; I hold on to it as the apple of my eye and except for absolute necessity, I would sell it only after my last shirt" (Malingue, 1946, p. 132). The painting may have remained with Schuffenecker, who had a substantial collection of his own, during Gauguin's sojourns in Pont-Aven that summer and in Arles later in the year, but Gauguin had it with him in Brittany the following winter, for he reproduced it on a much-enlarged scale in the background of his *Portrait of a Woman, with Still Life by Cézanne* of 1890 (*The Art of Paul Gauguin*, exh. cat., National Gallery of Art, Washington, D.C., 1988, no. 111; G. Wildenstein and R. Cogniat, *Gauguin*, Paris, 1964, no. 387).

At Le Pouldu with a small band of young followers eager for his advice, Gauguin must have frequently dwelt on his favorite possession. A young companion of that time, Paul Sérusier, later recalled that when undertaking to paint fruit still lifes, Gauguin would rally the group with the words, "Come, let's make a Cézanne" (C. Chassé, *Gauguin et le groupe de Pont-Aven*, Paris, 1921, p. 72). Indeed, the plate of apples that appears in a major work of that period, the *Portrait of Jacob Meyer de Haan* (p. 39), reflects the impact of this work on Gauguin's own style. Ambroise Vollard recorded that this painting was the center of attraction in Gauguin's studio on the rue Vercingétorix during his final sojourn in Paris in 1893–94, and a Polish painter named Maskonoski related in some memoirs of 1894 that Gauguin would show this painting to the young painters of the Académie Colarossi and explain Cézanne's art to them (Bodelsen, 1970, p. 606).

Upon his final return to Tahiti in 1895, Gauguin left this still life in Paris either with his friend Georges-Daniel de Monfreid (J. de Rotonchamp, 1906, p. 20) or with the artist-dealer Georges Chaudet, who had been in Gauguin's entourage at Pont-Aven the summer before and was authorized to sell pictures on his behalf. Short of funds and in urgent need of hospital treatment in 1897, Gauguin wrote from Tahiti asking Chaudet to sell the picture and learned sometime later that the work had been sold for the modest sum of 600 francs (A. Joly-Segalen, 1950, pp. 130, 139). By December of 1899, this work was owned by the prominent dentist and collector Dr. Georges Viau; and while in his possession, it was copied by one of Gauguin's earliest admirers, Maurice Denis, who may well have seen the painting while it was still in Gauguin's possession (M. Denis, 1957, "Dec. 7–9, 1899: Je copie le Cézanne de Viaud [*sic*]"). Denis also made a lithograph of the work (repr. Bernheim-Jeune, eds., *L'Album Cézanne*, Paris, 1914, pl. 4). Denis makes it clear that Gauguin urged his fellow artists to take careful note of Cézanne's work "not as that of an independent genius, an apostate from Manet's school, but for what it actually is—the fulfillment of a long endeavor, the compelling outcome of a great crisis" (quoted in C. Geelhaar, 1989, p. 285).

In 1900 this still life was one of three Cézannes shown in the Impressionist gallery of the major review of nineteenth-century French art, *Exposition centennale de l'art français de 1800 à 1889*, within the context of the Paris World's Fair of 1900; and Denis chose to represent it as the focal point of his *Homage to Cézanne* (fig. 1). In Denis's work, this still life (or perhaps his own copy, as the setting appears to be Vollard's gallery) is shown on an easel flanked by the figures of Redon, Vuillard, the critic Mellerio, Vollard, Sérusier, Ranson, Roussel, Bonnard, Denis himself, and his wife. Redon had also copied a work by Cézanne in the

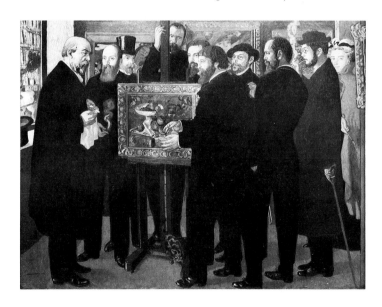

1. Maurice Denis. *Homage to Cézanne.* 1900.
Oil on canvas, 71 x 94 ½ in. Musée d'Orsay, Paris.

collection of his friend Andries Bonger, and his position here indicates that he too was a revered older master for the young Nabi painters in attendance; in fact, one of the earliest writers on Cézanne, Georges Rivière, supposed that Cézanne himself was portrayed in the figure of Redon (1923, pp. 127–28). Denis's *Homage* was exhibited in 1901 at the Salon du Champs de Mars and bought by Denis's close friend, André Gide; supposedly it was shown side-by-side with the Cézanne still life at the influential avant-garde salon La Libre Esthétique in Brussels in 1904 (acc. to R. Huyghe, *L'Amour de l'art*, 1936, p. 173; not listed with Denis entries in exh. cat.). In a letter of 1901 to Cézanne, Denis explained that this painting represents "the position as a painter you occupy in our time . . . the admiration which you evoke and . . . the enlightened enthusiasm of a group of young people to which I belong and who can rightly call themselves your pupils, as they owe to you everything which they

know about painting" (quoted in Geelhaar, 1989, p. 245). Gauguin, in the year of his death, remembered this work with particular admiration and described it in his final manuscript, *Avant et après*: "A compotier and ripe grapes spilling over the edge, on the linen the apple-green apples and the plum-red ones are linked to each other—the whites are blue and the blues are white. What a masterful painter Cézanne is" (facsimile ed., 1918, p. 31).

This work is one of a number of paintings (thirteen still lifes and two portraits in oil and a still life in watercolor) in which a blue-and-white foliate pattern appears in the background (still lifes, V. 337–48, 353; portraits, V. 369, 374;[2] watercolor, not in Venturi, exhibited in *Cézanne Watercolors*, M. Knoedler and Co., New York, 1963, no. 7, repr. in color). Although it is neither the largest nor the most ambitious of this "blue wallpaper" series, this work has consistently drawn the most critical attention, and two of the earliest and most articulate writers on Cézanne both singled out this still life as the first definitive statement of his mature style. In 1927 Roger Fry prefaced a lengthy commentary on the picture with the statement: "We may take as typical of this series [of still lifes] and as one of the most completely achieved, the celebrated still-life of the *Compotier*. It dates, no doubt, from well on into the period under consideration, from a time when Cézanne had completely established his personal method" (1927, p. 42). Ten years later, Fritz Novotny wrote: "The famous still life . . . which can be dated from 1877 to 1879, is without doubt the first picture in which Cézanne achieves his definitive manner. Naturally his art undergoes still further modifications, but we can nevertheless use the term 'definitive,' for after that, his essential principles no longer change" (1937, p. 17). As elaborated by these and later critics, this still life displays a unifying weave of parallel brushstrokes throughout the canvas; modeling of rounded volumes by color alone, along with a concern for clear definition of contour; subtle distortions of perspective to harmonize verticals and horizontals (as in the elision of the right angle between the front and top of the chest and the elliptical curves of fruit bowl and glass); and a correspondence and balance of the compositional elements through color as well as form—all characteristics that provide the intense vitality, within an overall coherence, which distinguishes the masterpieces of his later style.

Recognition of the decisive achievement represented by this painting has aroused considerable interest in its date on the part of those concerned with the evolution of Cézanne's style. The work has been variously dated between 1876 and 1882, based in part on tradition, in part on attempts to identify the foliate design in the background with various lodgings that Cézanne occupied during those years, and, more recently, on stylistic analysis as well, especially of the palette and brushstroke. A photograph of the work made under the auspices of E. Druet, an art dealer who also ran a photographic establishment, was reproduced as early as 1903 (*Kunst und Künstler*, 1903, p. 192), but no date was cited for the painting until the appearance of Vollard's first volume on Cézanne, published in 1914, where it was assigned the date of 1877 (p. 40). This is the date that Cézanne's son had annotated on a photograph of the work for Vollard's archives (information courtesy of J. Rewald), and doubtless Vollard accepted it uncritically, although the younger Cézanne was only five years old in 1877. This traditional date was frequently adopted in subsequent publications until the appearance of the catalogue raisonné by Lionello Venturi in 1936.

Also closely related to tradition is the identification and evaluation of the foliate background as a clue to the date of this work. The first published description of this background, in the catalogue of the Viau sale of 1907, where the work itself is not dated, used the terminology "tenture du fond à décor de feuillage" (hanging or wallpaper with a leaf decoration). In the catalogue of the von Nemeš sale in 1913 appears the following wording: "Dans le fond, tapisserie à feuillages" (In the background, tapestry with leaves). Both these descriptions may also have stemmed from Cézanne's son, who played an active role both as a dealer and as an

"expert" on his father's behalf but who cannot be relied on for factual accuracy, particularly for the years of his early childhood. There is no evidence in the surviving correspondence that the younger Cézanne consulted his father about the date or setting of this or any other work, although the possibility cannot be ruled out.

The first analytic approach to the dating of Cézanne's work was attempted by Georges Rivière, who as a young critic had known Cézanne slightly and vigorously defended his entries in the Third Impressionist Exhibition of April 1877. Rivière proposed that a background pattern containing diamond- and cross-shaped motifs in a roughly contemporary work was a wallpaper design that decorated an apartment Cézanne occupied on the rue de l'Ouest in Paris (Musées Nationaux, Paris; V. 356); he dated several works displaying this pattern between 1878 and 1883. Perhaps influenced by earlier descriptions, he identified the foliate pattern of this still life as "un fond de tapisserie à fleurs" (background of tapestry with flowers) and dated three works with this background design between 1876 and 1880. Rivière's incomplete chronologies were published as late as 1923 and 1933, and although prepared in consultation with Cézanne's son, then his own son-in-law, they are not acceptable as documentary evidence. In Rivière's first biography of Cézanne, he dated this still life 1877 and in the second volume, 1876 (1923, p. 205; 1933, p. 109).

Venturi, subsequently dealing in his catalogue raisonné with a substantially complete photographic record of Cézanne's work, recognized that there were two roughly contemporary groups of a dozen or more still lifes and portraits displaying elements of each background pattern. Venturi believed both to be wallpapers and qualified the dating for each group based on fuller knowledge of Cézanne's movements at that time: the artist occupied an apartment at 67, rue de l'Ouest between September 1876 and March 1878; traveled south to spend almost a year between Aix and L'Estaque; returned to 67, rue de l'Ouest for perhaps as much as three months between March and early June of 1879; went to Melun near the forest of Fontainebleau for approximately nine months; and returned on April 1, 1880, to another apartment on the rue de l'Ouest, no. 32, which he continued to occupy intermittently in 1881–82. (Cézanne's letters, largely to his boyhood friend Emile Zola, permit only approximate dating to the month; cf. J. Rewald, *Paul Cézanne Letters*, 4th ed., New York, 1976; 1st ed., Paris, 1937.) Noting an evolution in style in the diamond–cross series, Venturi somewhat implausibly supposed that two wallpapers were represented in this group alone; he assigned an earlier group to the 67, rue de l'Ouest location of ca. 1877 and another five to Melun or the second apartment on the rue de l'Ouest, no. 32, between 1879 and 1882. He believed the blue-and-white foliate pattern was to be found at one of these latter addresses and accordingly attributed this still life to the years 1879–82. In the same year as Venturi's publication, Charles Sterling adhered to the traditional date of ca. 1877 for his catalogue of the major Cézanne exhibition in Paris in 1936 (Musée de l'Orangerie, Paris, 1936, no. 39).

Other critics have questioned the usefulness of the wallpaper backgrounds as a criterion for dating the paintings in which they appear. Marie-Thérèse Lemoyne de Forges suggested that patterns such as these were extremely common at that time and could have been found in any one of Cézanne's several lodgings during those years (*Collection Jean Walter–Paul Guillaume*, exh. cat., Musée de l'Orangerie, Paris, 1966, nos. 4 and 5). This proposal was echoed by Martin Davies and Cecil Gould in cataloguing an important self-portrait with the diamond-patterned ground (*National Gallery Catalogues: French School*, London, 1970, p. 17; V. 365). While true in itself, this argument does not contribute to greater precision of dating. In a similar vein, Michel Hoog and Simone Rufenacht came to the conclusion that the wallpapers were so common that Cézanne could have represented them even when he no longer had them before his eyes (*Cézanne dans les Musées Nationaux*, exh. cat., Musée de l'Orangerie, Paris, 1974, no. 29). Not only Cézanne's well-

known adherence to his motif, but also the care with which these still lifes and portraits are composed in relation to the backgrounds (usually the patterns either frame or establish an axis with the subjects) might argue against such a proposal. The strong shadows cast to the right in the still lifes of both groups would suggest a single source of light for their setting. Wayne Andersen's suggestion (1967, p. 139) that the patterns might have been adapted from transportable fabric backdrops also seems unacceptable in view of their relationships to the architectural settings in the portraits of Mme Cézanne in each group (V. 292 and 369); further, while Cézanne used patterned fabric backgrounds throughout his life, he never depicted them flat against a wall.

If one assumes that Cézanne attempted to render what he saw before his eyes, although his representation of the patterns is selective, then a single location of considerable duration, or one to which he returned, must be postulated to account for the parallel evolution of style within the wallpaper groups. Within each group, there are both differences and similarities in brushstroke, impasto, and palette; for the diamond pattern, compare, for example, V. 213 (dated 1877 by Venturi) with V. 356 (as 1879–82), and for the foliate pattern, compare V. 337 with V. 343 (both as 1879–82).

The attempt to refine Venturi's broad dating has been the focus of more recent analysis. The most immediately apparent element of the new "constructive style" which emerged during these years (Venturi's term but more fully analyzed by T. Reff, 1961–62, pp. 214–26) is the systematic parallel brushstroke—more consistently applied in the present still life than in others of the two wallpaper groups.

Two major Cézanne exhibitions in Paris and London in 1954 (this work was exhibited in Paris with Venturi's dating of 1879–82) provided an opportunity for two of the most astute contemporary critics of Cézanne to focus closely on this crucial stylistic development. Douglas Cooper, disregarding the background patterns as valid evidence for dating, considered the present still life in the context of other works with a similar palette and brushstroke and found acceptable the traditional date of 1877 (1954, p. 346; in a letter to the author in 1980, he found ca. 1878 more likely). Lawrence Gowing, in a minutely argued analysis of the evolution of the late 1870s, believed that the two wallpapers decorated different rooms at the 67, rue de l'Ouest apartment and that two stylistic groups, each containing works of both patterns, could be distinguished. He identified the larger group, in which color is laid on in rectangular patches, with the style of 1877 and assigned this still life and six others to the shorter period spent at the same apartment in the spring of 1879. Discussing the emergence of the parallel stroke, Gowing wrote: "The transition, in the development of the *facture* which became a foundation of Cézanne's style, evidently took place during the unhappy year spent in the South in 1878 . . . 1879 seems to have been devoted to the development of this style" (1956, p. 188). John Rewald, from the perspective of decades of research for a revision of Venturi's catalogue raisonné, believed that the foliate background may have decorated the lodging at Melun and thus dated this work somewhat later: 1879–80; he believed the other wallpaper pattern comes from a different place and a slightly later date (correspondence with the author, 1980).

Another generation of Cézanne scholars continued to scrutinize both style and limited documentation in an effort to date this work. Robert Ratcliffe accepted Gowing's thesis regarding the two wallpapers as the most reasonable and tentatively stated that this still life "may be of 1879," presumably before Cézanne's departure for Melun (1960, p. 232). Theodore Reff, however, noting that the attempt to pinpoint a date within so few years is justified only by increased understanding of a critical innovation in Cézanne's style, disputed the reliance of both Cooper and Gowing on palette and touch as primary criteria in establishing a chronology. Without explanation, he found unwarranted Gowing's conclusion that the two wallpapers decorated the same Paris apartment, and he further questioned whether Cézanne spent enough time at 67, rue de

l'Ouest in the spring of 1879 to paint the second group of still lifes (1961–62, p. 223). For Reff, a group of fantasy compositions usually dated ca. 1875–76 exhibits the constructive brushstroke much earlier than works based on nature; thus he regarded this technique as "a synthetic device adapted to the rendering of invented, somewhat schematic forms rather than the more variable sensations of nature." Citing this still life, he noted: "Certainly none of those based on observation, with the possible exception of the still life that Gauguin owned (V. 341), contains as consistent a 'weave' of parallel diagonal touches as *L'Eternel feminin*" (V. 247). Reff found no landscape or still life with the parallel stroke securely datable before 1880 (*Le Château de Médan*, V. 325) and subsequently dated this still life ca. 1880 (1979, p. 90). It may be noted that both the thick granular impasto and intermittent parallel stroke characteristic of these works are fully evident in a landscape of L'Estaque (Musée du Louvre, Paris; V. 428), which is generally accepted as dating from Cézanne's 1878 sojourn in the south (Cooper, Gowing, Rewald), and that the stylistically more coherent *Le Pont de Maincy* (Musée du Louvre, Paris; V. 396), in which the parallel stroke is used with great fluency, is now securely dated to the summer of 1879. In a convincing argument about the origin of the constructive stroke, Reff failed to explain why this technique should appear in still life and landscape some four to five years later than in invented compositions.

Subsequently, Andersen corrected Reff in noting accurately that the evidence of Cézanne's letters leaves open the possibility that he spent as much as three months in Paris in the spring of 1879, and thus Gowing's hypothesis that both wallpaper groups were painted during separate stays at 67, rue de l'Ouest may be valid. In a wide-ranging argument in which he raised several possibilities, Andersen begged the question by proposing that "the problem of the wallpaper patterns should now be dropped" in favor of the visual evidence offered by several pictures in these groups (1967, p. 139).

This writer's conclusion is that documentary evidence for the dating of the wallpaper groups is limited and inconclusive and that the "visual evidence" will remain as varied as the eyes that study these works. In all likelihood, a satisfyingly precise chronology of Cézanne's stylistic development during this crucial phase cannot be charted from year to year, no matter how repeatedly sought; for such scholarly aspirations may well belie the true course of the artist's achievements. The fewest visual and factual contradictions are inherent in Gowing's hypothesis that both wallpaper groups originated at 67, rue de l'Ouest. It would seem, however, that the larger number of still lifes displaying both patterns, including this one, were probably painted during the long sojourn there between September of 1876 and March of 1878. The classical conception and brilliant palette of this work link it as closely to Cézanne's earlier still lifes (for example, V. 196, believed to have been exhibited in April 1877) as to the still life of the same foliate background but with a dark, cold tonality and drastic perspectival distortion in the Reinhart Collection, Winterthur (V. 344). Perhaps painted in 1877, in the fall when grapes were in season, this relatively small masterpiece may record a moment of happy equilibrium in a rapidly evolving style.

PROVENANCE:[3] Paul Gauguin, before 1884 until 1898 (sold for 600 francs); Dr. Georges Viau, Paris, by 1899; sale, Paris, Durand-Ruel, Mar. 4, 1907, no. 13, repr. (19,000 francs); Prince de Wagram, Paris; Marczell von Nemeš, Budapest, by 1911; sale, Paris, Galerie Manzi et Joyant, June 18, 1913, no. 85, repr. (48,000 francs); Auguste Pellerin, Paris; Private collection, Paris; David and Peggy Rockefeller, 1978, fractional gift to The Museum of Modern Art, New York (the donors retaining a life interest in the remainder).

EXHIBITIONS: Paris, Grand Palais, *Exposition centennale de l'art français de 1800 à 1889* (*Exposition international universelle*), Apr. 15–Oct. 1900, no. 86; Vienna, Secession, *Entwicklung des Impressionismus in Malerei und Plastik*, Jan.–Feb. 1903, no. 62; Brussels, La Libre esthétique, *Exposition des Peintres Impressionnistes*, Feb. 25–Mar. 29, 1904, no. 13; Budapest, Museum of Fine Arts, 1911; Munich, Alte Pinakothek, *Sammlung Marczell von Nemeš–Budapest*, by 1911; sale, Paris, Galerie Manzi et Joyant, June 18, 1913, no. 85, repr. (48,000 francs); Auguste Pellerin, Paris; Private collection, Paris; David and Peggy Rockefeller, 1978, fractional gift to The Museum of Modern Art, New York (the donors retaining a life interest in the remainder).

EXHIBITIONS: Paris, Grand Palais, *Exposition centennale de l'art français de 1800 à 1889* (*Exposition international universelle*), Apr. 15–Oct. 1900, no. 86; Vienna, Secession, *Entwicklung des Impressionismus in Malerei und Plastik*, Jan.–Feb. 1903, no. 62; Brussels, La Libre esthétique, *Exposition des Peintres Impressionnistes*, Feb. 25–Mar. 29, 1904, no. 13; Budapest, Museum of Fine Arts, 1911; Munich, Alte Pinakothek, *Sammlung Marczell von Nemeš–Budapest*, June–Dec. 1911, no. 28, repr.; Düsseldorf, Städtische Kunsthalle, *Sammlung Marczell von Nemeš–Budapest*, 1912, no. 113, repr.; Paris, Musée de l'Orangerie, *Cézanne*, May–Oct. 1936, no. 39, pl. XXXV; Paris, Musée de l'Orangerie, *Hommage à Cézanne*, July–Sept. 1954, no. 43, pl. XVIII; Paris, Grand Palais, *Centenaire*

de l'impressionnisme, Sept. 21–Nov. 24, 1974, no. 7, pp. 56–58, repr. p. 57, color (included in cat. of same exh. at The Metropolitan Museum of Art, New York, Dec. 1974–Feb. 1975, but not shown).

REFERENCES: E. Heilbut, "Die Impressionisten-Ausstellung der Wiener Secession," Kunst und Künstler, vol. I, May 1903, repr. p. 192; J. de Rotonchamp, Paul Gauguin, Weimar, 1906, p. 20; T. Duret, Histoire des peintres impressionnistes, Paris, 1906, repr. p. 189; E. Faure, Paul Cézanne (Portraits d'hier, no. 28), Paris, May 1, 1910, repr. p. 105; A. Vollard, Paul Cézanne, Paris, 1914, p. 40, pl. 14; P. Gauguin, Avant et après, facsimile ed., Leipzig, 1918, p. 31; J. Gasquet, Cézanne, Paris, 1921, repr. p. 118; E. Faure, Histoire de l'art—L'art moderne, Paris, 1921, p. 417, repr.; J. Meier-Graefe, Cézanne und sein Kreis, Munich, 1922, pl. 127; E. Faure, P. Cézanne, Paris, 1923, pl. 24; G. Rivière, Le Maître Paul Cézanne, Paris, 1923, p. 205; T. Klingsor, Cézanne, Paris, 1924, pl. 10; E. Bernard, Sur Paul Cézanne, Paris, 1925, repr. p. 125; R. Fry, "Le Developpement de Cézanne," L'Amour de l'art, vol. VII, Dec. 1926, pp. 402–6, repr. p. 403; idem, Cézanne: A Study of His Development, London, 1927, pp. 42–43, fig. 16; New York, 1958, pp. 42–51, pl. 16; Chicago, 1989, pp. 40–49, frontis. and no. 16; ; K. Pfister, Cézanne, Gestalt-Werk-Mythos, Potsdam, 1927, pl. 36; E. d'Ors, Paul Cézanne, Paris, 1930, repr.; G. Rivière, Cézanne, le peintre solitaire, Paris, 1933, p. 109; G. Mack, Paul Cézanne, New York, 1935, pl. 25; N. Javorskaia, Paul Cézanne, Milan, 1935, pl. 9; L. Venturi, Cézanne: Son Art, son oeuvre, Paris, 1936, vol. I, no. 341; vol. II, pl. 94; R. Huyghe, "Cézanne et son oeuvre," L'Amour de l'art, vol. XVII, May 1936, p. 169, fig. 53; idem, Cézanne, Paris, 1936, fig. 21; L'Art sacré (special no.), May 1936, fig. 9; Die Kunst, vol. LXXV, Dec. 1936, repr. p. 66; F. Novotny, Cézanne, Vienna, 1937, p. 17, pl. 25; London, n.d., p. 15, color pl. 12; J. Rewald, "A propos du catalogue raisonné de l'oeuvre de Paul Cézanne et de la chronologie de cette oeuvre," Renaissance de l'art, XXᵉ année, Mar.–Apr. 1937, p. 56; A. Barnes and V. de Mazia, Cézanne, New York, 1939, pp. 329, 409, repr. p. 191; G. Bazin, "Cézanne devant l'impressionnisme," Labyrinthe, no. 5, Feb. 15, 1945, repr. p. 6; M. Malingue, ed., Lettres de Gauguin à sa femme et à ses amis, Paris, 1946, pp. 75, 132; J. Rewald, The History of Impressionism, New York, 1946, repr. p. 346; 4th rev. ed., New York, 1973, pp. 560, 578, repr. p. 474; B. Dorival, Cézanne, Paris, 1948, pp. 46, 154, pl. 64; A. Joly-Segalen, ed., Lettres de Gauguin à Daniel de Monfreid, Paris, 1950, nos. XXXV, XLVII, LII, and LXII; M. Schapiro, Cézanne, New York, 1952, p. 54, repr. p. 55; D. Cooper, "Two Cézanne Exhibitions, I," Burlington Magazine, vol. XCVI, Nov. 1954, pp. 346–47; L. Gowing, "Notes on the Development of Cézanne," Burlington Magazine, vol. XCVIII, June 1956, pp. 188–89; M. Denis, Journal, I (1884–1904), Paris, 1957, p. 157; R. Ratcliffe, "Cézanne's Working Methods and Their Theoretical Background," Ph.D. diss., London, Courtauld Institute, 1960, pp. 14, 37, 101, 232, 253, 383 n. 35, 397–98 n. 113, 429 n. 149a, 430; T. Reff, "Cézanne's Constructive Stroke," Art Quarterly, vol. XXIV–XXV, 1961–62, pp. 214, 223, 225 n. 2; M. Bodelsen, "Gauguin's Cézannes," Burlington Magazine, vol. CIV, May 1962, pp. 207–8, fig. 42; Cézanne (Collection génies et réalités), Paris, 1966, p. 254; W. Andersen, "Cézanne, Tanguy, Chocquet," Art Bulletin, vol. XLIX, June 1967, pp. 138–39; M.-G. de La Coste-Messelière, "Un Jeune Prince amateur d'impressionnistes et chauffeur," L'Oeil, no. 179, Nov. 1969, pp. 21, 26, repr. p. 22; M. Roskill, Van Gogh, Gauguin and the Impressionist Circle, London, 1969, pp. 46–47, pl. 19; idem, Van Gogh, Gauguin and French Painting of the 1880's: A Catalogue Raisonné of Key Works, University Microfilms, Ann Arbor, 1970, pp. 236–38; M. Bodelsen, "Gauguin, the Collector," Burlington Magazine, vol. CXII, Sept. 1970, p. 606; The Complete Paintings of Cézanne, intro. by I. Dunlop, notes and cat. by S. Orienti, New York, 1972, no. 452; T. Reff, "The Pictures within Cézanne's Pictures," Art in America, vol. LIII, June 1979, pp. 90–91, repr. p. 90; J. Rewald, Cézanne: A Biography, New York, 1986, p. 119; R. Schiff, "The End of Impressionism," in The New Painting: Impressionism 1874–1886, exh. cat., San Francisco, 1986, p. 64, repr. p. 60, fig. 6; M. Schapiro, Paul Cézanne, New York, 1988 [concise edition of 1962 book], pp. 66–67; C. B. Bailey et al., Masterpieces of Impressionism and Post Impressionism: The Annenberg Collection, Philadelphia, 1989, p. 93, repr. p. 186, fig. 145; C. Geelhaar, "The Painters Who Had the Right Eyes: On the Reception of Cézanne's Bathers," in M. Krumrine, The Bathers, Basel, 1989, pp. 275–303, no. 217; M. Howard, Cézanne, London, 1990, p. 76; J. Gasquet, Joachim Gasquet's Cézanne: A Memoir with Conversations, trans. C. Pemberton, New York, 1991, p. 218; R. Verdi, Cézanne, London, 1992, pp. 7–10, 14–5, 206–8, no. 6.

1. The signature was evidently damaged at an early date. It appears in this form in the Druet photograph in the first reproduction of this painting known to the author (1903) and in the lithographic copy of the work by Maurice Denis, published in 1914 but possibly executed about 1900.
2. For the Cézanne entries, the abbreviation "V." followed by arabic numerals refers to the catalogue number(s) of a work or works in Lionello Venturi's Cézanne: Son Art, son oeuvre, Paris, 1936, vols. I and II.
3. Venturi and subsequent cataloguers erroneously listed two dealers in the collection history of this painting: Georges Chaudet and J.-H. Hessel. Gauguin's letters to de Monfreid indicate that this work was only on consignment to Chaudet, and a contemporary account of the von Nemeš sale reveals that Hessel acquired this painting for Pellerin (Cicerone, vol. V, 1913, p. 518).

William Rubin heard that this magnificent still life, which was in a private collection in Paris, was available and directed our attention to it. It took a considerable amount of time to negotiate its purchase. Rick Salomon, an associate of mine, made a couple of trips to France to work out arrangements, and indeed the painting itself was sent twice across the Atlantic for us to look at. The first time we did not buy it, as we were not able to agree on a price. Finally, after it had been returned, we decided to make a higher offer, which was accepted. When we purchased the painting, it was in a very poor frame and had never been cleaned, so its full beauty was hidden. Once it was cleaned by Jean Volkmer, chief conservator at The Museum of Modern Art, and put in a really good frame, it turned out to be one of the most exquisite paintings we own. D.R.

⌘ Paul Cézanne

Boy in a Red Vest (*Garçon au gilet rouge*). (1888–90)

Oil on canvas, 32 x 25⅝ in. (81.2 x 65 cm.). Not signed or dated. The Museum of Modern Art, New York. Fractional gift of David and Peggy Rockefeller (the donors retaining a life interest in the remainder).

One of a series of four paintings of an adolescent boy wearing a red vest, this work was for many years in the collection of Cézanne's friend Claude Monet. A second painting, of the same size and showing the youth seated in three-quarter profile, is in the Bührle Foundation Collection, Zürich (V. 681), and a third, slightly larger view of the boy standing frontally is in the collection of the National Gallery of Art, Washington, D.C., a promised gift of Mr. and Mrs. Paul Mellon (V. 682). The fourth, a smaller, half-length version of the subject seated in a frontal pose, is in the Barnes Foundation, Merion, Pa. (V. 683; for illustrations of all four, see Barnes Foundation, 1993, pp. 115–16). Two watercolors of the boy are also known: one in the collection of Marianne Feilchenfeldt, Zürich (V. 1054), and a second, in a private collection in Paris, which, according to John Rewald, was also once owned by Monet (1983, nos. 375 and 376, pls. 29 and 30). These watercolors, with green tonalities in the background, appear to have been done in the open air (Rewald, 1983, p. 174).

Nothing is known for certain about the subject, the date, the location, or the order in which Cézanne painted this series of portraits. Georges Rivière, probably in consultation with Cézanne's son, identified the youth as a young Italian named Michelangelo di Rosa (*Le Maître Paul Cézanne*, Paris, 1923, p. 216). In his catalogue raisonné, Lionello Venturi accepted this identification and added that the young Italian model was "dressed as a peasant of the Roman Campagna" (1936, vol. I, pp. 61, 211). Citing tradition, Venturi noted that the subject of *Italian Girl Resting on Her Elbow* (V. 701), which he dated ca. 1896, was supposedly a close relative of the youth (1936, vol. I, p. 216). Rewald, also citing tradition regarding the relationship of the two subjects but dating the portrait of the girl ca. 1900, referred to the boy as "a long-haired young Italian model named Michelangelo di Rosa" (1983, p. 174). The names and addresses of several Italian models, but not that of Michelangelo di Rosa, were recorded in undated notebooks used by Cézanne in the 1880s and early 1890s (Venturi, 1936, vol. I, pp. 310, 313), but no further evidence has been found that Cézanne used professional Italian models. If true in this instance, this series would seem a notable exception to Cézanne's typical practice. The use of a model may have allowed Cézanne to achieve the great "degree of concentration" and "depth of penetration" in this portrait (Barnes Foundation, 1993, p. 115).

A date for the completion of at least one of the paintings of the boy in a red vest is provided by the critic Gustave Geffroy's review of the first Cézanne exhibition at the Galerie Vollard in Paris in November–December 1895 (*Le Journal*, Nov. 16, 1895; reprinted in *La Vie artistique*, vol. VI, 1900, p. 218). Geffroy wrote: "To Cézanne's retreat, his secret labor, we owe this magnificent portrait of a young man in a red waistcoat which can stand comparison with any of the most beautiful figures in painting." Geffroy had first published a sympathetic account of Cézanne's current efforts after three of his earlier paintings fetched respectable prices at the Duret sale in March 1894, a courtesy promptly acknowledged by the artist (J. Rewald, ed., *Cézanne Letters*, New York, 1976, p. 235). A close friend and later biographer of Monet, Geffroy subsequently met Cézanne at Monet's house in Giverny in November 1894. The following April, Cézanne proposed to paint Geffroy's portrait and embarked on the project in the library of the writer's home in the Belleville quarter of Paris. After numerous sessions, he abandoned the work as beyond his capacity to finish and returned to Aix in June 1895; but it is reasonable to suppose that Geffroy grew familiar with the artist's habits, probably also with his recent work, during the repeated posing sessions. His comment five months later on the origin of one of the por-

traits of the boy in Cézanne's "mise en retraite" may merely refer to the artist's habitual reclusiveness. On the other hand, his awareness of Cézanne's periodic returns to Aix permits interpretation of his phrase to mean an actual "retreat," suggesting that the series portraying the boy in a red vest was painted in Aix-en-Provence rather than in Paris.

Other factors also point to the probability that Cézanne painted this group of portraits at the Jas de Bouffan, the large property on the outskirts of Aix that he had inherited after his father's death in 1886. In the background of three of these works (V. 680, 681, 683) is a burgundy-red stripe, and in two the stripe is seen just above a wall molding (V. 681, 683). These decorative features first appeared in a painting of the late 1860s, *Jeune Fille au piano* (V. 90), showing Cézanne's sister Marie playing the piano in one of the salons at the Jas de Bouffan; and both stripe and molding appear in three of the four portraits of Mme Cézanne in a red wool dress (V. 570–72), probably also painted at Aix. Although Cézanne frequently used horizontal bands as a compositional device in his last decades, the conjunction of stripe and molding with subject matter in the works cited above suggests a single location.

It is known that Cézanne did not always confine himself to his studio when painting figure subjects at the Jas. According to reminiscences by his niece, Paule Conil, "After the death of old Cézanne, Paul occasionally abandoned his studio at the Jas de Bouffan in order to paint in the grand salon on the main floor; here reigned an incomparable disorder: flowers, fruit, white napkins, three skulls on the mantle . . ." (C. Flory-Blondel, "Quelques Souvenirs sur Paul Cézanne," *Gazette des Beaux-Arts*, vol. LVI, Nov. 1960, p. 300). The wife of Joachim Gasquet, whose portrait Cézanne began and abandoned after ten sittings in the winter of 1896–97, stated in 1956: "The master decided to paint me *en face*, seated in the corner of an old Louis XIII sofa, near the fireplace, hands at ease on my knees" (cited by R. Ratcliffe, "Cézanne's Working Methods and Their Theoretical Background," Ph.D. diss., London, Courtauld Institute, 1960, p. 389). Although the large salon in which Cézanne had painted murals in the 1860s was redecorated after the Jas de Bouffan was sold in 1899 (D. Cooper, "Au Jas de Bouffan," *L'Oeil*, no. 2, Feb. 15, 1955, pp. 12 ff.) and the present molding may be a later addition, it seems likely that one of the main-floor rooms was the setting for the portraits showing the wall molding and stripe above it. Neither the fireplace which appears in one of the portraits of Mme Cézanne in a red dress (V. 570) nor the figured curtain in that painting and in one of the portraits of the boy (V. 682) points to a specific location; fireplaces were common to the Jas and Cézanne's previous lodging on the quai d'Anjou in Paris, and the figured curtain—a favorite accessory since its introduction in the *Mardigras* of 1888—may well have been part of the artist's baggage on his journeys throughout the nineties. More significant is the fact that the watercolor reproduced by Leo Larguier shows the youth seated out-of-doors before a leafy background, which also suggests that Aix rather than Paris was the locale for these portraits.

The probability that Cézanne painted this series in Aix has a bearing on their date, which has hitherto been placed between 1888 and 1895. In the earliest chronology of Cézanne's work, published seventeen years after his death, Rivière listed single works from both series of portraits with the molding and stripe in the background as painted in 1888 in the third-floor apartment on the quai d'Anjou, which Cézanne occupied intermittently between that year and early 1890 (*Le Maître Paul Cézanne*, Paris, 1923, p. 216; neither this nor Rivière's 1933 chronology mentions this work). For a long time, Lawrence Gowing (1954, no. 47) was alone in accepting the quai d'Anjou locale for both series (1888–90), while other scholars placed the paintings of the boy in the early to mid-1890s (V. 680: 1890–95; D. Cooper, *Catalogue of the Bührle Collection*, London and Edinburgh, 1961, no. 36: 1894–95 in Paris; J. Rewald, *Cézanne*, exh. cat., Washington, Chicago, and Boston, 1971, no. 24: 1893–95). More recently, however, Rewald rethought this question, returning to Rivière's and Gowing's earlier hypotheses; further research led him to determine that

the painting was executed in Paris, not later than 1890. Rewald's conclusion is based on what he called "topographic indications" common to apartment and picture: the fireplace with a framed mirror above and slightly larger than the mantle, the molding and accompanying wine-red band that ran along the walls, the small curtained door or opening. All of these elements that are seen in the portraits of the young Italian were "distinctive features" of the Paris apartment at 15, quai d'Anjou where Cézanne lived between 1888 and 1890 (Rewald, 1983, p. 174).

On the supposition that Cézanne painted the portraits of the boy in a single location within a period of a few months, this writer has concluded that the year 1893 or the second half of 1895 (prior to the exhibition at Vollard's) seem the most plausible dates, as he spent most of 1894 and the first six months of 1895 in the north. In the concentrated angularity of the composition, the brushwork and treatment of volume in the sleeves, as well as the curiously frontal rendition of the pupil in a profile eye, the present work seems parallel in conception to the right-hand figure in the last of *The Cardplayers* series (Musée du Louvre, Paris; V. 558), most recently dated ca. 1894–95 by Theodore Reff (W. Rubin, ed., *Cézanne: The Late Work*, New York, 1977, p. 17).

No sequence for the execution of these works has hitherto been proposed, but it seems to this writer likely that the two watercolors showing the boy seated in a casual frontal position, with shirtsleeves rolled up, were painted first. These are related by the relaxed pose and informal composition to the smallest of the oils, the half-length version in the Barnes Foundation (V. 683), which may have been the first of the oil paintings. In the three larger oils, the boy is posed with greater deliberation in a curtained setting; it seems probable that the standing frontal figure in the Mellon Collection (V. 682)[1] and the seated figure in three-quarter profile in the Bührle Collection (V. 681), both of which show a slight boy with pensive features and delicate limbs, may have been painted next. In the present work, the boy is more solid and naturalistic in proportion yet more impassive and remote in expression. Posing the figure in profile before a flat wedge of curtain that meets the hands and shoulder at right angles, the artist achieved here a monumental stability which suggests that this work may be the last of the series.

Although it has not been possible to verify Venturi's assertion that the boy is dressed as "a peasant of the Roman Campagna," his costume may have had more than coloristic appeal for Cézanne. The youth with unusually long hair—a style long out of fashion—and wearing a red vest may have evoked in the aging Cézanne memories associated with both poetry and youthful rebellion. At the premiere of Victor Hugo's controversial play *Hernani* in 1830, the long-haired young poet Théophile Gautier had appeared in a red waistcoat, leading a band of youthful followers to acclaim the author before a hostile audience. Following this famous episode in the history of the Romantic movement, the term *un gilet rouge* (a red vest) became an epithet identifying one who defied bourgeois convention and appears often in nineteenth-century French literature. Accounts of Cézanne's own romantic temperament in his youth lend credibility to Ambroise Vollard's report that he had adopted this symbol of solidarity with rebellious youth during his early years in Paris: "An old painter who had known Cézanne at that epoch [1860s; possibly Guillemet] said of him, 'Yes, I remember him well! He wore a red waistcoat and always had enough in his pocket to buy dinner for a comrade'" (*Cézanne*, Paris, 1914, p. 19).

There is no evidence to indicate when Monet acquired this painting. In an interview with the Duc de Trévise in 1920 (*Revue de l'art ancien et moderne*, vol. LI, Feb. 1927, p. 127), he claimed to own fourteen works by Cézanne, and the limited documentation shows that he acquired them by gifts from the artist, by exchange, or by purchase. Camille Pissarro, commenting on the 1895 exhibition at Vollard's to his son Lucien, wrote that "Degas and Monet have bought some marvelous Cézannes" (Nov. 21, 1895; J. Rewald, ed., *Camille Pissarro: Letters to His Son Lucien*, New York, 1943, p. 276); and Henri Perruchot stated that

Monet bought three oils on that occasion (*La Vie de Cézanne*, Paris, 1956, p. 345). Monet may have bought the present painting at that time, and it may also be the work to which his friend Geffroy referred in his review (see above), although Venturi and subsequent scholars have applied this reference to the version now in the Bührle Collection. In his 1914 biography of Cézanne, Vollard did not list either version among the works he remembered including in that exhibition (pp. 58–59).

According to the anecdotalist Michel Georges-Michel, who accompanied the statesman Georges Clemenceau on a visit to his close friend Monet at Giverny, the *Boy in a Red Vest* was the artist's favorite among his large collection of works by his friends and contemporaries (1942, pp. 34–35). In Georges-Michel's account, "Monet said, 'If you are fond of paintings, you must see the ones in my bedroom. You should also take a look at the room next to it because you'll find my best picture there.' 'That's not a favor he grants everyone,' said Clemenceau. 'No. But not everyone comes here with Clemenceau, either,' he replied. The bedroom upstairs was lighted by windows looking out on to the garden. To the left of the fireplace my eye was caught, first of all, by Cézanne's famous *Château Noir*, which Monet had bought from the artist himself; on the other side hung a *Vue de l'Estaque* and below it a *Baigneurs*." After describing works by Renoir, Pissarro, Morisot, and others, Georges-Michel continued: "I went into the adjoining room and found only one picture there, and that unframed: Cézanne's *Boy in a Red Vest.* I stood looking at it for a long time. All at once I was aware that Clemenceau and Monet had also come in, and after a long silence I heard the painter say in his deep, beautiful voice: 'Yes, Cézanne is the greatest of us all. . . .'"

PROVENANCE: Claude Monet, Giverny; Michel Monet, Giverny, until 1931; Paul Rosenberg, Paris; Mrs. A. Chester Beatty, London, by 1936; Paul Rosenberg, New York, by 1955; David and Peggy Rockefeller, 1955, fractional gift to The Museum of Modern Art, New York (the donors retaining a life interest in the remainder).

EXHIBITIONS: New York, The Museum of Modern Art, *Paintings from Private Collections: A 25th Anniversary Exhibition*, May 31–Sept. 5, 1955, no. 21 (repr. in "Paintings from Private Collections," *The Museum of Modern Art Bulletin*, vol. XXII, Summer 1955, p. 14); New York, M. Knoedler and Co., *A Family Exhibit*, Apr. 6–25, 1959, no. 6, repr.; New York, Wildenstein and Co., *Masterpieces, A Memorial Exhibition for Adele R. Levy*, Apr.–May 1961, no. 39, repr.; Cambridge, Mass, The Fogg Art Museum, Harvard University, *Works of Art from the Collections of the Harvard Class of 1936*, June 11–Aug. 25, 1961, no. 8, pl. XI; New York, The Metropolitan Museum of Art, *Summer Loan Exhibition*, July 12–Sept. 3, 1963; Buenos Aires, Museo Nacional de Bellas Artes, *De Cézanne à Miró*, Summer 1968, p. 9, repr., traveled to Santiago, Museo de Arte Contemporáneo, and to Caracas, Museo de Bellas Artes; New York, Center for Inter-American Relations, *Cézanne to Miró*, Sept. 12–22, 1968; New York, The Museum of Modern Art, reopening installation of the museum collection, May 6, 1984–Jan. 6, 1985.

REFERENCES: J. Rewald, *Cézanne and Zola*, Paris, 1936, p. 147, pl. 65; L. Venturi, *Cézanne: Son Art, son oeuvre*, Paris, 1936, vol. I, pp. 61–62, 211, no. 680; vol. I, pl. 219; R. Huyghe, "Cézanne et son oeuvre," *L'Amour de l'art*, vol. XVII, May 1936, p. 186, fig. 80; J. Rewald, "A propos du catalogue raisonné de l'oeuvre de Paul Cézanne et de la chronologie de cette oeuvre," *Renaissance de l'art*, XXᵉ année, Mar.–Apr. 1937, p. 54; M. Georges-Michel, *Peintres et sculpteurs que j'ai connus, 1900–1942*, New York, 1942, pp. 34–35; G. Bazin, "Cézanne devant l'impressionnisme," *Labyrinthe*, no. 5, Feb. 15, 1945, repr. p. 7; B. Dorival, *Cézanne*, Paris, 1948, pp. 59, 61, 164, pl. 116; L. Gowing, *An Exhibition of Paintings by Cézanne*, Royal Scottish Academy, Edinburgh, 1954, no. 47; D. Cooper, "Two Cézanne Exhibitions, II," *Burlington Magazine*, vol. XCVI, Dec. 1954, p. 380; *Art News*, vol. LIV, Summer 1955, repr. p. 46; *Vogue*, Feb. 1, 1956, repr. in color, p. 173; A. Saarinen, "A Painting that Tells Modern Art's Story," *New York Times Magazine*, Nov. 2, 1958, pp. 16, 76, repr.; *Connoisseur*, vol. XLIII, June 1959, p. 273, repr.; R. Murphy, *The World of Cézanne*, New York, 1968, pp. 93, 99, color pl. 92; F. Elgar, *Cézanne*, New York, 1969, pp. 134–36; J. Lindsay, *Cézanne: His Life and Art*, New York, 1969, p. 239, repr. opp. p. 33; *The Complete Paintings of Cézanne*, intro. by I. Dunlop, notes and cat. by S. Orienti, New York, 1972, no. 579; L. Venturi, *Cézanne*, New York, 1978, p. 129; J. Rewald, *Paul Cézanne: The Watercolors*, New York, 1983, p. 174; R. Verdi, *Cézanne*, New York, 1992, p. 133; *Great French Paintings from the Barnes Foundation: Impressionist, Post-Impressionist, and Early Modern*, New York, 1993, p. 116, fig. 1.

1. The *contrapposto* pose of this figure with his hand on his hip, the broadbrimmed hat, and the downward glance to the right suggest a parallel with Donatello's *David* (Museo Bargello, Florence). Cézanne's interest in Renaissance sculpture is well documented by the many drawings he made from originals or casts in Paris (cf. G. Berthold, *Cézanne und die alten Meister*, Stuttgart, 1958, nos. 83–94). Although this resemblance may be accidental, it is possible that a photograph or cast of this famous figure may have lingered in Cézanne's memory when posing the boy in this unusually mannered stance.

This was one of three paintings acquired from Mrs. A. Chester Beatty's collection.

∞ Paul Cézanne
Mont Sainte-Victoire. (1902–6)

Pencil and watercolor on paper, 16¾ x 21⅜ in. (42.5 x 54.3 cm.). Not signed or dated. The Museum of Modern Art, New York. Fractional gift of David and Peggy Rockefeller (the donors retaining a life interest in the remainder).

Mont Sainte-Victoire, with its dramatically steep cliff facing west and its long flank stretching through miles of countryside, had been a favorite motif of Cézanne's since he first painted it about 1870 (*La Tranchée*, Neue Staatsgalerie, Munich; V. 50), and he depicted it from varying aspects in both oils and watercolors. This view was painted from the vantage point of the crest of Les Lauves, a hill on the northern outskirts of Aix-en-Provence; in 1902 Cézanne had a studio built to his specifications halfway up its slope. In the catalogue raisonné of Cézanne's watercolors, John Rewald wrote that from this view the mountain "presented itself as an irregular triangle, its long back gently rising to the abrupt, clifflike front. . . . At Cézanne's feet extended a vast, undulating plain with a quilt-like pattern of fields and clusters of trees . . . the mountain seems pointed toward heaven . . . a glorious symbol of Provence" (1983, p. 240). In its "vivid, most carefully contrasted colors," this work shows the "self assurance and fluency characteristic of the late watercolors" (1983, pp. 37, 240). Although Cézanne did begin this work with a pencil sketch, in many of the late watercolors he dispenses with the need for such compositional guidance. Rewald described the artist's watercolor techniques as "unconventional." In the words of Emile Bernard, who accompanied Cézanne on his outings up the mountain, "He began on the shadow with a single patch, which he then overlapped with a second, then a third, until all those tints, hinging one to another like screens, not only colored the object but modeled its form" (E. Bernard, *Sur Paul Cézanne*, Paris, 1925, pp. 23–24). Rewald elaborated, "He put down brushstrokes all over the paper instead of concentrating on a specific section," and he would wait for these patches to dry before the next overlapping layer was added. Colors, thus, did not run into one another, and the result was transparent, veil-like layers (1983, p. 412).

In the last four years of his life, the artist painted the mountain from almost the same position as in the present work in several other watercolors (V. 1030–33, 1564, 1569) and in a number of oils (V. 798–804, 1529). During these last years, Cézanne's output of watercolors actually increased (Rewald, 1983, p. 38). Just about one year after the artist's death, the first major exhibition of watercolors opened at Bernheim-Jeune, the result of an agreement worked out between the artist's son, his dealer Vollard, and the gallery.

Lionello Venturi proposed a generalized dating of 1902–6 for most of the works painted from or near Cézanne's studio on the Chemin des Lauves, and this has been accepted by Rewald. Douglas Cooper has suggested that the lightness of palette and the unusually complete definition of form in the present work would indicate a date toward the middle of the period, ca. 1904–5 (verbally, 1978).

PROVENANCE: Ambroise Vollard, Paris; Paul Guillaume, Paris; Mme Jean Walter (Guillaume), Paris; Rosamond Bernier, Paris; David and Peggy Rockefeller, 1962, fractional gift to The Museum of Modern Art, New York (the donors retaining a life interest in the remainder).

EXHIBITIONS: *Recent Acquisitions*, The Museum of Modern Art, New York, 1962–63; Pasadena Art Museum, *Cézanne Watercolors*, Nov.–Dec. 1967, no. 35, repr. p. 51; New York, The Museum of Modern Art, *Seurat to Matisse: Drawing in France*, June 13–Sept. 8, 1974, no. 22, repr. p. 19; New York, The Museum of Modern Art, *Cézanne: The Late Work*, Oct. 7, 1977–Jan. 3, 1978, no. 106, p. 413, pl. 134, traveled to Houston, Museum of Fine Arts, Jan. 25–Mar. 31, 1978, and to Paris, Grand Palais, Apr. 20–July 23, 1978.

REFERENCES: "Painting and Sculpture Acquisitions, Jan. 1, 1962, through Dec. 31, 1962," *The Museum of Modern Art Bulletin*, vol. XXX, nos. 2–3, 1963, repr. p. 3; *MOMA: A Publication for Members of The Museum of Modern Art*, Winter 1974–75, repr. in color; W. Rubin, ed., *Cézanne: The Late Work*, New York, 1977, no. 106, p. 413, pl. 134, color; J. Rewald, *Paul Cézanne: The Watercolors*, New York, 1983, p. 240, no. 595.

In 1962 Alfred Barr told us of a very beautiful Cézanne watercolor of 'Mont Sainte-Victoire,' which belonged to Mme Georges Bernier in Paris. We asked to have it sent over and were immediately drawn to it. I am very glad that we decided to buy it, as we both feel it is one of the more alluring Cézanne watercolors we have seen. D.R.

🐦 Pierre-Auguste Renoir. French, 1841–1919
Gabrielle at the Mirror (Gabrielle au miroir). 1910

Oil on canvas, 32⅛ x 25¾ in. (81 x 65 cm.). Signed lower left: *Renoir.* Not dated. David and Peggy Rockefeller Collection.

Gabrielle Renard (1879–1959), a distant cousin of Mme Renoir from Burgundy, was engaged as a nursemaid shortly before the birth of Renoir's second son, Jean, in 1894. During the twenty years that she remained with the family, she assisted Renoir in the studio, cleaning brushes and preparing palettes as he became increasingly crippled with arthritis. She also became the favorite model of his old age, and numerous portraits of her exist. According to Jean Renoir, Gabrielle first began to pose for his father in the nude when she was twenty and he was unable to engage a professional model from Grasse (*Renoir, My Father,* Boston and Toronto, 1962, pp. 391–92). Gaston Bernheim de Villers described her as "an extremely beautiful brunette—charming and intelligent. When you arrived for luncheon you were almost certain to find Renoir painting her, either in the nude or wearing transparent oriental robes. A quarter of an hour later, still clad in these garments, she would lay the table and serve the lunch" (1949, pp. 77–78). Early in 1914 she married an American painter, Conrad Slade, and lived in California until her death in 1959.

This work depicts a scene that has become a convention in painting: a woman, looking into a mirror, completely absorbed in her own image and the activity of her own adornment. Such "vanitas" paintings allow the viewer both to enjoy the spectacle of the woman's beauty, including most often her naked body, and at the same time, to condemn her for her self-indulgent and trivial vanity. Moreover, the woman seated in front of the mirror, looking at her own face or body, joins the viewer of the painting in treating herself as "first and foremost, a sight" (John Berger, *Ways of Seeing,* New York, 1977, p. 51). In Renoir's painting, the odalisque-style robe, carefully contrived to look as if it has fallen casually open so that we can see her breasts, and the bright colors (especially the reds) and thick pigment, evoking languor and exoticism, conspire to create Gabrielle as an object presented purely for viewers' voyeuristic pleasure (she is, after all, in the "privacy" of her boudoir). Renoir's painted women, especially the late nudes, have been described as earthy and natural; however, some recent literature has criticized such readings, seeing this work as accepting stereotypes of female vanity and passivity (see articles in *Oxford Art Journal,* vol. 8, no. 2, 1985, especially by Tamar Garb and Desa Philippi).

Renoir created other versions of this picture, painting Gabrielle several times in this transparent gown. In another work of the same date and size, and very similar in composition, *Gabrielle with Jewelry,* she is seated before the mirror in the reverse position, wearing a necklace and holding a rose to her hair (private collection; *Renoir,* exh. cat., Hayward Gallery, 1984, no. 115). Smaller versions of the latter composition with the same costume and accessories are dated 1910 and 1911 (repr. M. Zahar, *Renoir,* Paris, 1948, pls. 85 and 87).

PROVENANCE: Josse and Gaston Bernheim-Jeune, Paris (acquired from the artist in 1910); Jean and Henri Dauberville (sons of Josse Bernheim), Paris, 1946; Bignou Gallery, New York, 1947; Sam Salz, New York; David and Peggy Rockefeller, 1951.

EXHIBITIONS: Paris, Bernheim-Jeune, *Renoir,* Mar. 10–29, 1913, no. 52 (repr. in color as frontis. in accompanying album; listed, p. 64, as *La Femme au miroir,* wrongly dated 1913); Paris, Musée de l'Orangerie, *Renoir,* 1933, no. 121; Paris, Bernheim-Jeune, *Renoir, Portraitiste,* June 10–July 27, 1938, no. 36; New York, The Museum of Modern Art, *Art in Our Time,* May 10–Sept. 30, 1939, no. 54, repr.; New York, Paul Rosenberg and Co., *Collectors Choice: Masterpieces of French Art from New York Private Collections,* Mar. 17–Apr. 18, 1953, no. 22, repr. p. 56; New York, The Museum of Modern Art, *Paintings from Private Collections,* May 31–Sept. 5, 1955, no. 128, repr.

REFERENCES: W. H. Wright, *Modern Painting,* New York and London, 1915, p. 127, repr. in color, p. 108; Bernheim-Jeune, eds., *L'Art moderne et quelques aspects de l'art autrefois,* Paris, 1919, vol. II, pl. 136; A. André, *Renoir,* Paris, 1928, pl. 73; A. Basler, *Pierre-Auguste Renoir,* Paris, 1928, repr. p. 59; J. Meier-Graefe, *Renoir,* Leipzig, 1929, p. 328, repr. p. 343; E. Piceni, *Auguste Renoir,* Milan, 1945, pl. XXXIV; G. Bernheim de Villers, *Little Tales of Great Artists,* New York, 1949, pp. 77–78, 83; W. Gaunt, *Renoir,* London, 1952, repr. pl. 95; J. Renoir, *Renoir, My Father,* Boston, 1962, pp. 391–92.

🐦 Georges-Pierre Seurat. French, 1859–1891
The Roadstead at Grandcamp (La Rade de Grandcamp). 1885

Oil on canvas, 25⅝ x 31⅞ in. (65 x 80.5 cm.). Signed lower right: *Seurat.* Not dated. David and Peggy Rockefeller Collection.

It was during the summer of 1885 at Grandcamp on the Channel coast of Normandy that Georges Seurat painted his first marine views. Twelve small studies on wood and five major canvases, several of which were exhibited the following year, date from this period (H. Dorra and J. Rewald, 1959, nos. 141–57; C. M. de Hauke, 1961, nos. 146–61). Two of the small panels are studies for the larger canvases, but no oil study or drawing for the present work is known. Robert Herbert believes that *The Roadstead at Grandcamp* was the first canvas undertaken that summer of 1885 (1991, p. 239), the first of several summers the artist spent painting along the Channel coast.

At this time, Seurat was interested in the scientific analysis of the color spectrum and was working with the small, uniform brushstroke that is now associated with this artist and is regarded as one of the techniques characteristic of Neo-Impressionism. There are many conflicting opinions about Seurat's investment in the science, optics, and physiology of his day. William Innes Homer was among the first to attempt to document Seurat's direct application of color theory in his pictures. More recently, Michael Zimmermann explained that Seurat sought to combine the art theory of Charles Blanc with the advances in physiological optics by scientists like Hermann von Helmholtz (1991, p. 445). For Seurat, Zimmermann wrote, these optical theories could be incorporated into the artist's own exploration of naturalism; later, after about 1886, Seurat turned to the work of Charles Henry, which was based on "harmonic" relations of colors as well as the physiology of human sense organs (1991, p. 446), an interest shared by Paul Signac and explored by him in another painting in the Rockefeller collection, the portrait of Félix Fénéon (p. 38). While acknowledging Seurat's interest in color theory and science, many scholars believe that the extent of Seurat's actual exploration and grasp of these fields should not be overemphasized. Alan Lee ("Seurat and Science," *Art History,* vol. 10, 1987) argued that the artist misunderstood many of these theories, while John Gage ("The Technique of Seurat: A Reappraisal," *Art Bulletin,* vol. LXIX, 1987) hypothesized that Seurat was actually more interested in the thoughts of Michel Chevreul and ideas about aesthetic harmony than in Helmholtz and Ogden Rood. Gage showed that Seurat was more concerned with the creation of an overall harmonious field than with breaking down pigment into discrete strokes. Robert Herbert has suggested that "rational" should replace "scientific" to describe Seurat's thinking and methods (New York, The Metropolitan Museum of Art, symposium, December 7, 1991; discussed by Ellen Lee in *Art Journal,* vol. 51, no. 2, Summer 1992, p. 105).

Seurat used multicolored brushstrokes (it has been said that these techniques were learned from Charles Blanc and the painter Eugène Delacroix) which, when placed next to one another, affect contrasts. Lights become lighter and darks darker, resulting in corresponding shifts

in color (Herbert, 1991, p. 173). The division of primary colors into tones reflecting the varied action of sunlight according to a predetermined scale, as well as the juxtaposition rather than mixture of tones for the sake of a more vibrant effect, had already been meticulously carried out in Seurat's mural-size *A Sunday Afternoon on the Island of La Grande-Jatte* (The Art Institute of Chicago), which he had begun in 1884 before he set to work on the Grandcamp marines. Lessons learned from the monumental canvas were helpful that summer, and, conversely, the five major canvases completed at Grandcamp were excellent practice for his reworking and completion of *A Sunday Afternoon* the following autumn and winter. *The Roadstead at Grandcamp* reflects the impact of Impressionism, with its more spontaneous response to color effects observed outdoors, particularly in the sky and water, while the varied brushwork evokes actual textures of the hedges and stone wall. Parallel strokes of pale green and white render the quietly rippling sea, and the mottled effect of the brushwork in the sky conveys the milky light of the Channel coast. In the foreground, irregular crisscross strokes recreate the texture of the foliage in golden ocher, olive green, and reddish-brown tones, with touches of darker green and black to indicate the more shaded areas. Zimmermann praised Seurat's rendering of the wall as the area in the canvas where "the full radical nature of Pointillism makes its first appearance" and the artist goes beyond simply representing surface qualities (1991, p. 210). Belgian poet Emile Verhaeren described Seurat's approach in the Grandcamp paintings as being instinctive: "Then in the summertime, wash the studio light out of the eye and translate as exactly as possible the pungent sunlight, with all its nuances. An existence divided in two by art itself" (interview, June 1887, in Herbert, 1959, p. 325).

Seurat was probably drawn to the unpretentious motif of this view by the classical serenity of the repeated horizontals of foreground, fence, hedge, and horizon, accented by the verticals of the stone wall and the masts and varied by the diagonals of the sails and the irregular mass of foliage. And while the parallel alignment of the boats with their sails in profile was probably a deliberate compositional device, it was also a sight often seen along the coasts in summertime, when pleasure boating increased. The impression of boats in full sail led Octave Maus to write of "a white flight of yachts" (*une blanche envolée de yachts*) when the work was first exhibited in the spring of 1886 (1886, p. 204). Fénéon subsequently described the work as a "slow procession of triangular sails" (*procession lente de voiles triangulaires*; 1888, p. 173). However, Seurat's own description of the painting, included in the list of works to be exhibited in Brussels in 1887 that he sent to Verhaeren, indicates that he conceived the central boats as resting at anchor: "The roadstead of Grandcamp, horizontal format, bit of wall, hedge, boats at anchor" (*La rade de Grandcamp, motif en largeur, bout de mur, hale, bateaux à l'ancre*; Herbert, 1959, p. 318; original letter with tiny sketch, repr. p. 316).

The Roadstead at Grandcamp was one of nine works by Seurat exhibited in the eighth and last *Exposition des peintres impressionistes* in May 1886 (exh. cat., 1986, p. 446). This seascape, along with another work of the previous summer, *Le Bec du Hoc* (Herbert, 1991, no. 161), were hung on either side of *A Sunday Afternoon* (Thomson, 1985, p. 96). These marines received far more praise than Seurat's monumental canvas, which was roundly abused by the critics (Herbert, 1991, p. 239).

PROVENANCE: Mme Seurat (mother of the artist), 1891;[1] Emile Seurat (brother of the artist); Mme Jeanne Aghion by 1900;[2] J. and G. Bernheim-Jeune, by 1904 until at least 1925; Alex Reid and Lefevre, London, by 1928; owned jointly by Alex Reid and Lefevre, and M. Knoedler and Co., New York, Jan. 1929–Dec. 1934;[3] Etienne Bignou, Dec. 1934; Alex Reid and Lefevre, London, in 1936; Mrs. A. Chester Beatty, London, May 1936; by inheritance to Sir Alfred Chester Beatty, Dublin, from 1952 to 1955; Paul Rosenberg and Co., New York, 1955; David and Peggy Rockefeller, 1955.

EXHIBITIONS: Paris, Maison Dorée, *VIII^e Exposition des peintres Impressionnistes*, May 15–June 15, 1886, no. 178; Paris, Tuileries, Baraquement B, *II^e Salon des artistes indépendants*, Aug. 21–Sept. 21, 1886, no. 355; Brussels, Musée d'Art Moderne, *IV^e Exposition des XX*, Feb. 1887, Seurat section, no. 3; Paris, Galerie de La Revue indépendante, Jan. 1888 (Fénéon, 1888); Brussels, Musée Moderne, *IX^e Exposition des XX, Seurat rétrospective*, Feb. 1892, no. 3; Paris, Pavillon de la Ville de Paris, *VIII^e Salon des artistes indépendants, Exposition commemorative Seurat*, Mar. 19–Apr. 27, 1892, no. 1092; Paris,

Galerie de La Revue Blanche, *Exposition posthume de Georges Seurat*, 1892;[4] Paris, Galerie de La Revue Blanche, *Georges Seurat: Oeuvres peintes et dessinés*, Mar. 19–Apr. 5, 1900, no. 18; Paris, Grand Palais, *Exposition centennale de l'art français de 1800 à 1889* (Exposition internationale universelle), Apr. 15–Oct. 1900, no. 610; Brussels, La Libre Esthétique, *Exposition des peintres Impressionnistes*, Feb. 25–Mar. 29, 1904, no. 144; Paris, Bernheim-Jeune, *Retrospective Georges Seurat*, Dec. 14, 1908–Jan. 9, 1909, no. 55; Paris, Bernheim-Jeune, *Georges Seurat*, Jan. 15–31, 1920, no. 20; Paris, Hôtel de la Curiosité et des Beaux-Arts, *L'Art français au service de la science: L'art des XVIII^e, XIX^e et XX^e siècles*, Apr. 25–May 15, 1923, no. 222;[5] Paris, Musée des Arts Décoratifs, *Cinquante Ans de peinture française, 1875–1925*, May 26–July 12, 1925, no. 72, repr.; Lucerne, *Peintures de l'école Impressionniste et Néo-Impressionniste*, Feb. 1929, no. 21; Glasgow, Lefevre Gallery, *Ten Masterpieces by Nineteenth Century French Painters*, Apr. 1929, no. 9, repr.; London, Alex Reid and Lefevre, *Ten Masterpieces by Nineteenth Century French Painters*, June–July 1929, no. 8, repr.; Providence, R.I., Museum of the Rhode Island School of Design, *Modern French Art*, Mar. 11–31, 1930, no. 37; Glasgow, Lefevre Gallery, *19th and 20th Century French Paintings*, 1930, no. 22; London, Royal Academy of Arts, *French Art, 1200–1900*, Jan. 4–Mar. 5, 1932, no. 553; *Commemorative Catalogue of the Exhibition of French Art, 1200–1900*, 1933, no. 506; London, Alex Reid and Lefevre, *French Paintings of the Nineteenth Century, Ingres to Cézanne*, June–July 1933, no. 40, repr.; Ottawa, National Gallery of Canada, *French Painting of the Nineteenth Century*, Jan. 1934, no. 104, repr., traveled to the Art Gallery of Toronto, Feb. 1934, and to the Art Association of Montreal, Mar. 1934; Glasgow, McClellan Galleries (organized by Alex Reid and Lefevre, London), *French Painting in the Nineteenth Century*, May 1934, no. 44; New York, The Museum of Modern Art, *Paintings from Private Collections: A 25th Anniversary Exhibition*, May 31–Sept. 5, 1955, no. 138 (repr. in "Paintings from Private Collections," *The Museum of Modern Art Bulletin*, vol. XXII, Summer 1955, p. 14); The Art Institute of Chicago, *Seurat, Paintings and Drawings*, Jan. 16–Mar. 7, 1958, no. 106, p. 85, traveled to New York, The Museum of Modern Art, Mar. 24–May 11, 1958; Cambridge, Mass., The Fogg Art Museum, Harvard University, *Works of Art from the Collections of the Harvard Class of 1936*, June 11–Aug. 25, 1961, no. 22, pl. VI; New York, The Metropolitan Museum of Art, *Summer Loan Exhibition*, July 12–Sept. 3, 1963; The Fine Arts Museums of San Francisco, *The New Painting: Impressionism 1874–1886*, Washington, D.C., January 16–April 6, 1986, pp. 438, 446, 465, no. 152; New York, The Metropolitan Museum of Art, *Seurat 1859–1891*, Sept. 9, 1991–Jan. 12, 1992, no. 160.

REFERENCES: O. Mirbeau, "Exposition de peinture," *La France*, May 20, 1886; J. Ajalbert, "Le Salon des Impressionnistes," *Revue moderne*, June 20, 1886, p. 393; O. Maus, "Les Vingtistes parisiennes," *L'Art moderne* (Brussels), June 27, 1886, p. 204; F. Fénéon, "L'Impressionnisme aux Tuileries," *L'Art moderne* (Brussels), Sept. 19, 1886, p. 301; F. Fénéon, "Calendrier de Décembre 1887," *La Revue indépendante*, Jan. 1888, p. 173; J. Meier-Graefe, *Entwicklungsgeschichte der modernen Kunst*, Stuttgart, 1904, vol. I, p. 232; J. and G. Bernheim-Jeune, eds., *L'Art moderne*, Paris, 1919, vol. II, pl. 150; R. Rey, *La Renaissance du sentiment classique dans la peinture française à la fin du XIX^e siècle*, Paris, 1921, pp. 131–32, 144–45; L. Cousturier, *Georges Seurat*, Paris, 1921, p. 18; G. Coquiot, *Seurat*, Paris, 1924, pp. 220, 246, repr. opp. p. 120; A. Salmon, "Cinquante Ans de peinture française," *L'Art vivant*, June 15, 1926, p. 3, repr. p. 20; *International Studio*, vol. XCIII, July 1929, repr. p. 63; *Apollo*, vol. X, July 1929, repr. opp. p. 61; C. Roger-Marx, *Seurat*, Paris, 1931, pp. 10–11; J. Rewald, *Seurat*, New York, 1943, fig. 61; 1946 ed., fig. 61; J. de Laprade, *Georges Seurat*, Monaco, 1945, repr. p. 32; 1951 ed., repr. p. 37; J. Rewald, *Seurat*, Paris, 1949, fig. 22; L. Venturi, *Impressionists and Symbolists*, New York, 1950, pp. 147–48, pl. 149; French ed., *De Manet à Lautrec*, Paris, 1953, p. 198, repr. p. 201; *Art News*, vol. LIV, Summer 1955, repr. p. 47; R. Herbert, "Seurat in Chicago and New York," *Burlington Magazine*, vol. C, May 1958, pp. 152, 155; R. Herbert, "Seurat and Emile Verhaeren: Unpublished Letters," *Gazette des Beaux-Arts*, vol. LIV, Dec. 1959, pp. 316, 318, 321; *Art News Annual*, no. 28, 1959, repr. p. 39; H. Dorra and J. Rewald, *Seurat*, Paris, 1959, no. 154, repr. p. 181; C. M. de Hauke, *Seurat et son oeuvre*, Paris, 1961, vol. I, p. 108, no. 160, repr. p. 109; J. Russell, *Seurat*, New York, 1965, p. 173, color pl. 163; P. Courthion, *Georges Seurat*, New York, 1968, p. 114, repr. in color, p. 115; *Tout l'oeuvre peint de Seurat*, intro. by A. Chastel, documentation by F. Minervino, Paris, 1973, no. 160, p. 104, repr. p. 103, color pl. XXIX; R. Thomson, *Seurat*, Salem, N.H., 1985, p. 96; J. U. Halperin, *Félix Fénéon: Aesthete and Anarchist in Fin-de-Siècle Paris*, New Haven, 1988, no. 7; J. Rewald, *Seurat: A Biography*, New York, 1990, p. 106; A. Madeleine-Perdrillat, *Seurat*, trans. J.-M. Clarke, New York, 1990, p. 83; M. Zimmermann, *Seurat and the Art Theory of His Time*, Antwerp, 1991, repr. no. 382, pp. 210, 285; R. Herbert, *Seurat: 1859–1891*, New York, 1991, pp. 238–39.

1. In April 1891, two months after Seurat's death, his family requested that his friends Fénéon, Signac, and Luce assist his brother Emile in making an inventory of the works remaining in his atelier. Prior to the inventory, dated May 3, 1891, Seurat's mistress, Madeleine Knobloch, made a list of works she wished to keep, including *La Rade de Grandcamp*. After the division was made, however, this work remained among those retained by the artist's family (cf. de Hauke, 1961, pp. XXIX–XXX; Knobloch list repr. p. XXVIII). Although Mme Seurat was listed as the lender to the Seurat retrospective at the Salon des Indépendants in 1892, ownership of the work by Fénéon in 1892 was cited in the catalogue of an exhibition at Alex Reid and Lefevre in June 1929, a provenance repeated in exhibition catalogues in the early 1930s and ultimately in the Dorra and Rewald catalogue raisonné, which contains several errors of provenance. In de Hauke's catalogue raisonné of 1961, however, Fénéon ownership is *not* listed, and as a decade of research (1926–36) by Fénéon, an early friend and lifelong advocate of Seurat, served as the basis of de Hauke's publication, it seems more likely that early ownership by the artist's family is correct. G. Bernheim de Villers, the owner by 1904, recorded in his memoirs: "I met him [Fénéon] at *La Revue Blanche* and he sold me two of Seurat's most important paintings, *La Parade* and the *Port of Grandville* [*sic*] for a thousand francs" (*Little Tales of Great Artists*, Paris and New York, 1949, p. 47); and Fénéon was probably the intermediary on the part of the family in selling Seurat's works. Too, Fénéon was employed by the Galerie Bernheim-Jeune from 1906 until 1924, and supposition of his ownership may have arisen from hearsay at the time the Bernheims sold the work to Alex Reid and Lefevre.

2. R. Rey (1921, pp. 131–32) recorded that this painting was among the fifty-six works sold at the large retrospective organized by Fénéon at *La Revue blanche* in 1900, but he does not list among the buyers the name of Mme Aghion, who is recorded as its owner in the catalogue of the *Exposition centennale*, which opened only a few weeks later. Fénéon, in an article correcting errors in recent Seurat literature, noted that ten paintings, ten *croquetons*, and fifty drawings were sold from that

exhibition (*Bulletin de la vie artistique*, vol. V, no. 16, Aug. 15, 1924, p. 360).

3. Knoedler records indicate that this work was acquired from Alex Reid and Lefevre along with others from the Bernheim-Jeune Collection in Jan. 1929, but the work remained in Europe for a series of exhibitions that year before coming briefly to America. It was returned to Europe and lent to several exhibitions in the early 1930s under the auspices of Alex Reid and Lefevre. According to Knoedler's records, title to the painting was transferred in Dec. 1934 to E. Bignou, who opened his own gallery in New York in 1935; a handwritten note in Knoedler's files indicates that he sold the painting to Mrs. A. Chester Beatty.

4. This reference first appeared in the catalogue of the exhibition at Alex Reid and Lefevre, London, 1929; it is included by Dorra and Rewald but not by de Hauke.

5. This reference first appeared in the catalogue of the exhibition at Alex Reid and Lefevre, London, 1933; it is included by Dorra and Rewald but not by de Hauke.

This was one of three paintings acquired from Mrs. A. Chester Beatty's collection.

There were two Seurats available for purchase at the time; the other one was bought by John Hay Whitney. We probably chose this one because it has sailboats in it and we love to sail. Seurat did so few paintings of this size that we were very lucky to have been able to acquire it. This painting was our introduction to the pointillist style and led to the acquisition of other paintings in a similar mode. D.R.

∾ Paul Signac. French, 1863–1935
Opus 217. Against the Enamel of a Background Rhythmic with Beats and Angles, Tones, and Tints, Portrait of M. Félix Fénéon in 1890 (*Opus 217. Sur l'émail d'un fond rhythmique de mesures et d'angles, de tons et de teintes, portrait de M. Félix Fénéon en 1890*). 1890

Oil on canvas, 29 x 36½ in. (73.5 x 92.5 cm.). Signed and dated lower right: *P. Signac 90*; inscribed lower left: *Op. 217*. The Museum of Modern Art, New York. Fractional gift of David and Peggy Rockefeller (the donors retaining a life interest in the remainder).

The subject of this portrait, Félix Fénéon (1861–1944), began a distinguished career as a partisan of contemporary art and literature by contributing brief reviews in a concise and evocative style to several of the short-lived periodicals devoted to the arts that proliferated in Paris in the 1880s. At that time he held a clerical post in the Ministry of War, a position he subsequently lost as a result of an ardent and lifelong commitment to anarchism, a movement that sought to replace organized government with decentralized and nonhierarchical communities (see R. D. Sonn, *Anarchism and Cultural Politics in Fin de Siècle France*, Lincoln, Nebraska, 1989). Accused of setting off a bomb in 1894, he was imprisoned for several months that year but not actually convicted. Although never proven, it is generally accepted that Fénéon did indeed fabricate a small bomb, detonating it at the luxurious restaurant in the Foyot Hotel in the Latin Quarter (J. Halperin, 1988, pp. 3–5, 267–95). This incident was only one in a wave of anarchist bombings in France in the years 1892–94. Many members of Paris's art and literary community besides Fénéon, including Gustave Kahn, Emile Verhaeren, and Georges Lecomte, came to anarchism from a radicalized liberalism (M. Zimmermann, 1991, p. 446). Upon his acquittal, Fénéon became involved with the most important avant-garde periodical of the time, *La Revue blanche*, and was instrumental in publishing there the work of the major Symbolist writers as well as sponsoring on the magazine's premises exhibitions of young artists. Fénéon began his tenure at the journal doing editorial work and soon became literary counselor and editorial secretary, remaining at *La Revue blanche* until 1903.

Contemporary viewers, many of whom knew both artist and subject, were startled and disconcerted when this painting was first exhibited at the Salon des Indépendants in the spring of 1891. Camille Pissarro wrote to his son Lucien of this "bizarre portrait of Fénéon, standing, holding a lily, against a background of interlacing ribbons of color which

are neither decorative nor comprehensible in terms of feeling, and do not even give the work decorative beauty" (letter of Mar. 30, 1891, quoted by M.-T. Lemoyne de Forges in exh. cat., Paris, 1963–64, p. 42). Reviewing the exhibition, the critic Gustave Geffroy dryly commented, "My taste for explication stops short in front of the painting labeled 'Sur l'émail . . . portrait de M. Félix Fénéon en 1890'" (Apr. 10, 1891); and the Belgian poet Emile Verhaeren wrote: "This cold and dry portrait can hardly please us as much as the landscapes by the same painter" (Apr. 5, 1891).

One critic, perhaps alerted by Signac or Fénéon, displayed greater insight into the meaning of the work. Arsène Alexandre noted: "M. Signac, who is very fervent and bold, has portrayed a model against a synthetic background of curves and associated tones, in which one must see, not the simple caprice of a colorist, but an experimental demonstration of the theories on color and line which will soon be published in a work by the artist in collaboration with M. Charles Henry" (Mar. 20, 1891; cited in exh. cat., Paris, 1963–64, pp. 42–43). The painting is, in fact, a pictorial illustration of current aesthetic ideas that had preoccupied both artist and subject and, in its programmatic character, it reflects both Neo-Impressionist theory and Symbolist thought.

Intuitively responsive to new currents in art and literature, Fénéon had by 1890 acted for several years as a perceptive interpreter of the fledgling Neo-Impressionist group. He had met both Georges Seurat (see his *Roadstead at Grandcamp*, p. 37) and Signac on the occasion of the eighth and last exhibition of the Impressionists in 1886, at which time he published a careful account of their stylistic innovations in a pamphlet entitled *The Impressionists in 1886*. In the following years, a series of essays in several art journals indicate his continuing sympathy for the visual and theoretical aspects of the new movement, for which he coined the term "Neo-Impressionism" to distinguish Seurat and his associates from the older generation of Impressionists. Fénéon also paid serious attention to the ideas and numerous publications of a contemporary aesthetician and experimental psychologist, Charles Henry, whose theories about the formal components of painting and its analogies with music intrigued and influenced many avant-garde writers and artists, among them Seurat and Signac. In 1889 Fénéon published an account of these theories, in which Henry had proposed mathematical formulas in an effort to relate internal sensations to external phenomena, with the ultimate goal of "the esthetic rectification of all forms," leading to the betterment of the human condition ("Une esthétique scientifique," *La Cravache*, May 18, 1889; reprinted in J. U. Halperin, 1970, vol. I, pp. 145–48). Central to Henry's preoccupations was the conviction that colors, lines, and directions, and their combinations, have specific expressive connotations and that adherence to rules rather than instinctive response to nature would produce a more noble and harmonious art. In a recent article Robyn Roslak described the politics of such aesthetic theories, specifically the links between Neo-Impressionism and anarchism, both of which share "faith in science as the foundation for their respective aesthetic and social systems" ("The Politics of Aesthetic Harmony: Neo-Impressionism, Science, and Anarchism," *The Art Bulletin*, vol. LXXIII, no. 3, Sept. 1991, pp. 381–90; pl. 384). Roslak argues that "artists and anarchists appropriated a common vocabulary from the laws and processes of chemical science and philosophy," and both believed that the deployment of such theories would naturally lead to "moral and social harmony" (pp. 383, 389).

Signac, too, had been attracted by Henry's social idealism as well as by the potential guidance of an aesthetic rationale. Beginning in 1888 he collaborated closely with Henry by providing charts and diagrams to illustrate his publications and lectures. Of one such collaborative venture in 1888 with the portentous title *Aesthetic Table with a Notice on its Application to Industrial Art, to the History of Art, to the Interpretation of the Graphic Method and in General to the Study and Aesthetic Rectification of All Forms*, he wrote to Vincent van Gogh in April 1889 that it was "a book on the esthetic of forms with an instrument—the esthetic table by

C. Henry—that permits the study of measures and angles. One can thus see whether a form is harmonious or not. This will have a great social importance, especially from the point of view of industrial art. We teach the workers, apprentices, etc., whose esthetic education until now has been based on empirical formulas or dishonest or stupid advice, how to see correctly and well" (quoted by J. Rewald, 1962, p. 139).

This activity reached a climax in 1890 with the appearance of a major summary of Henry's ideas, for which the artist had taken numerous measurements and prepared the plates, *Application of New Instruments of Precision (Chromatic Circle, Aesthetic Table and Aesthetic Treble-Decimeter) to Archaeology.* That spring Signac drew charts and a poster for a lecture Henry gave to a group of furniture workers of the Saint-Antoine district (published in 1891 as "Harmonie de formes et de couleurs" (cf. R. Herbert, "Artists and Anarchism," *Burlington Magazine*, vol. CII, Nov. 1960, p. 481, n. 48); and yet another collaborative work, *L'Education du sens des formes*, was announced by Fénéon in the short monograph on Signac he published in June 1890 in the series *Les Hommes d'aujourd'hui*.

It was in this context of active collaboration and mutual consultation among Signac, Fénéon, and Henry that the conception for this portrait emerged early in the summer of 1890. The artist's granddaughter, the art historian Françoise Cachin, has published the correspondence of June and July of that year in which Signac and Fénéon continued a verbal discussion of the project, and it is difficult to miss the note of high-spirited mockery with which the two men developed the scheme. Fénéon announced his willingness to be Signac's "accomplice" and asked whether the pose, the costume, and the setting had been determined. Signac replied that he was eager to proceed with a portrait he conceived as "not at all banal, but very composed, very arranged in line and color. A pose both angular and rhythmic. A decorative Félix entering with hat or flower in hand on a tall and very narrow canvas. A studied (*voulu*) background with two complementary tints and harmonizing costume; let's seek together and we shall find." Besides assuring Fénéon that the time needed for a portrait sitting would be minimal, Signac asked for suggestions from his subject and promised that posing would be limited to the time required to make a panel and a drawing. Fénéon's reply, "I will express only one opinion: effigy absolutely full-face," was, ironically, ignored. And despite these early protests against a portrait in profile, later painters including Toulouse-Lautrec, Vuillard, Vallotton, and van Dongen all chose to present him in a side view (Halperin, 1988, p. 144). A pencil drawing of Fénéon in profile is believed to be a preparatory sketch for the painting (F. Cachin, 1969, pp. 90–91, with repr. of drawing).

Signac's first idea of a tall and very narrow format, which would have echoed Fénéon's own figure, apparently changed when he found a decorative motif which would permit him to develop fully his desire for a "studied" background. Cachin has identified the source of the pinwheel design in the background as a Japanese woodcut of a decorative pattern, perhaps for a kimono, in a scrapbook of Japanese prints once in Signac's studio (1969 and 1971, repr.; Zimmermann, 1991, p. 298, no. 441). As Joan Halperin, a biographer of Fénéon, has noted, this reference to Japanese design is particulary appropriate for the subject, who, besides being dubbed "Utagawafénéon," had a long-standing interest in Japanese prints (1988, p. 144). In place of the traditional Japanese motifs in the spokes of the pinwheel, Signac substituted motifs inspired by the theoretical propositions of Charles Henry, which both he and Fénéon had been deeply engaged to explain and demonstrate. Signac apparently did not reveal the source of the startling background motif, thus leading to widespread mystification on the part of his contemporaries.

The contrived representation of the figure—designed to be "angular and rhythmic"—also misled viewers, for the stiffness of pose and gesture, and even the jut of the goatee in the figure of Fénéon, a laconic man of ironic wit as well as something of a dandy, corresponded to a contemporary notion that he possessed the attributes of a "Yankee" in both physical appearance and character traits. In 1894 a journalist described him as being "quite original in aspect, very tall, dry, and bony; he affected the appearance of a Yankee, and his face, clean-shaven except for a long goatee, his unusual and angular gestures, his slow and emphatic manner of speaking, bore out this resemblance very exactly" (*Le Soir*, Apr. 27, 1894; quoted by Halperin, 1970, vol. I, p. XXXI). Terms such as "Yankee Mephisto" and "veritable Uncle Sam of irony" appear in contemporary references to Fénéon (F. Hermann, 1959, vol. I, p. 79 and n. 23), and similar observations were made by several critics when the portrait was shown at the Salon des Indépendants in 1891. Verhaeren wrote: "The portrayal of the subject, against a multicolored background of segments adorned with stars, disks, crescents, and arabesques, makes his yankeeism even stiffer, but the flower he holds in his hand to offer to some imaginary woman reveals in contrast his qualities of grace and smiling politeness" (Apr. 5, 1891, cited in exh. cat., Paris, 1963–64, p. 42). Fénéon's colleague as an editor and critic, Georges Lecomte, also related the pose to Fénéon's character: "M. Paul Signac has painted the slenderness and the lofty gestures of the subtle stylist Félix Fénéon. The dual nature of his personality is clearly rendered: a yankee rigidity which unbends and becomes gracious. The lines of the background curve in order to engage in their volutes and render more haughty still the carriage of the head, and the goatee curves and the gesture is rounded as if to associate themselves with the system of curves. The physiognomy lives without suffering from the prominence of these impeccable harmonies" (Apr. 4, 1891).

The image that contemporaries associated with Fénéon's appearance may have stemmed from the portrayal of the title role in the long-running play *L'Oncle Sam* by Victorien Sardou, the most popular playwright of the period. The play first appeared at the Théâtre Français in 1879. Another contemporary wrote that Fénéon's manner was reminiscent of American reporters then seen in plays at the Théâtre du Chatelet: "those whose magnificent coolness manifests itself in all circumstances and in all countries in proportion to the obstacles to be met, who foil traps and plots hatched by their adversaries and end up in triumph" (Hermann, 1959, vol. I, p. 79 and n. 22). While all of these suggestions may provide clues to Signac's intentions for this work, it must be acknowledged that a full and convincing account of its visual and symbolic content remains to be written.

The elaborate title of the painting, probably the invention of Fénéon, echoes the terminology of his article on Henry of 1889, in which he attempted to define the terms "measure," "rhythm," "angle," "tint," and "tone" as understood by the scientist. ("La mesure ne diffère du rhythme que par la nature spécial des représentations. Au lieu d'avoir pour élément un angle, nous avons pour élément un segment de droite. Les définitions s'appliquent aux couleurs comme aux formes. Le rhythme concernera les tints, et la mesure les tons." From "Une esthétique scientifique," *La Cravache*, May 18, 1889; reprinted in J. U. Halperin, 1970, vol. I, pp. 145–48). Halperin, however, read the title as much more of a "tongue-in-cheek" invention of the painter himself. "The inordinately long title Signac gave the painting," she wrote, "shows that he meant it to be both a significant portrait and a joyous spoof" (1988, pp. 144–45). Nonetheless, the choice of words strongly reflects Henry's theories and ideas, specifically the scientist's investigations of the synthesis of sound, music, motion, lines, light, and color (1988, p. 143). Halperin continued, "The title quotes Henry's own terms ["mesures" and "angles," for example] and specifies the year as if to commemorate the time when the scientist, the critic, and the painter all collaborated in the research and illustration of works such as Henry's *Education du sens des formes*" (1988, p. 145). In a practice begun in 1887, Signac gave his paintings opus numbers as if they were pieces of music, melding the visual and the aural. The use of opus numbers also reflects Signac's connection with Symbolism, which had as a central component the linkage of music to the other arts. The word "enamel" may stem from the rarefied vocabulary of Fénéon, who used the term "tin-luster enamel" as an analogy for the color in one

of Signac's marines exhibited at the Salon des Indépendants in 1889 (review reprinted in Halperin, 1970, vol. I, p. 165).

Although the association of this work with the thought of Charles Henry has been noted by many scholars, the relationship of the pose and individual motifs to his ideas was first systematically explored by José Argüellas (1969, pp. 49–53, and 1972, pp. 131–42). He found the key to the portrayal of Fénéon in a statement in Henry's publication of 1885, *Introduction à une esthétique scientifique*: "Each figure being an ensemble of changes of directions, we now possess a theory of agreeable directions, of rhythms and measures; thus we can evidently trace agreeable figures" (1972, p. 93). Unaware of the Japanese source for the pinwheel motif, he supposed it to be an invention by Signac to illustrate Henry's concept of "continual autogenesis" or cycle of self-renewing energy (1972, pp. 131–42); and this esoteric concept may, indeed, have prompted Signac's choice of the background motif and the echoing shape of the cyclamen. Halperin agreed with Argüellas that Signac and Fénéon's selection of this particular flower is meant as a reference to Henry's ideas. Instead of simply painting an orchid, which would have alluded to "decadent refinement," Signac's cyclamen, "coming from the Greek word for circle, is redolent of Henry's *Cercle chromatique*, and of his theory of lines as *directions* (cycles, not circles)" (1988, p. 146). Argüellas also pointed out that the juxtaposition of complementary colors—red-green, orange-blue, yellow-violet—in each band of the background corresponded to Henry's and Neo-Impressionist theories, and he traced the origin of the "planetary, astral, and organic forms" to the cosmic implications of Henry's thought. More recently, Halperin has explained that the "harmonic" angles of the pinwheel background also illustrate Henry's theories. Signac "altered the proportions of the Japanese pattern so that the segments formed a variety of angles closer to the rhythmic angles prescribed by Henry" (1988, p. 145). Echoing the decorative background's shapes and angles are Fénéon's arms, one of which holds out a flower while the other grasps a hat, cane (most probably a gift to Fénéon from Signac), and glove. Measurement reveals that only the extended arm with the cyclamen is poised at a harmonic angle.

It has also been suggested that the stars, the astral globes, and the flower in Fénéon's hand might constitute a satirical reference to the interest in occultism and mystical religions common to the Nabis and the Symbolists (R. Herbert, in exh. cat., New York, 1968, pp. 140–41); Robert Herbert tentatively proposed that the flower might be a "decadent lily" and the gesture a reference to the English Esthetic Movement and one of its primary members, Fénéon's friend Oscar Wilde, who never left his house without a carnation dyed green (Halperin, 1988, p. 146). Several scholars have supposed that the band of yellow stars on a blue field directly behind the subject might refer to the American flag and thus to Fénéon's identification with "Uncle Sam" (exh. cat., Paris, 1963–64, p. 43; Herbert, exh. cat., 1968, p. 140; Cachin, 1969, p. 90; see discussion below). It may also be noted, however, that the representation of a star was one of the many pseudonyms adopted by Fénéon at this time. In the cabalistic writings to which he frequently referred, the star symbolizes "man"; and this sign, or simply the word *homme*, often served as Fénéon's signature, particularly in the anarchist journals to which he contributed anonymously while still an employee of the War Ministry (cf. Halperin, 1970, vol. I, p. XXXIII, and 1988, p. 17). Cachin has noted that the upper-left segment of the pinwheel contains an arabesque pattern similar to those with which Gauguin adorned the beaches in his Tahitian paintings; both Signac's and Gauguin's decorative patterns may derive from Japanese sources (1969, p. 90). The motif of undulating bands at the center left may have originated simply as a repetition of the profile of the base of the adjacent cyclamen flower, a repetition which expands outward in contrasting angles and curves and in the complementaries of red and green in a comically literal application of several of Henry's cherished ideas. (Signac's most recent collaboration with Henry had required the measurement of the profiles of numerous Greek vases,

and he must have been keenly aware of the aesthetic and moral significance Henry found in their profiles.)

Signac and Fénéon's youthful high spirits (they were respectively twenty-seven and twenty-nine years old) determined this painting's outcome. Signac never repeated this experiment in visual parody, and Fénéon, perhaps in recognition of its prankish conception, referred to his portrait many years later as "the least happy work ever painted by Signac; in 1890 he did not yet know me well enough" (unpublished letter to J. Paulhan, cited by Halperin, 1970, vol. I, fig. 1).

Both men would seem to have grown impatient with the highly theoretical aspects of Henry's treatises and their fervent espousal by Seurat. Signac's last collaboration with Henry, in 1890, would ultimately appear in *La Revue blanche* in 1894–95 as *Esthétique des formes*, and the painter also soon dropped the practice of assigning opus numbers to his works. Fénéon's and Signac's understandings of the history and development of Neo-Impressionism also began to diverge. Signac, in his major study of Neo-Impressionism published in 1899, traced the origin of the style to Eugène Delacroix rather than Seurat. (This text is translated into English in its entirety in F. Ratliff, 1992, and, despite giving precedence to Delacroix, is dedicated "to the memory of Georges Seurat, Henri-Edmond Cross and in the cause of color.") Writing a different historical narrative of the movement, Fénéon's brochure on Signac, published in June 1890, displayed a portrait of Signac by Seurat as a cover illustration but did not mention the latter's name in the analysis of Neo-Impressionist practice, an oversight that drew a letter of protest from Seurat.[1] Halperin noted that by 1888 Fénéon "had become so touchy over his 'paternity rights' to Neo-Impressionism that he quarreled with even his old comrade Signac on the subject." Nevertheless, Fénéon and Signac collaborated in promoting recognition of Seurat after his early death in 1891 and continued to express respect for the fertility of Henry's ideas. In 1900 Fénéon organized on the premises of *La Revue blanche* the first major retrospective of Seurat, in which *The Roadstead at Grandcamp* (p. 37) was shown, as well as several later exhibitions of the artist's work. The last years of Fénéon's life were devoted to assembling the massive documentation for a catalogue raisonné of Seurat's oeuvre, which was ultimately published by César de Hauke.

Many paintings and drawings portraying Fénéon testify to his active participation in the artistic life of his time, among them works by Toulouse-Lautrec, Luce, van Dongen, Bonnard, Vuillard, and van Rysselberghe (several are reproduced in Rewald, 1947, and Halperin, 1988). When *La Revue blanche* ceased publication in 1903, Fénéon first worked as a journalist for *Le Figaro* and *Le Matin* and then joined the Galerie Bernheim-Jeune in 1906. As director of contemporary art until his retirement in 1924, he continued to support the artists he admired, among them Matisse, whose *Interior with Girl Reading* (see p. 55) was for many years in his personal collection, along with numerous other paintings and drawings by his friends. On two occasions Fénéon attempted to dispose of his collection according to his political convictions: at the outbreak of the Russian Revolution in 1917 he made a will bequeathing his collection to the Russian people, a document he destroyed after the suppression and massacre of anarchists in Russia. Seriously ill in 1943, he made a further attempt to bequeath his collection to a museum in Moscow but was frustrated by the exigencies of war. After his death in 1944, Fénéon's widow was unsuccessful in persuading the Louvre to accept the works on her conditions, and the collection was dispersed after her death in several auctions whose proceeds, administered by the Sorbonne, sponsor an annual prize for young artists and writers (cf. Halperin, 1970, vol. I, pp. XXVI, XXLX, XXX).

PROVENANCE: Félix Fénéon, Paris; Mme Félix Fénéon, Paris; Emil Bührle, Zurich; Private collection, Paris, 1951, 1954; Joshua Logan, New York; sale, London, Sotheby, July 1, 1964, no. 80, repr. in color; Samuel Josefowitz, Geneva; sale, New York, Parke Bernet, Nov. 20, 1968, no. 52, repr. in color; David and Peggy Rockefeller, 1968, fractional gift to The Museum of Modern Art, New York (the donors retaining a life interest in the remainder).

EXHIBITIONS: Paris, *Septième Exposition des artistes indépendants*, Mar. 20–Apr. 27, 1891, no. 1107; Brussels, *Neuvième Exposition annuelle des XX*, Feb. 1892, Signac section, no. 1; Paris, Petit Palais, *Paul Signac*, Feb.–Mar. 1934, no. 11; Paris, Musée National d'Art Moderne, *Paul Signac*, Oct. 25–Dec. 2, 1951, no. 15; London, Marlborough Fine Art, Ltd., *Paul Signac*, Mar. 11–Apr. 15, 1954, no. 13, repr. p. 18; London, Marlborough Fine Art, Ltd., *XIXth and XXth Century European Masters*, June–July 1958, no. 63, repr. in color. p. 67; Paris, Musée National d'Art Moderne, *Les Sources du XXᵉ siècle*, Nov. 4, 1960–Jan. 23, 1961, no. 673; Paris, Musée du Louvre, *Paul Signac*, Dec. 1963–Feb. 1964, no. 37, pp. 42–44, repr.; New York, The Solomon R. Guggenheim Museum, *Neo-Impressionism*, Feb. 9–Apr. 7, 1968, no. 98, pp. 140–41, repr.; New York, The Museum of Modern Art, collections galleries, Nov. 22, 1972–Feb. 28, 1974; Pittsburgh, Carnegie Institute Museum of Art, *Celebration*, Oct. 25, 1974–Jan. 5, 1975; London, Royal Academy of Arts, *Post-Impressionism: Cross-Currents in European Painting*, 1979–80, pp. 138–39, no. 211, repr.; revised exh. in Washington, D.C., National Gallery of Art, *Post-Impressionism: Crosscurrents in European and American Painting*, May 25–Sept. 1, 1980, no. 108, repr.; New York, The Museum of Modern Art, reopening installation of the museum collection, May 6, 1984–Jan. 6, 1985; Tokyo, The National Museum of Western Art, *Exposition du Pointillisme*, April 26–May 1985, to Japan, Kyoto Municipal Museum of Art, June 4–July 14, 1985, no. 12.

REFERENCES:[2] A. Alexandre, "Le Salon des Indépendants," *Paris*, Mar. 20, 1891;* H. Gauthier-Villars, "Artistes Indépendants: Stenographie par Willy," *Le Chat noir*, Mar. 21, 1891 (reprinted in Halperin, 1970, vol. I, pp. 181–82); A. Germain, *Moniteur des arts*, Mar. 27, 1891;* G. Lecomte, "Artistes Indépendants," *L'Art dans les deux mondes*, Apr. 4, 1891, p. 234; E. Verhaeren, *L'Art moderne* (Brussels), Apr. 5, 1891;* G. Geffroy, article of Apr. 10, 1891 (reprinted in *La Vie artistique*, 1892); J. Christophe, *Journal des artistes*, Apr. 12, 1891, p. 100;* H. Gauthier-Villars, *La Revue indépendante*, Apr. 1891, pp. 109–10;* J. Antoine, *La Plume*, May 1, 1891, p. 157;* J. Leclercq, *Mercure de France*, May 1891, p. 298;* R. Sertat, *Revue encyclopédique*, 1891, p. 365;* P.-M. Olin, *Mercure de France*, Apr. 1892;* A. de la Rochefoucauld, *Le Coeur*, May 1893;* G. Moore, *Modern Painting*, London, 1893; 1912 ed., pp. 94–95; M. O. Maus, *Trente Années de lutte pour l'art, 1884–1914*, Brussels, 1926, p. 133; J. Ajalbert, *Mémoires en vrac*, Paris, 1938, repr. p. 113; J. Rewald, ed., *Camille Pissarro: Letters to His Son Lucien*, New York, 1943, letter of Mar. 30, 1891, p. 156; French ed., Paris, 1950, p. 222; M. Saint-Clair [Mme T. van Rysselberghe], *Galerie privée*, Paris, 1947, pp. 75–76; J. Rewald, "Félix Fénéon. I," *Gazette des Beaux-Arts*, vol. XXXII, July–Aug. 1947, p. 49, fig. 3; J. Rewald, *Seurat*, Paris, 1948, p. 79, pl. 55; G. Cachin-Signac, "Autour de la correspondance de Signac," *Arts* (Paris), Sept. 7, 1951, p. 8, repr. p. 1; G. Besson, *Paul Signac*, Paris, 1954, pl. 45; F. Hermann, *Die Revue blanche und die Nabis*, Munich, 1959, vol. II, pl. 62; J. Rewald, *Post-Impressionism from van Gogh to Gauguin*, 2nd ed., New York, 1962, pp. 99–100, 139–40, 160, repr. p. 140; "L'Exposition Paul Signac au Musée du Louvre," *Revue du Louvre*, vol. XIII, June 1963, pp. 251–52, fig. 4, p. 249; J.-F. Revel, "Charles Henry et la science des arts," *L'Oeil*, no. 119, Nov. 1964, pp. 20–27, 44, 58, repr. in color, p. 20; M. Kozloff, "Neo-Impressionism and the Dream of Analysis," *Artforum*, vol. VI, Apr. 1968, p. 44; J. Argüellas, "Paul Signac's *Against the Enamel of a Background Rhythmic with Beats and Angles, Tones and Colors, Portrait of M. Félix Fénéon in 1890, Opus 217*," *Journal of Aesthetics and Art Criticism*, vol. XXVIII, Fall 1969, pp. 49–53, repr. p. 50; reprinted in J. Argüellas, *Charles Henry and the Formation of a Psychophysical Aesthetic*, Chicago, 1972, chap. 7 and *passim*, repr. in color as frontis.; F. Cachin, "Le Portrait de Fénéon par Signac: Une Source inédite," *Revue de l'art*, vol. VI, 1969, pp. 90–91, repr. p. 91; J. U. Halperin, ed., *Félix Fénéon: Les Oeuvres plus que complètes*, Geneva, 1970, Vol. I, pl. I; J. Sutter, *Les Néo-Impressionistes*, Neuchâtel, 1970, p. 50, repr. in color, p. 53; F. Cachin, *Paul Signac*, Paris, 1971, pp. 44–46, repr. in color, p. 49; English ed., New York, 1971, pp. 48–51, pl. 39, color; J. U. Halperin, *Félix Fénéon and the Language of Art Criticism*, Ann Arbor, 1980 [from Ph. D. diss. 1967], p. 47, frontispiece; G. Bernier, *La Revue Blanche: Paris in the Days of Post-Impressionism and Symbolism*, New York [Wildenstein Gallery cat.], 1983, pp. 30–31; J.-P. Bouillon, *Art Nouveau 1870–1914*, New York, 1985, pp. 38–39, repr. p. 38; *Exposition du pointillism*, Tokyo, 1985, pp. 31 –32, no. 12; J. C. Welchman, "Image and Language: Syllables and Charisma," in H. Singerman, ed., *Individuals: A Selected History of Contemporary Art, 1945–1986*, New York and Los Angeles, 1986, p. 264; D. Kelder, *The Great Book of Post-Impressionism*, New York, 1986, p. 92, no. 84; J. U. Halperin, *Félix Fénéon: Aesthete and Anarchist in Fin-de-Siècle Paris*, New Haven, 1988, pp. 143–49, pl. 16; J. Rewald, *Seurat: A Biography*, New York, 1990, p. 110; G. Bernier, *La Revue Blanche: Ses Amis, ses artistes*, Paris, 1991, pp. 129–30, repr. pp. 126–27; M. Zimmermann, *Seurat and Art Theory of His Time*, Antwerp, 1991, pp. 287–98, no. 440; F. Ratliff, *Paul Signac and Color in Neo-Impressionism*, New York, 1992, pp. 13–15, repr. p. 14; B. Denvir, *Post-Impressionism*, London, 1992, no. 114.

1. In correspondence with Signac prior to its publication, Fénéon expressed concern that his analysis should satisfy both Seurat and Henry, remarking of the latter's terminology that one had to think in terms of the studio rather than the laboratory. Signac advised him not to worry about criticism from Henry; and with Signac's approval Fénéon published as a tailpiece to the pamphlet a mysterious round blot, which he described privately as "this so seductive work produced by the collaboration between Henry and the bottom of a casserole" (Sorbonne thesis, 1968, by F. Cachin, cited by Halperin, 1970, vol. I, p. 174, n. 1).

2. It has not been possible to check all of the early references; those marked with an asterisk were taken from the carefully documented catalogue by M.-T. Lemoyne de Forges for the Paris exhibition of 1963–64.

This painting was brought to our attention by William Rubin. It came up at auction at Parke Bernet, and we asked Eugene Thaw to acquire it for us. It is certainly one of the most unusual pointillist paintings that we own. The background, with great swirls of color, is almost suggestive of more contemporary Pop Art. The subject, Félix Fénéon, was an art critic and contemporary of the pointillists. He is said to have given the name Neo-Impressionism to their school of painting. Our painting has been very much in demand for various exhibitions, so it has been away almost as much as we have had it.

D.R.

❧ Paul Gauguin. French
(died Atuana, Hiva-oa, Marquesas Islands), 1848–1903
The Wave (La Vague). 1888

Oil on unprimed canvas, 23¾ x 28¾ in. (60 x 73 cm.). Dated and signed lower left: *88. P. Gauguin*. David and Peggy Rockefeller Collection.

This work was probably painted in August of 1888, while Gauguin was staying at Mlle Gloanec's inn, a popular haven for artists at Pont-Aven in Brittany. Gauguin's style was undergoing a transformation at this time as he began to synthesize sources drawn from both art and nature. This new approach culminated in his first great imaginative work, *The Vision after the Sermon—Jacob Wrestling with the Angel* (National Gallery of Scotland, Edinburgh; G. Wildenstein and R. Cogniat, 1964, no. 245; R. Brettell et al., 1988, no. 50), dating from August to September of that year. The use of color to evoke a realm beyond the natural, a technique seen in the red ground of *The Vision*, is echoed here by the bright orange-red of the beach (F. Cachin, 1988, p. 66).

In spite of the beach's fantastic color, the composition derives from observation of an actual site near Le Pouldu, a seaside village some eight miles by water from Pont-Aven, where Gauguin would later stay and work for several months in 1889 (July to August) and from October 1889 to February 1890 (see the *Portrait of Jacob Meyer de Haan*, p. 43). As Wayne Andersen has demonstrated, the motif of the two larger rocks is based on two boulders covered with glossy black lichen that rise from the sea some fifty yards off the Plage de Porguerrac near Le Pouldu (1970, p. 619, with photograph of the site, fig. 72). Douglas Cooper has learned that only at low tide could Gauguin reach the grass-covered spur of rock from which this view was observed (correspondence with the author, 1980). Françoise Cachin described these rocks as "natural towers" that have been stylized in a Japanese manner and compared Gauguin's depiction of these monuments of nature to similar formations in the painting *Life and Death* (Mahmoud Khalil Museum, Cairo, Wildenstein and Cogniat, no. 335; Brettell, 1988, no. 79) and an engraving called *At the Black Rocks* (Cachin, 1988, p. 66; E. Mongan et al., *Paul Gauguin: Catalogue Raisonné of His Prints*, Bern, 1988, no. 52). He probably made drawings or watercolor sketches on the spot for later use at Pont-Aven, as it seems unlikely that the Impressionist practice of painting landscapes solely out-of-doors lingered with him at this transitional period. Merete Bodelsen, however, noted that only a camera could render the rocks and curved coastline in the same perspective as they appear in the painting and has suggested that Gauguin, in addition to visiting the site, may have had a photograph of it (correspondence with the author, 1974).

Gauguin was perhaps drawn to the dramatic perspective of this view by his admiration for Japanese prints. Yvonne Thirion (1956, pp. 105–6) was the first to point out that the plunging perspective and diagonal axis of the composition in this work have affinities with Japanese prints, an influence Gauguin acknowledged in a letter to Emile Schuffenecker of July 8, 1888 (M. Malingue, ed., *Lettres de Gauguin à sa femme et à ses amis*, Paris, 1946, no. 66). She also cited Japanese precedents for single motifs: Hiroshige's triptych *Whirlpools* for the curvilinear eddies in the water and Hokusai's *Mangwa* for the fringelike waves; she found the tiny figures emerging from the water at the upper right also reminiscent of Hokusai. Bernard Dorival (1960, p. 89) also cited *Whirlpools* as a direct inspiration for this work, while Bodelsen (1964, pp. 178 ff.) made a more general comparison of the ornamental treatment of the waves with Japanese decorative arts, in which Hokusai's linear conventions have many precedents. In addition to compositional similarities between Gauguin's painting and Japanese art, the title of the work is borrowed from the famous Hokusai print *The Wave*, from the series "36 Views of Fujiyama."[1] Appropriately, Jules Chavasse, who purchased this work at Gauguin's first public auction, held in February 1891 to finance his first trip to Tahiti, was a noted collector of Japanese prints. This was not the only painting in which Gauguin presented a plunging perspective.

Cachin compared the sharp downward view in *The Wave* to that of *Seascape with Cow on the Edge of a Cliff*, 1888 (Wildenstein and Cogniat no. 282; Brettell, 1988, no. 53; Cachin, 1988, pp. 68–69, no. 69).

John Rewald (1973) has published Gauguin's inventory of works on consignment in 1890 to Boussod et Valadon, the art-dealing firm through which Vincent van Gogh's brother Theo tried to sell Gauguin's works. This work appears on that list as *Marine avec plage et petite baigneuse* (identification by D. Cooper for his revision of the Gauguin catalogue raisonné; correspondence with the author, 1979). In the catalogue of his 1891 auction, Gauguin titled this picture *La Vague (arc-en-ciel)*; the identification of this work with the 1891 sale, not previously noted, has been accepted by Bodelsen and Cooper. The significance of the parenthetical term *arc-en-ciel* (rainbow) is a matter of speculation, for no rainbow is visible. The light-reflecting tones of the water—pink, green, and blue—washing against the arc of the shore may have suggested it to him as a handy descriptive phrase.

The introduction of vivid tones in this and other works of 1888 has been convincingly explained by Bodelsen as an outcome of Gauguin's experiments with stoneware glazes during the preceding winter in Paris (1964, p. 164). She believes that close observation of the modulations of brilliant color and the mingling of tones as his glazed pots were fired led Gauguin to attempt similar glowing color effects in his subsequent paintings.

PROVENANCE: On consignment with Boussod et Valadon (Theo van Gogh), Paris, 1888–90; unsold, returned to Gauguin; sale, Paris, Hôtel Drouot, Feb. 23, 1891, no. 28 (240 francs; cf. "procès verbal" reprinted in *Gauguin Centenaire*, exh. cat., Musée de l'Orangerie, Paris, Summer 1949, p. 96); Jules Chavasse, Paris, by 1900 (stock no. 3376); Galerie Druet, Paris, by 1908 (label on reverse with title *Plage rouge*); Alden Brooks, Paris; Mrs. Filippa Brooks Veren, Big Sur, Calif.; sale, New York, Parke Bernet, May 19, 1966, no. 18, repr. in color, p. 27; David and Peggy Rockefeller, 1966.

EXHIBITION: Moscow, Salon de la Toison d'Or, Apr. 18–May 24, 1908, no. 69.

REFERENCES: *Zolotoe Runo* (*La Toison d'Or*) (Moscow), nos. 7–9, 1908, repr. p. 55 (as *Plage rouge*); *Apollon* (Moscow), July 1911, repr. following p. 8 (as *Bretagne*); C. Morice, *Paul Gauguin*, Paris, 1919, repr. p. 4 (as *La Vague*); E. Faure, *Histoire de l'art—L'art moderne*, Paris, 1921, repr. p. 426 (as *La Vague*); M. Malingue, *Gauguin: Le Peintre et son oeuvre*, Paris, 1948, p. 34, pl. 116 (as *Marine en Bretagne*); L. van Dovski, *Paul Gauguin, oder die Flucht von der Zivilisation*, Bern, 1950, p. 342, no. 112 (as *Marine en Bretagne*); D. Sutton, "Notes on Paul Gauguin apropos a Recent Exhibition," *Burlington Magazine*, vol. XCVIII, Mar. 1956, p. 91; Y. Thirion, "L'Influence de l'estampe japonaise dans l'oeuvre de Gauguin," *Gazette des Beaux-Arts*, vol. XLVII, Jan.–Apr. 1956 (printed 1958), pp. 105–6, fig. 6, reprinted in G. Wildenstein, ed., *Gauguin: Sa Vie, ses oeuvres*, Paris, 1958; B. Dorival, "Le Peintre dans son siècle," in *Gauguin* (*Collection génies et réalités*), Paris, 1960, p. 89; M. Bodelsen, *Gauguin's Ceramics: A Study in the Development of His Art*, London, 1964, pp. 178 ff.; G. Wildenstein and R. Cogniat, *Gauguin*, Paris, 1964, vol. I, no. 286, p. 106, repr.; D. Sutton, in *Gauguin and the Pont-Aven Group*, exh. cat., Tate Gallery, London, Jan.–Feb. 1966, p. 7; W. Andersen, "Gauguin's Motifs from Le Pouldu—Preliminary Report," *Burlington Magazine*, vol. CXVI, Sept. 1970, p. 616, fig. 73; G. Sugana, *L'Opera completa di Gauguin*, Milan, 1972, no. 118, repr. p. 93; J. Rewald, "Theo van Gogh, Goupil, and the Impressionists," *Gazette des Beaux-Arts*, serie 6, vol. LXXXI, Jan. 1973, P. 49; C. Ives, *The Great Wave: The Influence of Japanese Woodcuts on French Prints*, New York, 1974, pp. 100–1; V. Jirat-Wasiutyński, *Paul Gauguin in the Context of Symbolism*, New York, 1978 [Ph. D. diss., Princeton, 1975], pp. 81–82, no. 48; R. Brettell et al., *The Art of Paul Gauguin*, Washington, D.C., 1988, p. 174; F. Cachin, *Gauguin*, trans. B. Ballard, Paris, 1988, p. 66, no. 67.

1. This print may have been owned by the van Gogh brothers, who were avid collectors of Japanese prints. Early in September of 1888, during the same week that Vincent wrote to Gauguin (correspondence lost), he exchanged comments with his brother about this print: "Hokusai wrings the same cry from you, but he does it by his *line*, his *drawing*, just as you say in your letter—'the waves are claws and the ship is caught in them, you feel it'" (V. W. van Gogh, ed., *The Complete Letters of Vincent van Gogh*, Greenwich, Conn., 1958, vol. III, p. 29). For van Gogh's use of motifs from several different Japanese prints in a single work, cf. the discussion of his *Oiran* in M. Roskill, *Van Gogh, Gauguin and French Painting of the 1880's: A Catalogue Raisonné of Key Works*, University Microfilms, Ann Arbor, 1970, pp. 20–21.

Peggy did not regularly look at art auction catalogues when they came in, but when she did she would sometimes find something very exceptional. This was certainly the case when she discovered Gauguin's 'Wave.' It was painted just one year before his 'Meyer de Haan' (p. 43), which we already owned. Peggy went to look at it at the auction rooms and was very much taken with it. Her judgment was confirmed by John Rewald. This was certainly another case where I do not believe I would have bought it left to

myself, although I have come to appreciate it enormously and am very glad that Peggy spotted it. Interestingly, it is listed in Georges Wildenstein's catalogue raisonné of Gauguin's work as being from an unknown source, so apparently it was lost from public view for a number of years. D.R.

꙼ Paul Gauguin
Portrait of Jacob Meyer de Haan. (Autumn) 1889

Oil on wood, 31 ⅜ x 20 ⅜ in. (79.6 x 51.7 cm.). Signed and dated lower right: *P Go 89*. The Museum of Modern Art. Fractional gift of David and Peggy Rockefeller (the donors retaining a life interest in the remainder).

In the summer of 1889, Paul Gauguin left the crowded inn of Mlle Gloanec at Pont-Aven to seek a quieter atmosphere eight miles away by water in the small coastal village of Le Pouldu (Finistère). He had known the village from the previous year (see *The Wave*, 1888, p. 41), and during August 1889 he and a few followers registered at the small inn of Marie Henry in Le Pouldu. His closest companion at this time was Jacob Meyer de Haan (1852–1895), a hunchbacked Dutch artist who had probably met Gauguin in Paris earlier that year through a fellow Dutchman, Theo van Gogh (W. Jaworska, 1967, pp. 198–200), or through Camille Pissarro (J. Rewald, 1956, rev. ed., 1962, p. 205). Intellectual and mild in temperament, de Haan had abandoned a comfortable existence in Amsterdam, where he painted biblical subjects in an academic style, to seek further instruction in Paris. At Le Pouldu, he paid the rent of a large studio for the small group to work in and discreetly shared a small allowance from his family with the destitute Gauguin.

During the early months of their residence at Le Pouldu, Gauguin and his companions set out to create a pleasant ambience for themselves by decorating the walls and furniture of the small dining room at the inn with their own works. Robert Welsh (1989, pp. 35–43) has methodically reconstructed the interior locations and chronology of the paintings in the dining room, and technical analysis (exh. cat., 1988, p. 165) has supported his conclusion that all of the work was carried out rapidly: sometime between 2 October and 7 November 1889. Among Gauguin's contributions were the present *Portrait of Jacob Meyer de Haan* and a companion *Self-Portrait* (fig. 2; G. Wildenstein and R. Cogniat, 1964, no.

2. Paul Gauguin. *Self-Portrait.* 1889. Oil on wood, 31 ¼ x 20 ¼ in. National Gallery of Art, Washington, D. C. Chester Dale Collection.

323; exh. cat., 1988, no. 92), both painted on wood panels of nearly identical size. The two portraits, linked stylistically and thematically, should be considered as a pair. Both paintings are divided into two distinct areas: in the portrait of de Haan a sharp pitch of the table forms a diagonal against which objects align in angles and parallels, and in the self-portrait, the unnatural curve of the shoulders, echoed by the arcs of the decorative vine in the foreground, divides the picture horizontally. The accentuated features—exaggeratedly bulbous in de Haan's portrait, angular in Gauguin's—and the apples that figure prominently in each portrait are strongly modeled against the planes of flat color.

Both artists have been endowed with attributes unrelated to their profession. The two books in the portrait of de Haan, with titles rendered as conspicuously as labels, supply the most direct clues to the significance of these paired but contrasting portrayals. Both Milton's *Paradise Lost* and Carlyle's *Sartor Resartus* have as their protagonists dual-natured characters in whom the divine and the diabolical contend. *Paradise Lost* is dominated by the angel Lucifer, who became Satan after having been expelled from Paradise for his pride and then, in the guise of a serpent, tempted Eve to disobedience by urging her to eat an apple from the Tree of the Knowledge of Good and Evil. Carlyle's metaphysical fable, "The Tailor Retailored," tells the story of a German professor of philosophy, Diogenes Teufelsdröckh, who restlessly seeks the spiritual meaning hidden beneath the outward appearance—the clothes—of social institutions and customs. The divine and diabolical aspects of his nature are symbolized by his name: Diogenes, that of the famous truth-seeking Greek philosopher, means "God-born," and Teufelsdröckh is the German for "devil's dung." His search for enlightenment leads him to a theory of the external world as symbolic of spiritual meaning: "All objects are as windows, through which the philosophic eye looks into infinity itself" (chap. IX). Although van Gogh had expressed admiration for *Sartor Resartus* in 1883 (letter to A. van Rappard in *Complete Letters of Vincent van Gogh*, New York, 1968, vol. I, p. 374), only a few parts of this dense allegory had been translated into French at that date. Carlyle's book was published in London in 1885, and de Haan may have read it when he was in London. In any case, it seems probable that its abstruse reasoning would have appealed chiefly to de Haan, who may have summarized its ideas in conversations with Gauguin. The themes of temptation and fall in *Paradise Lost*, first published in French in 1875 and again between 1877 and 1881, were of enduring interest to Gauguin.

For Françoise Cachin the National Gallery of Art *Self-Portrait* and this painting of Meyer de Haan are examples both of painted caricature and hieroglyphic portraiture. Gauguin did, in fact, have a reputation among his colleagues as a joker and a master of irony. By considering the portraits as a pair, Cachin showed how Gauguin saw himself vis-à-vis de Haan and, by analogy, the rest of his followers. In Cachin's view, Gauguin positioned himself as master—not so much the initiate or the magus that other writers have made him out to be (V. Jirat-Wasiutyński, 1987, pp. 22–28), but rather the master of *painting*. In this sense, the *Self-Portrait* shows tremendous confidence in his own artistic abilities and ideas. For de Haan, on the other hand, talent and knowledge did not come so easily, and, in the other half of the pair, the less confident painter is depicted by Gauguin as pensive, struggling with his books (exh. cat., 1988, p. 167). Other writers have taken a more symbolic approach to these works, interpreting the various objects Gauguin included in both paintings. Denys Sutton proposed that the halo, apples, and snake in the National Gallery of Art *Self-Portrait* indicate that Gauguin based his self-image, with its heavy-lidded, cynical gaze, on the proud and defiant figure of Lucifer-Satan (1949, pp. 284–85). The features are an exaggerated version of those in his *Les Misérables* of 1888 (Rijksmuseum Vincent van Gogh, Vincent van Gogh Foundation, Amsterdam; Wildenstein and Cogniat no. 239; exh. cat., 1988, p. XXI) and in his *Self-Portrait with Yellow Christ* of 1889 (private collection; Wildenstein and Cogniat no. 324; exh. cat., 1988, no. 99). In the companion portrait, the huddled

contemplative pose, the books, and the lamp suggest a corresponding identification of de Haan with the studious and troubled Diogenes Teufelsdröckh; his eyes are fixed in a wide-open stare, as if his were "the philosophical eye [which] looks into infinity itself," and the faint archway at the upper right may be a symbol of that infinity. The prominent forehead, with its domed shape curiously echoed by the globe of the lamp, and his introspective attitude suggest his noble calling as a seeker after truth, while the hornlike tuft of hair, the rimmed and slanted eyes, and the pawlike hand suggest the lower, animal aspects of his character. Wladyslawa Jaworska (1972, p. 106) and Wayne Andersen (1971, pp. 106–7) have noted visual connotations of both a fox and a devil in de Haan's features, which bear little resemblance to those in his two self-portraits painted during this period (repr. Jaworska, pp. 96–97).

Although allying de Haan and himself as dual-natured heroes, Gauguin has also clearly differentiated their roles in relation to the symbolic apples of temptation. In the *Self-Portrait*, the apples dangling behind the artist's head resemble a self-designed heraldic device and imply the experience and bold acceptance of temptation. The gesture with which he holds the serpent, controlled between his fingers as an artist might hold a brush, seems to show Gauguin carrying out Satan's role as tempter as well. In the companion portrait, the large plate of apples looming in the foreground and the transfixed gaze of de Haan suggest that, for him, temptation is not yet behind him but a matter of immediate and intense concern.

According to Welsh, the portraits were painted on the upper panels of cupboard doors on either side of the fireplace on the south wall of the room, de Haan on the left and Gauguin on the right. An earlier account written by Marie Henry's husband, Motheré, stated that the two portraits were painted on the upper panels of an armoire, that of de Haan on the left and the *Self-Portrait* on the right (C. Chassé, 1921, p. 48). Marie Henry herself disputed Motheré's description, explaining in later years that the two portraits were painted on the upper panels of doors in her dining room (M. Malingue, 1959, p. 35). This testimony is part of the evidence Welsh used to build his view of the room. Centered on the room's south wall was a fireplace with the two portraits hung on either side. On the mantel sat a ceramic bust of de Haan made by Gauguin, while on the wall above the fireplace and between the two paintings were two small sculptures: to the left was the small *Negresse Martinique* by Gauguin and to the right a fragment of a ceramic Javanese dancer bought by Gauguin at the Paris Universal Exposition in 1889. Welsh read this entire tableau as a comment by Gauguin on de Haan's interest in women and female sexuality, a theme that would be explored much later in another portrait of de Haan called *Nirvana* (Welsh, 1989, pp. 41–42; Wadsworth Atheneum, Hartford, Ella Gallup Sumner and Mary Catlin Sumner Collection; Wildenstein and Cogniat no. 320; exh. cat., 1988, p. 169). In this small painting on silk, de Haan is again seated in contemplation, with figures symbolic of the tempted and fallen Eve, as well as of Life and Death, behind him. In a gesture similar to that of Gauguin in the *Self-Portrait*, he holds a serpent whose curvilinear outline forms the G of Gauguin's signature. The transferred gesture and associated symbols may imply that he had come to share Gauguin's easy acceptance of sexual temptation and had thereby achieved the spiritual state indicated by the title.

Welsh's reading of the south wall's tableau seems even more legitimate in light of the sexual relationships at the inn; the two portraits might refer to a specific situation of sexual temptation in which Gauguin saw an opportunity to contrast pictorially his own greater experience to de Haan's uncertainty. It is known that both Gauguin and de Haan aspired to the affections of their landlady, Marie Henry, and that the gentle and affectionate de Haan was successful while the blasé Gauguin contented himself with her maid. De Haan's liaison with Marie Henry resulted in an illegitimate child who was raised with reverence for her father's memory and taught to blame Gauguin for de Haan's failure to marry her mother. At his early death in 1895, de Haan willed all of his effects to Marie Henry.

Contrary to the interpretations of Jaworska (1972, pp. 103–6) and Andersen (1971, p. 108), there is no evidence that a break in the friendship of the two artists occurred over the pretty innkeeper. De Haan subsequently spoke enthusiastically of his experience with Gauguin at Le Pouldu (quoted in Dom Willibrord Verkade, *Yesterdays of an Artist-Monk*, New York, 1930, p. 59). During their stay in Le Pouldu, Gauguin referred to de Haan as his "best pupil," and in the following year he expressed the hope that de Haan would accompany him to Tahiti (letters of June, Aug., and Sept. 1890, quoted in Malingue, 1959). In 1893 he wrote his friend Georges-Daniel de Monfreid asking for news of de Haan (*Lettres de Gauguin à Daniel de Monfreid*, Paris, 1919, no. XI of Mar. 31, 1893).

From contemporary accounts, it is known that the small band of artists at Le Pouldu engaged in frequent and heated discussions of aesthetic theories currently popular in Paris, notably those of the Neo-Impressionists, Synthetists, and especially the Symbolists. In these two symbolically rich portraits, the use of objects and formal devices to suggest a spiritual condition appears so programmatic as to imply a wry comment on Symbolism itself. Too, the obvious juxtaposition of sinuously curved lines in the *Self-Portrait* with the diagonal division and geometric alignments in the de Haan portrait, along with the use of flat planes of arbitrary color may constitute a satirical rejoinder to the Neo-Impressionists, whose theories about the expressive value of curved and straight lines and adherence to the rules of complementary color were ridiculed by Gauguin (cf. his pseudo–Neo-Impressionist still life signed with the invented name "Ripipoint" of the same period; repr. Rewald, 1956, rev. ed., 1962, p. 298).

It is possible to speculate on the impact of other artists on the *Portrait of Jacob Meyer de Haan*. The tipped plate of apples with their strongly outlined contours may owe something to Gauguin's admiration for Paul Cézanne, whose *Still Life with Fruit Dish* in the Rockefeller Collection (see p. 28) he owned and had with him in Brittany at that time. Also, the use of books, prominently titled, as indicative of character recalls a similar device in paintings by Vincent van Gogh: in the companion paintings symbolizing himself and Gauguin, *Van Gogh's Chair* and *Gauguin's Chair*, painted shortly before Gauguin's abrupt departure from Arles in December 1888, van Gogh used pink and yellow "modern novels" and a lighted candle to evoke the presence of Gauguin. Is it coincidental that the two books in this work are pink and yellow? Yvonne Thirion has suggested that the oblique division of the composition derives from precedents in Japanese prints (1958, pp. 108–9), and Andersen has compared the contemplative pose to that of Auguste Rodin's *The Thinker*, which had been exhibited in Paris in 1889 (1971, p. 107). Cachin described the contraction of Gauguin's signature to "P Go" as a sign of his interest in "primitive mannerisms and borrowings from other cultures" (1988, p. 108).

The sheer density of references in the two portraits—to current artistic, emotional, and intellectual concerns, perhaps also to a specific situation at Marie Henry's inn—suggests a degree of self-consciousness in their creation which is both more deliberate and more wide-ranging than is conveyed by the frequent description of the two paintings as "satanic" conceptions. In their original setting at the inn of Marie Henry, surrounded by numerous other works of sardonic and symbolic character, the portraits were perhaps conceived as topical documents—*peintures à clef* for the artist and his companions—whose intricacy of stylistic and iconographic content testify to the complexity of Gauguin's inspiration.

A watercolor version of the *Portrait of Jacob Meyer de Haan* (The Museum of Modern Art, New York; repr. in color, F. Daulte, *French Watercolors of the Nineteenth Century*, New York, 1970, p. 107) shows a more symmetrical division of the composition, both in the background planes and in the relation of the upper and lower portions. In the definitive painting, the globe of the lamp is more fully shown, the table rises more steeply, and the confrontation between de Haan and the plate of apples is intensified.

Gauguin represented de Haan's features in other mediums. In late 1889, he carved in oak and painted an over-life-size bust of de Haan and placed it on the mantelpiece in Marie Henry's dining room (exh. cat., 1988, no. 94). A reversed image of de Haan's features appears in a woodcut, *Souvenir de Meyer de Haan,* made in Tahiti in 1896 after the death of his friend; Gauguin sent one proof to de Monfreid and pasted another into the original manuscript of *Noa-Noa* (M. Guerin, *L'Oeuvre gravé de Gauguin*, Paris, 1927, vol. II, no. 53, repr.). In 1902 Gauguin again represented de Haan in a Tahitian painting with the inscribed title, *Contes barbares [Primitive Tales]* (Museum Folkwang, Essen; Wildenstein and Cogniat no. 625; exh. cat., 1988, no. 280). In addition, John Rewald has identified a watercolor portrait as a "Study for a Portrait of Jacob Meyer de Haan (Brittany)" and dated it about 1890 (*Gauguin Drawings*, New York, 1958, no. 26, repr.); and a drawing titled *Portrait of Meyer de Haan Reading, Pont-Aven* was exhibited in Berlin in 1928 (present location unknown; *Paul Gauguin*, exh. cat., Galerie Thannhauser, no. 80).

PROVENANCE: Mlle Marie Henry (later Mme Motheré), Le Pouldu; Galerie Barbazanges, Paris, 1919; Alex Reid and Lefevre, London, 1923; Kraushaar Galleries, New York, 1928; Mr. and Mrs. Quincy A. Shaw McKean, Boston, acquired Nov. 1928; Mrs. Sargent McKean, Beverly, Mass.; M. Knoedler and Co., New York; David and Peggy Rockefeller, 1958, fractional gift to The Museum of Modern Art, New York (the donors retaining a life interest in the remainder).

EXHIBITIONS: Paris, Galerie Barbazanges, *Paul Gauguin, oeuvres inconnus,* Oct. 10–30, 1919, no. 3 (as *Le Soir à la lampe, Portrait de Meyer de Haan*); Paris, Galerie Dru, *Gauguin,* Apr. 16–May 11, 1923, no. 14; London, Alex Reid and Lefevre, *Post-Impressionist Masters,* Oct. 29–Nov. 24, 1923, no. 22; New York, Kraushaar Galleries, *Modern French Paintings, Watercolors and Drawings,* Oct. 1–18, 1928, no. 8; Cambridge, Mass., The Fogg Art Museum, Harvard University, *French Paintings of the 19th and 20th Centuries,* Mar. 6–Apr. 6, 1929, no. 50, repr. pl. 37; New York, The Museum of Modern Art, *Cézanne, Gauguin, Seurat, van Gogh,* Nov. 1929, no. 36, repr.; New York, Wildenstein and Co., *Paul Gauguin,* Mar. 20–Apr. 18, 1936, no. 13; Cambridge, Mass., The Fogg Art Museum, Harvard University, *Paul Gauguin,* May 1–21, 1936, no. 14; San Francisco Museum of Art, *Paul Gauguin,* Sept. 5–Oct. 4, 1936, no. 8, repr.; Boston, Museum of Fine Arts, *Art in New England,* June 9–Sept. 10, 1939, no. 49, pl. XXVII; New York, The Museum of Modern Art, *Works of Art Given or Promised,* Oct. 6–Nov. 9, 1958 (repr. in *The Museum of Modern Art Bulletin,* vol. XXVI, Fall 1958, p. 23); New York, M. Knoedler and Co., *A Family Exhibit,* Apr. 6–25, 1959, no. 15, repr.; Vienna, Oesterreichische Galerie im Oberen Belvedere, *Paul Gauguin,* June 7–July 31, 1960, no. 20; Cambridge, Mass., The Fogg Art Museum, Harvard University, *Works of Art from the Collections of the Harvard Class of 1936,* June 11–Aug. 25, 1961, no. 13; New York, Wildenstein and Co., *Faces from the World of Impressionism and Post-Impressionism,* Nov. 2–Dec. 9, 1972, no. 33, repr.; New York, The Museum of Modern Art, reopening installation of the museum collection, May 6, 1984–Jan. 6, 1985; Washington, D.C., National Gallery of Art, *The Art of Paul Gauguin,* April 17–July 31, 1988, pp. 167–68, no. 93, traveled to The Art Institute of Chicago, Sept. 7–Dec. 11, 1988, and to Paris, Grand Palais, Jan. 10–Apr. 20, 1989.

REFERENCES: C. Chassé, *Gauguin et le groupe de Pont-Aven,* Paris, 1921, pp. 39, 44, 48, 50; K. Van Hook, "A Self-Portrait by Paul Gauguin from the Chester Dale Collection," *Gazette des Beaux-Arts,* vol. XXII, Dec. 1942, pp. 184–85, repr.; D. Sutton, "The Paul Gauguin Exhibition," *Burlington Magazine,* vol. XCI, Oct. 1949, pp. 284–85; C. Chassé, *Gauguin et son temps,* Paris, 1955, p. 74; J. Rewald, *Post-Impressionism from van Gogh to Gauguin,* New York, 1956, p. 297, repr. p. 295; 2nd rev. ed., New York, 1962, p. 291, repr. p. 295; Y. Thirion, "L'Influence de l'estampe japonaise dans l'oeuvre de Gauguin," *Gazette des Beaux-Arts,* vol. XLVII, Jan.–Apr. 1956 (printed 1958), pp. 108–9, repr. p. 109; S. Lovgren, *The Genesis of Modernism: Seurat, Gauguin, van Gogh and French Symbolism in the 1880's,* Stockholm, 1959, p. 119, repr. p. 121; H. R. Rookmaaker, *Synthetist Art Theories: Genesis and Nature of the Ideas on Art of Gauguin and His Circle,* Amsterdam, 1959, p. 233; reprinted as *Gauguin and 19th-Century Art Theory,* Amsterdam, 1972, p. 136; *Connoisseur,* vol. CXLIII, June 1959, repr. p. 273; M. Malingue, "Du Nouveau sur Gauguin," *L'Oeil,* July–Aug. 1959, pp. 32 ff., repr.; G. Wildenstein and R. Cogniat, *Gauguin,* Paris, 1964, vol. I, pp. 119–20, no. 317, repr.; D. Sutton, in *Gauguin and the Pont-Aven Group,* exh. cat., Tate Gallery, London, Jan.–Feb. 1966, p. 12; W. Andersen, "Gauguin and a Peruvian Mummy," *Burlington Magazine,* vol. CIX, Apr. 1967, repr. p. 240; W. Jaworska, "Jacob Meyer de Haan," *Nederlands Konsthistorisch Jaarboek,* vol. XVIII, 1967, pp. 197–226; F. Cachin, *Gauguin,* Paris, 1968, pp. 161, 292, repr. p. 160; Rev. T. Buser, S.J., "Gauguin's Religion," *Art Journal,* vol. XXVII, Summer 1968, pp. 376–78, repr. p. 377; W. Andersen, "Gauguin's Calvary of the Maiden," *Art Quarterly,* vol. XXXIV, Spring 1971, pp. 101–2, repr. p. 100; reprinted in idem, *Gauguin's Paradise Lost,* New York, 1971, pp. 79 ff., 106 ff., 194, repr. fig. 80; W. Jaworska, *Gauguin and the Pont-Aven School,* Greenwich, Conn., 1972 (trans. by P. Evans from *Paul Gauguin et l'école de Pont-Aven,* Neuchâtel, 1971), pp. 105–6, 232, watercolor repr. p. 105; G. Sugana, *L'Opera completa di Gauguin,* Milan, 1972, no. 200, repr. p. 95; D. Wildenstein and R. Cogniat, *Gauguin,* Garden City, N.Y., 1974, fig. 2, p. 87; *25 Great Masters of Modern Art: Vol. 12, Gauguin,* Tokyo, 1980, no. 22; V. Jirat-Wasiutyński, "Paul Gauguin's *Self Portrait with Halo and Snake*: The Artist as Initiate and Magus," *Art Journal,* vol. 46, no. 1, Spring 1987, pp. 22–28, repr. p. 23; M. Hoog, *Paul Gauguin: Life and Work,* New York, 1987, pp. 133, 280, repr. p. 101; M. Prather and C. Stuckey, eds., *Gauguin: A Retrospective,* New York, 1987, p. 122; F. Cachin, *Gauguin,* trans. B. Ballard, Paris, 1988, p. 108, no. 109; R. Welsh, "Gauguin et l'auberge de Marie Henry au Pouldu," *Revue de l'Art,* no. 86, 1989, pp. 35–43, repr. p. 41; B. Thomson, ed., *Gauguin by Himself,* New York, 1993, pp. 106–7, no. 74.

In 1958 Alfred Barr brought to our attention this Gauguin portrait, which had belonged to the McKeans of Boston for many years and had been shown at the first exhibition of The Museum of Modern Art in the Heckscher Building in 1929. I had seen it at that time. Alfred felt that it was one of Gauguin's very fine paintings and persuaded us to buy it. Some years later, I went to the Museum Folkwang in Essen and was intrigued to find the same figure of Meyer de Haan in a painting done thirteen years later in Tahiti with the rather devilish figure of this Dutch artist looking on at a scene with attractive Tahitian girls. Although the colors vary in the two pictures, the pose of the figure is precisely the same. Therefore, Gauguin must have taken a sketch with him to Tahiti which he incorporated into this later painting. Although Peggy recognizes its quality, she has never liked the 'Meyer de Haan' as much as I do because she feels he is such a demonic, even threatening, figure. On the other hand, it is a tremendously powerful work, and I have managed to persuade her to leave it in conspicuous places despite her feelings. D.R.

Pierre Bonnard. French, 1867–1947
The Promenade (*Promenade des nourrices, frise des fiacres*). 1894

Four-panel folding screen of distemper on unprimed canvas with carved wood frame, each panel 58 x 17¾ in. (147 x 45 cm.), overall 58 x 71 in. (147 x 180 cm.). Signed lower right, third panel, with monogram: *PB*; burned into upper edge of frame, fourth panel: *Bonnard 94*. The Museum of Modern Art, New York. Fractional gift of David and Peggy Rockefeller (the donors retaining a life interest in the remainder).

Like the other Nabis, Bonnard shared the enthusiasm for the decorative arts that became widespread in the early 1890s, and he created textile and furniture designs as well as stage sets. He was the first of the Nabis to design a folding screen, *Femmes au jardin*, which he exhibited at the Salon des Indépendants in Paris in 1891 (M. Komanecky and V. Butera, 1984, p. 72, fig. 73). Other members Édouard Vuillard, Maurice Denis, and Odilon Redon soon also undertook works in this format. In addition to the Rockefeller *Promenade*, Bonnard is known to have designed at least two other screens around this same time. One of these, his *Ensemble champêtre* of 1894, is now in the collection of The Museum of Modern Art (called *Three Panels of a Screen* [1894–96], gift of Mr. and Mrs. Allan D. Emil); unfortunately one of the four original panels is missing. In 1896, just two years after the present screen was completed, a lithographed version was issued in a large edition of 110. Of his interest in the decorative arts, Bonnard explained late in his life, "Our generation sought to link art with life. At that time [1890s] I personally envisaged a popular art that was of everyday application: fans, furniture, screens..." (J. Rewald, 1948).

As both a decorative and a functional object for the home, a folding screen presents a host of challenges different from those faced in traditional painting on canvas. The artist must take into consideration, among other things, the breaks and folds, the back and the front. With *The Promenade*, Bonnard shifted from creating separate images for each panel, as in the case of the earlier *Femmes au jardin*, to working out a continuous design that would stretch across all four panels. The decision to extend the composition in this way may have been sparked by the two continuous scenes in Armand Seguin's four-paneled *The Delights of Life* (*Les Délices de la vie*), 1892–93. Bonnard's composition takes full advantage of the screen's ability to fold at a variety of angles. For example, depending on the angle at which the hinged panels are set, the action of the group on the right-hand side is either halted, as the woman scolds her charges, or thrust forward with the speed of the rolling hoops (Komanecky and Butera, 1984, p. 75).

Children and adults in public parks is a subject common to the work of both Impressionists and members of the Nabi group. The same year

that this screen was completed, Bonnard's good friend, and fellow Nabi, Vuillard was in the midst of decorating Alexandre Natanson's dining room with anecdotal scenes from the Tuileries and the Bois de Boulogne (C. Ives et al., 1989, p. 114). People going about their day to day business in Parisian public spaces is also a motif seen throughout Bonnard's graphic oeuvre. Michael Komanecky related both technique and subject of *The Promenade* to Bonnard's series of prints *Petites Scènes familières*, begun in 1893 but not published until 1895. These lithographs depict "outlined figures in horizontally disposed street scenes" (Komanecky and Butera, 1984, p. 74). As is true for the blank middle ground of Bonnard's *Quadrille* from the *Petites Scènes, The Promenade* relies on unpainted canvas to represent pavement: the canvas is both pictorial and literal ground.

Sources for the imagery in *The Promenade* can be found easily in Bonnard's other work as well as in contemporary graphic art. The group of dogs before the line of carriages has a precedent in a lithograph, *Les Chiens*, which was reproduced in the December 10, 1893, issue of the short-lived illustrated weekly *L'Escaramouche* (C. Roger-Marx, *Bonnard lithographe*, Monaco, 1952, no. 25, repr.; Ives, 1989, no. 25, fig. 166). *Les Chiens* reveals Bonnard's attitude toward the city: "viewed as if it were his own backyard: an arena of activity he treated with humor and a kind of jaunty grace" (Ives et al., 1989, p. 121). The young woman in the tier-caped costume and elaborate hat appears both in the poster Bonnard designed for *La Revue blanche* (Roger-Marx, no. 32, repr.), which came out in May 1894 (F. Hermann, 1959, vol. II, p. 571), and in a small oil, *Femme assise au chapeau noir*, which J. and H. Dauberville date 1894 in their catalogue raisonné of Bonnard's paintings (1965, no. 82, repr.). Fritz Hermann noted similarities in the costume of the young woman to that in the two-color lithograph *Femme au parapluie,* which appeared first as a supplement to the September 1894 number of *La Revue blanche* and subsequently in an album (Roger-Marx, no. 35, repr.; Ives et al., 1989, no. 31, fig. 45). Arguing that Bonnard was indifferent to fashionable modes, Hermann discussed the young woman as a rare type of "Bonnard Kokotte" (vol. I, pp. 241–46). The choice of this costume as well as the composition itself may owe something to a painting by Henri de Toulouse-Lautrec, *Entrance to the Café des Ambassadeurs*, in which a woman in a very similar tier-caped outfit occupies the left foreground and a horse-drawn carriage moves horizontally across the background (repr. M. G. Dortu, *Toulouse-Lautrec et son oeuvre*, New York, 1971, vol. II, p. 293, no. P. 480). Lautrec's work was reproduced in the first of two articles by Gustave Geffroy entitled "Le Plaisir à Paris: les restaurants et les cafés-concerts des Champs-Elysées" in *Le Figaro illustré* of July 1893. Patricia Boyer has noted relationships between Bonnard's motifs (the dog, children, nannies) and those seen in the humorous journalistic illustrations published throughout the popular press at that time. Boyer explained that Bonnard's silhouetted style of rendering echoes not only the imagery in these illustrations, but also Paul Gauguin's painting. Bonnard's silhouettes also bear resemblance to those figures depicted in the shadow theater plays seen by members of the Nabi group at the Montmartre café Le Chat Noir. For example, the silhouetted carriages running across the top of the screen is the type of frieze used to fill background space in the shadow theater (Boyer, 1988, pp. 27, 53–58).

Although it can be assumed that Bonnard made preliminary studies for this screen, only one has been noted by the author: a charcoal drawing, *La Promenade sur les boulevards*, is described as showing in the center "the nurse and child that one finds later in the screen" (*Bonnard illustrateur*, exh. cat., Huguette Berès, Paris, 1971, no. 4; there dated 1894).

Bonnard was known to his friends as the "Nabi très japonard" ("the very Japanese Nabi"). Félix Fénéon, the subject of Paul Signac's portrait (see p. 39), gave Bonnard this title. The impact of Japanese prints may be seen in Bonnard's economical drawing, his emphasis on silhouette, and the artful balance of vertical and horizontal elements against large empty areas. Ursula Perucchi-Petri has shown that woodcuts by Hiroshige

and Kuniyoshi contain precedents for certain motifs in the screen. For example, she compared the running children with bent knees to similar figures in Hiroshige's *Shono, Rainshower* from the "Tokaido Gojusan-Tsugi" series (repr. *Hiroshige*, exh. cat., Bern Kunstmuseum, 1958, no. 65) and in Kuniyoshi's *The Poet Yasuhide* (B. W. Robinson, *Kuniyoshi*, London, 1961, fig. 30). She also suggested that the bent-over posture and foreshortening of the woman in the foreground have prototypes in Japanese art, where the overtones are of a comic nature (1976, pp. 80–81, and n. 236).

Although in the past the lithographic version of the screen, printed in five colors, has been dated 1897 (J. Floury, 1927, no. 35) and 1899 (Roger-Marx, 1952, no. 47, repr. in color, pp. 92–93), the work can more accurately be dated either 1895 or 1896: the publication of an edition of 110 by the Galerie Lafitte was announced in *Studio*, vol. 9, no. 43, October 15, 1896, p. 68, illus. p. 67. In loose sheets the set sold for 40 francs; mounted as a screen the price was 60 francs (*L'Estampe et l'affiche*, Feb. 1897, p. 24 [Hermann, vol. II, p. 418]). More recently, Colta Ives, acknowledging the publication date of 1896, claimed that the prints must have been completed late in 1895. Ives explained the extensive transformation that occurred with the shift from paint to lithography: Bonnard adjusted and clarified the composition by "lowering the principal figural ensemble, remodeling the stylish whippet, and emphasizing striped and checked patterns throughout" (1989, p. 115). One complete set of four lithographs is now in the collection of The Museum of Modern Art. Also in the Museum's collection is a fragment cut from the top of the right-hand sheet of one of these sets showing part of the horse-cab frieze (Rewald, 1948, p. 17).

The early ownership of this work cannot be definitively established, but it may have belonged to the *Revue blanche* publisher, Thadée Natanson, who already had a small collection of Bonnard's works. The Rockefeller *Promenade* may correspond to the work listed in the "painting section" of the catalogue for the artist's first one-man exhibition at the Galeries Durand-Ruel, January 1896, as no. 49, "Promenade. Appartient à M. T[hadée]. N[atanson]." It was probably one of the two screens mentioned by Geffroy in *Le Journal* of January 8, 1896, as currently on exhibition at the gallery. Although the word "screen" is only used to describe one work in the "print" section of the catalogue, it is believed that another screen was exhibited *hors concours* (Ives, 1989, p. 201, n. 41 and 42, and p. 218). There is no ambiguity about the painted screen's second owner: Albert S. Henraux, who joined the Société des Amis du Louvre in 1908 and served as its president from 1932 until 1953.

PROVENANCE: Thadée Natanson, Paris; Albert S. Henraux, Paris; J. C. Abreu, Paris; M. Knoedler and Co., New York, June 1958; David and Peggy Rockefeller, 1958, fractional gift to The Museum of Modern Art, New York, 1991 (the donors retaining a life interest in the remainder).

EXHIBITIONS: Paris, Durand-Ruel, *P. Bonnard*, Jan. 1896, no. 52 (listed as *Paravent*; probably this screen); New York, The Museum of Modern Art, *Bonnard and His Environment*, Oct. 7–Nov. 29, 1964, no. 3, repr. p. 31, traveled to The Art Institute of Chicago, Jan. 8–Feb. 28, 1965, and to the Los Angeles County Museum of Art, Mar. 31–May 30, 1965; New York, The Metropolitan Museum of Art, *Pierre Bonnard: The Graphic Art*, Dec. 2, 1989–Feb. 4, 1990, no. 35.

REFERENCES: G. Geffroy in *Le Journal*, Jan. 8, 1896 (review reprinted in *La Vie artistique*, vol. VI, 1900, p. 296); C. Terrasse, *Bonnard*, including "Essai de catalogue de l'oeuvre gravé et lithographié" by J. Floury, Paris, 1927, pp. 50, 52; J. Rewald, *Pierre Bonnard*, New York, 1948, repr. p. 65; F. Hermann, *Die Revue Blanche und die Nabis*, Munich, 1959, vol. I, p. 190; vol. II, p. 418, n. 30; J. and H. Dauberville, *Bonnard: Catalogue raisonné de l'oeuvre peint*, vol. I: *1888–1905*, Paris, 1965, no. 60, repr.; U. Perucchi-Petri, *Die Nabis und Japan: Das Frühwerk von Bonnard, Vuillard und Denis* (*Studien zur Kunst des neunzehnten Jahrhunderts*, no. 37), Munich, 1976, pp. 80–81, fig. 42; M. Komanecky and V. F. Butera, *The Folding Image: Screens by Western Artists of the Nineteenth and Twentieth Centuries*, New Haven, 1984, pp. 73–75, 143–44; P. Boyer, "The Nabis, Parisian Vanguard Humorous Illustrators, and the Circle of the Chat Noir," in Boyer, ed., *The Nabis and the Parisian Avant-Garde*, New Brunswick, 1988, pp. 27, 53–58, 115; J. Clair, *Pierre Bonnard*, Milan, 1988, pp. 179–80; A. Terrasse, *Bonnard*, Paris, 1988 [revised from 1967 edition], pp. 49–50, 244; C. Ives et al., *Pierre Bonnard: The Graphic Art*, New York, 1989, pp. 110–16, 218, no. 35, fig. 155; C. Frèches-Thory and A. Terrasse, *The Nabis: Bonnard, Vuillard, and Their Circle*, New York, 1991, p. 166.

Bonnard used the designs on this screen as the basis for a series of litho-

graphs which are quite well known. The screen is particularly interesting in that it was framed by Bonnard himself, and his signature is on the frame rather than on the canvas. D.R.

⮑ Pierre Bonnard
Basket of Fruit Reflected in a Mirror
(*Corbeille de fruits se reflétant dans une glace de buffet*). (Ca. 1944–46)

Oil on canvas, 18 ⅝ x 28 ⅛ in. (47.3 x 71.4 cm.). Signed lower right: *Bonnard*. Not dated. The Museum of Modern Art, New York. Gift of David and Peggy Rockefeller.

In his monograph on Bonnard, Antoine Terrasse recorded that after a brief trip to Paris, the artist returned to his studio at Le Cannet in July 1946 and resumed work on several paintings begun many months earlier (1988, p. 226). Terrasse had earlier reproduced a snapshot taken at that time (1967, pp. 186–87) in which the present still life is among the works shown unstretched and tacked to a wall.

Throughout his life, Bonnard relied on mirror reflections to compound the visual ambiguity in which he delighted. In this late work, the curvilinear forms of a double-handled basket of fruit, a compote, a plate, and an egg cup are seen reflected within the rectangular edges of a mirror frame; but the position of these objects in relation to the stepped surface and flat, figured ground on which they seem to rest is obscure. Thus the observer is engaged in a playful exercise to determine the relationship, and even the identity, of all of the reflected forms. The milky tones of the mirror frame suggest a marble-enclosed glass above a fireplace, but the deliberate spatial ambiguities leave no doubt that the artist's intention is to pose a visual riddle.

PROVENANCE: Estate of the artist; Galerie Beyeler, Basel, by 1966; David and Peggy Rockefeller, 1969; The Museum of Modern Art, New York, Gift of David and Peggy Rockefeller, 1984.

EXHIBITIONS: Venice, *XXV Esposizione Biennale Internazionale d'Arte*, June 8–Oct. 18, 1950, French representation, Bonnard section, no. 19, p. 286 (as *Le Buffet*); Basel, Galerie Beyeler, *Bonnard*, Sept.–Nov. 1966, no. 43, repr. in color (as "ca. 1944"); Milan, Galeria Il Milione, *Bonnard*, 1967, no. 16, repr. (as *Il Buffet*); New York, The Museum of Modern Art, *Five Recent Acquisitions*, Apr. 18–June 22, 1975; Düsseldorf, Kunstsammlung Nordrhein-Westfalen, *Pierre Bonnard*, Jan. 22–Apr. 12, 1993.

REFERENCES: A. Terrasse, *Pierre Bonnard*, Paris, 1967, repr. in installation photograph, pp. 186–87; J. and H. Dauberville, *Bonnard: Catalogue raisonné de l'oeuvre peint*, vol. IV: *1940–1947*, Paris, 1974, no. 1681, repr. in black and white, p. 98, in color, p. 99; A. Terrasse, *Bonnard at Le Cannet*, New York, 1988, p. 74–75 (called *Corbeille de fruits dans le placard rouge* [*Basket of Fruit in a Red Cupboard*]).

This painting, one of Bonnard's last, was brought to our attention by William Rubin. He felt that its abstract quality was of particular interest and hoped that we might buy it with the view of leaving it to The Museum of Modern Art. This we agreed to do. D.R.

⮑ André Derain. French, 1880–1954
Charing Cross Bridge. (1905–6)

Oil on canvas, 32 ⅛ x 39 ⅜ in. (81 x 100 cm.). Signed lower left: *A. Derain*. Not dated. The Museum of Modern Art, New York. Fractional gift of David and Peggy Rockefeller (the donors retaining a life interest in the remainder).

This painting of a brilliant sunset over London shows Charing Cross Bridge in the middle ground, with puffs of blue smoke indicating the passage of trains over the bridge, and the silhouettes of the Big Ben clock tower and the buildings of Westminster beyond. The view is apparently seen from mid-river and somewhat above the water—perhaps from the walkway on Waterloo Bridge.

The dealer Ambroise Vollard, who had begun to buy Derain's work

in February 1905, recalled that it was his suggestion that the artist go to London to paint a series of views (*Recollections of a Picture Dealer*, Boston, 1936, p. 201). This was confirmed by Derain himself, who late in life wrote that Vollard "sent me in the hope of renewing completely at that date the expression which Claude Monet had so strikingly achieved which had made a very strong impression in Paris in the preceding years" (letter of May 15, 1953, to the president of the Royal Academy, London, quoted by R. Alley in *Tate Gallery Catalogues: The Foreign Paintings, Drawings and Sculpture*, London, 1959, pp. 64–65). Monet's London views, painted in three successive visits between 1899 and 1901 and completed in his studio (dated 1902–4 on the canvases), were exhibited to great acclaim at Durand-Ruel in 1904 (for a detailed discussion of Monet's visits to London, see G. Seiberling, *Monet in London*, Atlanta, 1988). They included eight views of Charing Cross Bridge, a structure which Camille Pissarro had earlier painted twice from the same vantage point as in the present picture (L.-R. Pissarro and L. Venturi, *Camille Pissarro: Son Art, son oeuvre*, Paris, 1939, nos. 745 and 805). Derain's London work has been described as both an emulation and rebuttal of the very successful and popular paintings by Monet (J. Herbert, *Fauve Painting: The Making Of Cultural Politics*, New Haven, 1992, p. 15). Derain painted at least thirty views of London, chiefly of the bridges and monuments along the Thames. A letter from Derain to Vollard recently unearthed in the Vollard archives clearly describes the purchase of twenty-six paintings by the dealer at 150 francs each. However, the letter also mentions another four paintings of London, raising the number of pictures painted to thirty. In addition, a receipt, also from the Vollard Archives, may have been written for the purchase of yet another ten paintings. These, however, have not been identified (see J. Freeman, 1990, p. 212, note 5). The Fauves, in general, were more attracted to established and familiar European cities than to exotic locales, but were able to examine familiar places and daily activities as if seeing them for the first time (Freeman, 1990, p. 178). The result was a display of the character of modern life. In *Charing Cross Bridge*, markers of modernity include a bridge, carrying both train and foot traffic, and the fog, a side effect of increased industrial pollution (Seiberling, pp. 49, 52).

It is generally believed that Derain made at least two visits to London, but the dates of these and the chronology of the London scenes—as of his entire Fauve period—are controversial. Only two of the London views, both of 1906, are dated on the canvases: *The Houses of Parliament and Westminster Bridge* (M. Kellermann, 1992, no. 82; Freeman, 1990, pl. 191) and *Westminster Bridge: Blue and Gray* (Kellermann no. 81; J. Freeman, 1990, pl. 294). In his last years, Derain made several statements regarding the London scenes, by then recognized as one of the major achievements of his career. When *The Pool of London* was acquired by the Tate Gallery in 1951, he wrote that he had painted it on the spot "around April 1906" (letter of Jan. 25, 1952, cited by R. Alley, who concluded that Derain visited London in both the spring and fall of 1906; 1959, p. 64). In an interview published a few months later, Derain stated that he had painted nine views of London in 1906, which he had sold, undoubtedly to Vollard, for the equivalent of £100 (*The Sunday Express*, May 4, 1952, cited in *Derain*, exh. cat., Wildenstein and Co., London, 1957, no. 10). It must be supposed that different dates or lapse of memory account for the rest of the group.

A year before his death, Derain stated in an interview with Denys Sutton that he first crossed the Channel in 1905; and on the basis of Derain's visits to Collioure and Marseille in the summer of 1905, Sutton concluded that this first trip to London took place in the fall of 1905 and was followed by a second in the spring of 1906 ("André Derain: Art as Fate," *Encounter*, vol. V, no. 4, 1955, p. 69; *André Derain*, London, 1959, p. 17). The visit in the spring of 1906 is confirmed by a letter written to his confidante, Maurice de Vlaminck, in which Derain wrote of being rather moved by London and what he had seen there (*Lettres à Vlaminck*, Paris, 1955, pp. 196–97). The letter is dated March 7, with no year given,

but in it he wrote, "The Thames is immense and it's just the opposite of Marseille." As he had not visited Marseille before the summer of 1905, this letter touching on his latest impressions must date from March of 1906. Another trip to London the following year was indicated by an undocumented account, possibly based on the recollections of Mme Alice Derain, in the catalogue of the memorial exhibition held in Paris the year after Derain's death (Musée National d'Art Moderne, Paris, 1954–55), which states that his trip in 1905 was repeated in the following two years and again in 1910. Within the lifetimes of Derain and Vollard, many of the London views were exhibited and reproduced as dating from 1907. A first trip in the spring of 1905 also has been proposed by two scholars who have studied Derain's role in the Fauve movement in depth (E. C. Oppler, *Fauvism Reexamined*, New York, 1976, pp. 104–5 [Ph.D. diss., Columbia University, 1969]; and J. Elderfield, 1976, pp. 35–36, and 152, n. 84; see discussion below).

Of the thirty London views known, sixteen have the same measurements as this canvas, the important size 40 in the French index of canvas sizes (approximately 81 x 100 cm.), but no documentation has come to light to indicate that Vollard either commissioned or exhibited in Paris a specific number of London scenes. In March 1907, four works identified only as "Vues de Londres" were exhibited in Brussels in the avant-garde salon La Libre Esthétique (nos. 87–90). In the spring of 1908, the present work and three others of the same size, but probably later in date, were lent by Vollard to an important exhibition of French art at the Salon de la Toison d'Or in Moscow. Again the works are listed only as "Vues de Londres" in the issue of the Salon's publication which served as the catalogue of the exhibition (1908, nos. 35–38), but an installation photograph permits identification of this work as well as another *Charing Cross Bridge, London* (National Gallery of Art, Washington, D.C., The John Hay Whitney Collection), *Westminster Bridge* (Musée du Louvre, Paris), and *Tower Bridge* (Private collection, U.S.). Given Vollard's high commercial expectations for Derain's pictures (following in the wake of Monet), it comes as a surprise that the London paintings actually received relatively little critical attention. James Herbert believes that Vollard actually withheld these works from the art market as a "speculation on their future monetary appreciation . . ." (1992, p. 185, n. 3).

The chronology of the London views is unresolved; equally uncertain is whether Derain completed all of them before the actual sites or later in his studio, when he may have worked over the larger canvases, several of which display downward-plunging perspectives seemingly observed directly above the river. His only recorded address in London was Blenheim Crescent in Chelsea (*Lettres à Vlaminck*, p. 197), so he did not paint his views of the Thames directly from a hotel or hospital window, as Monet had done. Derain's own testimony in the letter of 1952 cited above was that he painted *The Pool of London* on the spot (Alley suggests from London Bridge) but retouched it later in his studio to repair some damages sustained in shipment. However, an early account of the London views, the language of which suggests an interview with the artist, implies that many of the pictures were only sketched on the spot and completed later in the studio: "Next year, in the spring of 1906, he started off on a painting trip down the Seine to Le Havre and, finding himself that close to England, crossed the channel and journeyed on to London. Arriving there in a spell of bright weather he was so struck with the way the sun splashed and flamed against the fog-weathered buildings along the Thames that he started in to paint one or two of the views then ended by sketching out a whole series of them, a dozen canvases which he finished up next winter in his studio at Chatou" (M. Vaughan, *Derain*, New York, 1941, pp. 37, 41). No complete study for any of these large compositions is currently known. There is, however, an extant sketchbook of Derain's London trip in the possession of Denys Sutton. Unfortunately, the book has not been made available to scholars. While doing research for the exhibition *The Fauve Landscape*, Judi Freeman saw photographs of several leaves of this sketchbook that showed detailed drawings with

blocked-out areas of color (Freeman, 1990, p. 212, n. 10; the sketchbook also was exhibited at the Museum of Fine Arts in Houston in 1961). The practice of finishing works in the studio, as Monet had done, may account for some of the stylistic fluctuations to be observed in the London views, but these variations also reflect the transitional character of Derain's style during a period in which he submitted to influences as diverse as the Neo-Impressionists, Paul Gauguin, Monet, Joseph Turner, and Henri Matisse. No one style took precedence; instead, his work was characterized by a mixture of borrowed techniques (Herbert, 1992, p. 30).

Although their dating remains uncertain, the London views appear to fall into three stylistic groups. Three works of the same size as the present canvas, with a similar horizontal composition and path of light reflected in the water, are usually attributed to Derain's first trip to London in 1905: *Houses of Parliament* (also called *London: Big Ben* [Musée d'Art Moderne, Troyes, Donation Pierre et Denise Lévy; Kellermann no. 77]); *Westminster* (also called *Londres: Le Palais de Westminster* [Musée de l'Annonciade, Saint-Tropez; Kellermann no. 78]), and *Old Waterloo Bridge* (Collection Thyssen-Bornemisza, Lugano-Castagnola; Kellermann no. 79). In these views, the interest in the differing effects of light in sky and on water is reminiscent of Monet's series, but Derain rendered his views in the Neo-Impressionist idiom of Paul Signac and Henri-Edmond Cross, which he had studied with Matisse and tentatively rejected at Collioure in the summer of 1905.

Possibly later on the first trip to London or at the beginning of his subsequent trip are the present *Charing Cross Bridge* and a similarly conceived work of the same size, *Reflections on the Water* (Musée de L'Annonciade, Saint-Tropez; J. P. Crespelle, 1962, p. 30, repr. in color; Kellerman no. 111). In both of these paintings, a brilliant fantasy in the sky, rendered in broader areas of color, probably reflects the impact of Derain's first encounter with Turner in the London museums, as has often been suggested. A reference to his response to Turner first appears in the previously quoted letter of March 7, 1906, to Vlaminck: "We are on the right path . . . I am sure of it, I have seen Turner. . . . It is absolutely necessary to escape the circle in which the Realists enclosed us."

John Elderfield, also noting the influence of Turner, believes it most likely that Derain first visited London in the spring, rather than the fall, of 1905, and that these two works were painted early in his first visit, to be followed by the more consistent Neo-Impressionist works (1976, pp. 35–36 and 152, n. 84). Acknowledging the lack of proof, Elderfield "most easily supported" the view of Ellen C. Oppler (1976, pp. 104–5), who had postulated a visit to London in the spring of 1905 in evaluating the anomaly of placing the Neo-Impressionist works after the letter Derain wrote to Vlaminck from Collioure on July 28, 1905, in which he rejected the Neo-Impressionist analysis of color ("To know how, in the vicinity of Matisse, to get rid of everything that the division of tone got into the skin"; *Lettres*, pp. 154–55). This remark may, however, refer only to Neo-Impressionist treatment of color rather than of divided brushstrokes, which Derain continued to use in preparing the large composition he hoped to submit to the Salon d'Automne of 1905 (*L'Age d'or*) and frequently in the views of London more securely attributed to 1906.

The most recent hypothesis was presented by Freeman in an essay on travels of Fauve group painters (1990, pp. 177–213). She concludes that *Charing Cross Bridge* was painted during the latter part of Derain's second stay in London. First, disputing Oppler's claim that Derain's first trip was in spring 1905, Freeman agreed with Derain scholars Denys Sutton and Michael Parke-Taylor and argued that the first London trip must have been in autumn 1905, after Derain watched Matisse work in Collioure. "The application of complementary tones side by side, first in measured strokes and subsequently in masses of color, appeared in Derain's work only after he began to paint with Matisse in Collioure" (p. 179). Freeman also pointed out that despite the fact that Vollard's purchase of the contents of the artist's studio in February 1905 would finance Derain's travels to the United Kingdom, it is unlikely that Derain would

have made the trip at that point when it would have been on the heels of a rather unsuccessful showing at the spring 1905 Salon des Indépendants and before visiting Matisse in Collioure. The artist's first trip, in the fall, was probably very short, but included planning his work for a subsequent visit. Freeman's more specific conclusion that *Charing Cross Bridge* was painted in the latter part of the second stay is based mainly on stylistic considerations.

The third stylistic group may be said to consist of the many other views of the Thames and its monuments in which the visionary color effects that dominate this *Charing Cross Bridge* and *Reflections on the Water* become a background for animated scenes of boats and figures, rendered in a broad, vigorous style, and flatter areas of color, such as *The Pool of London* (Tate Gallery, London; Kellermann no. 97) and *St. Paul's Cathedral* (Minneapolis Institute of Arts; Kellermann no. 103). Considered as a group, Derain's London views can function as a "comprehensive survey of the English capital," a catalogue of places and urban types (Herbert, 1992, p. 39).

The present work and the second view of *Charing Cross Bridge, London* in the National Gallery of Art, Washington, D.C., The John Hay Whitney Collection, are two of four views of London acquired by the noted American collector John Quinn; in the 1926 catalogue of his collection they are listed respectively as *London Bridge* and *View Of London*. In a letter of January 30, 1918, to Walter Pach, his intermediary in dealing with Vollard, Quinn acknowledged receipt of four London scenes by Derain, from which he intended to make a selection; but on October 29, 1919, he confirmed his acquisition of all four for $300 each (Quinn archives, Manuscripts and Archives Division, New York Public Library, Astor, Lenox, and Tilden Foundations).

PROVENANCE: Ambroise Vollard, Paris, by 1908; on consignment to Walter Pach, New York, 1917; John Quinn, New York, 1919–24; Estate of John Quinn, 1924–25; Joseph Brummer, New York, 1925; Mrs. Hunter Galloway, New York, 1926–61; M. Knoedler and Co., New York, 1961; David and Peggy Rockefeller, 1961, fractional gift to The Museum of Modern Art, New York (the donors retaining a life interest in the remainder).

EXHIBITIONS: Moscow, Salon de la Toison d'Or, Apr. 18–May 24, 1908 (one of four "Vues de Londres," nos. 35–38); New York, The Museum of Modern Art, *The "Wild Beasts": Fauvism and Its Affinities*, Mar. 26–June 1, 1976, no. 13, traveled to the San Francisco Museum of Modern Art, June 29–Aug. 15, 1976, and to Fort Worth, Kimbell Art Museum, Sept. 11–Oct. 31, 1976.

REFERENCES: *Zolotoe Runo* (*La Toison d'Or*) (Moscow), nos. 7–9, 1908, pl. IIa (installation view); *John Quinn 1870–1925: Collection of Paintings, Water Colors, Drawings, & Sculpture*, Huntington, N.Y., 1926, p. 8 (as *London Bridge*); J. P. Crespelle, *Les Fauves*, Neuchâtel, 1962, repr. in color, pl. 33; J. Elderfield, *The "Wild Beasts": Fauvism and Its Affinities*, New York, 1976, p. 35, repr. in color, p. 46; M. Giry, *Fauvism: Origins and Development*, trans. H. Harrison, New York, 1982, p. 156, pl. 79; J. Freeman, *The Fauve Landscape*, Los Angeles, 1990, pp. 187, 191, pl. 195; M. Kellermann, *André Derain; Catalogue Raisonné de l'oeuvre peinte*, Paris, 1992, no. 87.

In 1961 James Johnson Sweeney, who was a member of the art committee of the Chase, brought to our attention this Fauve painting by Derain. A very daring picture with bright colors, it was the first Fauve painting that we bought. It led us subsequently to buy other paintings in this style to fill the small morning room on the ground floor at 65th Street. Although Derain's later work never appealed to us particularly, this painting is one of our favorites. D.R.

∾ Georges Braque. French, 1882–1963
The Large Trees (*Les Gros Arbres*). (Fall–Winter 1906–7)

Oil on canvas mounted on composition board, 31½ x 27¾ in. (80 x 70.5 cm.). Signed on back (concealed by lining). The Museum of Modern Art, New York. Fractional gift of David and Peggy Rockefeller (the donors retaining a life interest in the remainder).

Braque went south to L'Estaque, a port to the west of Marseille where

Paul Cézanne had frequently painted, in October 1906. He returned to Paris by February 7, 1907, to exhibit his Fauve paintings for the first time at the spring Salon des Indépendants. Braque later admitted that it was because of Cézanne that he left for L'Estaque, adding, "and I already had an idea in mind. I can say that my first pictures of L'Estaque were already conceived before my departure. I nonetheless applied myself to subjecting them to the influences of the light and the atmosphere, and to the effect of the rain which brightened up the colors" (from a 1961 interview, quoted in J. Cousins, 1989, p. 342). Before leaving Paris, Braque had seen the Salon d'Automne's Cézanne retrospectives of 1904 and 1905 (Pouillon, 1982, p. 18) as well as the smaller Salon exhibition of ten works by Cézanne that opened in the autumn of 1906.

Braque was drawn into the Fauve orbit by his friendship with Raoul Dufy and Emile-Othon Friesz, and he painted his first works in that style during the summer of 1906, which he spent with Friesz in Antwerp. A document, found recently in the Braque family archives, shows that his stay in Belgium was longer than previously thought: from June 12 to July 12 and from August 11 to September 11 (Cousins, 1989, p. 341).

The Large Trees probably dates from the latter part of Braque's first stay at L'Estaque (he was to make many trips to this area between 1906 and 1910; see Cousins, 1989, pp. 336–37), for the Neo-Impressionist brushstroke and restrained color typical of his first studies of the port have given way here to broader areas of richly modulated tones; and the attempt to render spatial depth found in his earlier harbor scenes is here replaced by a more active surface patterning created by boldly outlined, interlocking shapes. This insistent emphasis on the surface, with consequent ambiguity in the relationship of planes, and the curvilinear rhythms established by the trees and picket fence suggest the impact of Paul Gauguin, whose major retrospective at the Salon d'Automne of 1906 Braque must have seen before his departure for the south. Douglas Cooper (exh. cat., 1956, p. 26, no. 8) has noted the use of a similar foreground fence in Gauguin's *Swineherd* (G. Wildenstein and R. Cogniat, *Gauguin*, Paris, 1964, no. 353), which in 1906 was owned by Georges-Daniel de Monfreid, a major lender to the 1906 retrospective. The two small figures below the central tree in this painting are compositional elements that Braque used in other works of the winter of 1906–7 (Musée de l'Annonciade, Saint-Tropez; Maeght Collection, Paris). While Zurcher argued that Braque's depiction of L'Estaque was "made with Paul Gauguin in mind," he added that the color scheme can be linked to that of Matisse and Derain and that the construction of the hill relates to the compositional structures of Cézanne (B. Zurcher, *Georges Braque: Life and Work*, New York, 1988, p. 17).

Braque's Fauve period lasted only some eighteen months. As he explained in an interview with Dora Vallier many years later: "What impressed me about Fauve painting was its novelty. It was painting full of fervor, and that suited me at my age. I was 23. . . . Romanticism was alien to me, but I liked this physical painting. It lasted no longer than anything else which is new, for then I realized that the paroxysm inherent in it could not be sustained. . . . When I returned a third time to the south [in the summer of 1908], I found that the exaltation which had overwhelmed me on my first visit, and which I put into my pictures, was no longer the same. I saw something else" ("Braque, la peinture et nous," *Cahiers d'art*, no. 1, 1954, pp. 13–24, quoted in Eng. trans. by Cooper, exh. cat., 1956, p. 28). That "something else" was depicted in such early Cubist landscapes as *Road near L'Estaque* (W. Rubin, 1989, p. 89). Judi Freeman has noted that the winding down of interest in Fauve painting coincided with the increased interest in Cézanne (1990, p. 144).

Although Braque's claim that he painted only two dozen Fauve works has long been accepted (cf. E. Oppler, 1976, p. 121), the present picture has proved to be one of some seventy of this brief period (reproductions verified by Braque's executor, Claude Laurens, Paris, 1976). It is the largest of Braque's known Fauve paintings. Several of his Fauve compositions exist in two versions—a small, on-site sketch recording an immediate sensation, followed by a large, more elaborate rendition of the subject. The complex color harmonies and decorative organization indicate that this work was painted in the studio rather than before the motif. No sketch for it is known today, although one undoubtedly once existed (Braque told Cooper that he burned several Fauve canvases in the 1930s; conversation with the author, 1976). The decorative intention here is particularly evident when this work is compared with a Cézannesque view of the same spot from a greater distance (Private collection, Geneva; repr. in color, sale cat., Christie's, London, Nov. 28, 1972, no. 74), undoubtedly painted during Braque's brief second visit to L'Estaque in autumn 1907, beginning sometime before September 28 and lasting through late October or early November (Cousins, 1989, p. 346). The latter work, with its simplified forms and more expansive view of the sea and mountains of the Marseilleveyre, indicates that the present picture is a close-up view of houses and trees at the edge of the bay of Marseille.

While in recent years the Rockefeller painting was known as *L'Estaque*, we have returned here to Braque's original title, *Les Gros Arbres*, listed in the 1907 Salon des Indépendants exhibition catalogue; *The Large Trees* was one of six paintings exhibited by Braque that spring. All six works were sold: five, including this one, to the German art collector and dealer Wilhelm Uhde, then living in Paris, and one to art dealer Daniel-Henry Kahnweiler, who later that year signed a contract with Braque for his entire production. A letter, dated April 10, from the Société des Artistes Indépendants, reported to Braque the good news that Uhde had offered 200 francs for two paintings, *The Large Trees* and *Boats*. Two weeks later, Braque received word that in addition to these paintings, Uhde had purchased an additional three, and that the Société des Artistes Indépendants held payment for the works "purchased by Mr. Uhde for the sum of 505 francs" (Cousins, 1989, p. 343, from Laurens Archive). Twenty years later, Uhde described his immediate response to these works: "I fell in love at first sight. The few hundred francs that I possessed at that moment, I gave for the paintings that he exhibited for the first time at the Salon d'Automne [*sic*] in Paris" (*Picasso et la tradition français*, Paris, 1928, p. 36).

PROVENANCE: Wilhelm Uhde, 1907; Edwin Suermondt (d. 1923), Berlin and Aachen, by 1914; Alex Vömel, Düsseldorf; Fine Arts Associates, New York, by 1951; Col. Samuel A. Berger, New York; David and Peggy Rockefeller, 1970, fractional gift to The Museum of Modern Art, New York (the donors retaining a life interest in the remainder).

EXHIBITIONS: Paris, *23ᵐᵉ Exposition de la Société des Artistes Indépendants*, Mar. 20–Apr. 30, 1907, no. 721; New York, The Museum of Modern Art, *Les Fauves*, Oct. 8, 1952–Jan. 4, 1953, no. 13, repr. in color, p. 36, traveled to the Minneapolis Institute of Arts, Jan. 21–Feb. 22, 1953, to the San Francisco Museum of Art, Mar. 13–Apr. 12, 1953, and to the Art Gallery of Toronto, May 1–31, 1953; Edinburgh, Royal Scottish Academy, Edinburgh International Festival, *G. Braque*, Summer 1956, no. 8, pl. 1, traveled to London, Tate Gallery, Sept. 28–Nov. 11, 1956; New York, Wildenstein and Co., *Modern French Painting*, Apr. 11–25, 1962, no. 5, repr. in color, frontis., traveled to Waltham, Mass., Rose Art Museum, Brandeis University, May 10–June 13, 1962; New York, Saidenberg Gallery, *Georges Braque, An American Tribute: Fauvism and Cubism*, Apr. 7–May 2, 1964, no. 7, repr.; New York, The Solomon R. Guggenheim Museum, *Van Gogh and Expressionism*, July 1–Sept. 13, 1964; New York, The Metropolitan Museum of Art, *New York Collects*, Summer 1966, no. 10; Summer 1967, no. 6; Summer 1968, no. 18; The Baltimore Museum of Art, *From El Greco to Pollock: Early and Late Works by European and American Artists*, Oct. 22–Dec. 8, 1968, cat. pp. 120–21, repr.; New York, The Museum of Modern Art, *Recent Acquisitions*, June 5–Sept. 11, 1970; New York, The Museum of Modern Art, *The "Wild Beasts": Fauvism and Its Affinities*, Mar. 26–June 1, 1976, no. 3, traveled to the San Francisco Museum of Modern Art, June 29–Aug. 15, 1976, and to Fort Worth, Kimbell Art Museum, Sept. 11–Oct. 31, 1976.

REFERENCES: *Illustrated London News*, Sept. 1, 1956, repr. p. 345; *Apollo*, vol. LXXX, Dec. 1956, p. 189; D. Sylvester, ed., *Modern Art from Fauvism to Abstract Expressionism*, New York and London, 1956, repr. p. 30; J. Leymarie, *Braque*, Lausanne, 1961, pp. 22, 125; *New York Times*, June 14, 1970, repr.; The Art Institute of Chicago, *Braque, The Great Years*, 1972, fig. I, p. 27; J. Elderfield, *The "Wild Beasts": Fauvism and Its Affinities*, New York, 1976, p. 83, repr. p. 90; E. C. Oppler, *Fauvism Reexamined*, New York, 1976, p. 123, n. 1 (photo reprint of Ph.D. diss., Columbia University, 1969); N. Pouillon, with I. Monod-Fontaine, *Braque: Oeuvres de Georges Braque (1882-1963), Collection du Musée National d'Art Moderne*, Paris, 1982; J. Cousins, "Documentary Chronology," in W. Rubin, *Picasso and Braque: Pioneering Cubism*, New York, 1989, pp. 343; J. Freeman, *The Fauve Landscape*, Los Angeles, 1990.

William Rubin knew that we were rather anxious to round out the Fauve paintings in the morning room at 65th Street and brought to our attention

this Braque. Braque painted in the Fauve style for only a short period; hence this work is of considerable historical interest as well as being a very dynamic picture. We agreed to buy it with the understanding that it would ultimately go to The Museum of Modern Art. D.R.

∾ Henri-Emile-Benoit Matisse. French, 1869–1954
Interior with a Young Girl/Girl Reading
(*Intérieur à la fillette/La Lecture*). (Autumn–Winter 1905–6)

Oil on canvas, 28⅝ x 23½ in. (72.2 x 59.7 cm.). Signed lower left: *Henri-Matisse*. Not dated. The Museum of Modern Art, New York. Fractional gift of David and Peggy Rockefeller (the donors retaining a life interest in the remainder).

The young girl reading at a lectern is Matisse's daughter Marguerite, who confirmed in 1974 that this work was painted in the family's Paris apartment at 19, quai Saint-Michel in 1905–6, when she was about eight years old (correspondence with the author, 1974). On the table are the fruit dish and silver chocolate pot that appear in many of Matisse's early still lifes. Likewise, books are also often seen in many of the artist's early paintings, and reading, a traditional Dutch subject, recurs throughout Matisse's oeuvre (P. Schneider, 1984, pp. 27, 203–4; J. Elderfield, 1992, p. 56). One of Matisse's first paintings with a figure happens to be *Woman Reading*, 1895 (Elderfield, 1992, no. 5). The fabric of brilliant color and the variety of brushstroke evident in this work have led John Elderfield to characterize its style as "mixed-technique Fauvism" (1976, pp. 79–81; 1978, pp. 44–46), meaning the use of many different types of paint marks—like drawn strips of pigment placed separately on the white canvas ground next to much larger planes of color. Of Matisse's Fauvism, Elderfield has explained that the artist "matures as a painter by rejecting the authority of Neo-Impressionism, to make . . . an art of unconstrained freedom. . . ." To accomplish this, "Matisse would construct from color. . . . [He] creates not the effects of light but light itself in abrupt contrasts of red and green and similarly vibrating polarities" (Elderfield, 1992, pp. 50, 52).

Structurally, *Girl Reading* is divided in half. In the upper part, the color and brushwork create a sense of frenetic energy and, like a fire, the pigment seems to spread out of control; in the lower section, where the girl is absorbed in her book, the color has been held in check, perhaps by the child's sheer concentration (Schneider, 1984, p. 204). Elderfield described this painting as "picturing absorption." Matisse, he wrote, "offers that plane of absorption as a quieter, clearer zone than what is outside it; and presents the absorbed figure and that horizontal plane in a relationship of mutual reinforcement" (1992, p. 56). A few months later, in 1906, Matisse painted another less visually exciting and more structural version of this subject, *Marguerite Reading* (Elderfield, 1992, pl. 85).

It was Félix Fénéon, the first owner of this painting, who, as manager of Bernheim-Jeune in Paris, persuaded that gallery to sign a contract with Matisse in September 1909 (A. Barr, Jr., *Matisse: His Art and His Public*, New York, 1951, p. 105). This three-year contract raised the prices of Matisse's work and, combined with the steady patronage of Russian collector Sergei Shchukin, provided the artist with a measure of financial security.

PROVENANCE: Galerie Druet, Paris; Félix Fénéon, Paris, 1906; sale, Paris, Hôtel Drouot, Dec. 4, 1941, no. 64, repr.; Frank Perls, Beverly Hills; Mr. and Mrs. William Goetz, Los Angeles, ca. 1952–70; sale, London, Sotheby's, Oct. 14, 1970, no. 10, repr. in color; David and Peggy Rockefeller, 1970, fractional gift to The Museum of Modern Art, New York (the donors retaining a life interest in the remainder).

EXHIBITIONS: Paris, Galerie Druet, *Henri Matisse*, Mar. 19–Apr. 7, 1906, no. 4; Paris, Galerie Bing, *Les Fauves 1904–08*, Apr. 1927, no. 7; Brussels, Palais des Beaux-Arts, *L'Art français moderne*, Apr.–May 1929, no. 462; Basel, Kunsthalle, *Henri Matisse*, Aug. 9–Sept. 15, 1931, no. 18; Paris, Salon d'Automne, Sept. 28–Oct. 20, 1945, Salle Henri Matisse, no. IX; Dallas, Museum of Fine Arts, *Some Businessmen Collect Contemporary Art*, Apr. 6–27, 1952, no. 34; Beverly Hills, Calif., Frank Perls Gallery, *Henri*

Matisse, May 22–June 30, 1952, no. 3, traveled to Los Angeles, Municipal Art Department, July 24–Aug. 17, 1952, no. 8; New York, The Museum of Modern Art, *Les Fauves*, Oct. 8, 1952–Jan. 4, 1953, no. 97, repr., traveled to the Minneapolis Institute of Arts, Jan. 21–Feb. 22, 1953, to the San Francisco Museum of Art, Mar. 13–Apr. 12, 1953, and to the Art Gallery of Toronto, May 1–31, 1953; San Francisco Museum of Art, *Collection of Mr. and Mrs. William Goetz*, Apr. 18–May 31, 1959, no. 39, repr.; Los Angeles, University of California Art Galleries, *Henri Matisse*, Jan. 5–Feb. 20, 1966, no. 22, repr. in color, p. 51, traveled to The Art Institute of Chicago, Mar. 4–Apr. 17, 1966, and to Boston, Museum of Fine Arts, May 11–June 26, 1966; Paris, Grand Palais, *Henri Matisse: Exposition du centenaire*, Apr.–Sept. 1970, no. 71, repr. p. 147; New York, The Museum of Modern Art, *Recent Acquisitions—Twentieth Century Pioneers*, Mar. 13–Apr. 26, 1971; New York, The Museum of Modern Art, *The "Wild Beasts": Fauvism and Its Affinities*, Mar. 26–June 1, 1976, no. 75, traveled to the San Francisco Museum of Modern Art, June 29–Aug. 15, 1976, and to Fort Worth, Kimbell Art Museum, Sept. 11–Oct. 31, 1976; New York, The Museum of Modern Art, *Matisse in the Collection of The Museum of Modern Art*, Oct. 27, 1978–Jan. 30, 1979; New York, The Museum of Modern Art, reopening installation of the museum collection, May 6, 1984–Jan. 6, 1985; New York, The Museum of Modern Art, *Henri Matisse: A Retrospective*, Sept. 24, 1992–Jan. 12, 1993, no. 67; Paris, Centre National d'Art et de Culture Georges Pompidou, *Henri Matisse, 1904–1917*, Feb. 23–June 21, 1993, no. 26.

REFERENCES: J. de Lassus, "Les Fauves," *L'Amour de l'art*, vol. VIII, June 1927, p. 211, repr. p. 209; G. Diehl, *Les Fauves*, Paris, 1943, pl. IX, color; 1948 ed., pl. X, color; L. Aragon, *Apologie de luxe*, Geneva, 1946, repr. in color; G. Duthuit, *Les Fauves*, Geneva, 1949, repr. p. 29; English ed., *The Fauvist Painters*, New York, 1950, pl. 18; A. M. Frankfurter, "The Goetz Collection," *Art News*, vol. L, Sept. 1951, p. 57, repr. in color, p. 30; E. Tériade, "Matisse Speaks," *Art News Annual*, 1952, repr. in color, p. 45; M. Raynal, *Modern Painting*, Geneva, 1953, repr. in color, p. 75; G. Diehl, *Henri Matisse*, Paris, 1954, pp. 46, 47, 160; idem, "Hommage à Henri Matisse," *XXᵉ Siècle*, Paris, 1970, repr. p. 37; L. Aragon, *Henri Matisse, Roman*, Paris, 1971, vol. 1, p. 300, pl. XLV, color; vol. II, p. 69; M. Luzi and M. Carrà, *L'Opera di Matisse dalla rivolta "fauve" all'intimismo, 1904–1928*, Milan, 1971, pl. VII, color; J. Russell, *The Meanings of Modern Art*, vol. II: *The Emancipation of Color*, New York, 1974, p. 23, repr.; J. Elderfield, *The "Wild Beasts": Fauvism and Its Affinities*, New York, 1976, pp. 79–81, repr. in color, p. 27; J. Elderfield, *Matisse in the Collection of The Museum of Modern Art*, New York, 1978, pp. 44–47, 181; repr. in color, p. 45; C. Bock, *Henri Matisse and Neo-Impressionism, 1898-1908*, Ann Arbor, 1981, pp. 97–98, pl. 57; P. Schneider, *Matisse*, New York, 1984, pp. 203–4, repr. p. 202; J. Flam, *Matisse: The Man and His Art, 1869–1918*, Ithaca, 1986, p. 149, pl. 142; E. G. Landau, *Jackson Pollock*, New York, 1989, p. 163; P. Yenawine, *How to Look at Modern Art*, New York, 1991, p. 149; J. Elderfield, *Henri Matisse: A Retrospective*, New York, 1992, p. 56, no. 67; Y.-A. Bois, "L'Aveuglement," in D. Fourcade et al., *Henri Matisse 1904–1917*, Paris, 1993, pp. 37, 429, no. 26.

By 1970 our acquisition of Fauve paintings for the morning room at 65th Street was nearly complete. We already had pictures by four of the great French Fauve painters—Matisse, Derain, Braque, and Vlaminck. We also had an early Kandinsky done in much the same style, which went very well with the Fauves. But in October of 1970 William Rubin brought to our attention this magnificent Matisse of a girl reading, which was coming up for sale. The other Matisse Fauve which we had, 'Landscape at Collioure,' is also a very beautiful picture, but it was a bit small for the morning room. Thus we were delighted to get this Matisse and found another good spot for the landscape. We agreed to leave 'Interior with Girl Reading' to The Museum of Modern Art, which has been somewhat weak in its Fauve collection. D.R.

∾ Pablo Picasso. Spanish (died Mougins, France), 1881–1973
Girl with a Basket of Flowers (*Jeune Fille à corbeille des fleurs*)
Autumn 1905

Oil on unprimed canvas, 61 x 26 in. (155 x 66 cm.). Signed upper right: *Picasso*; signed and dated on back: *Picasso/rue Ravignan/1905*. David and Peggy Rockefeller Collection.

Geneviève Laporte, who was closely associated with Picasso between 1944 and 1954, recorded that Picasso escorted her to an exhibition, at the Galerie Kaganovitch in 1951, in which this work appeared. He told her that "the model was a little flower girl, who at the start had posed for him in her First Communion dress, before posing in the nude" (1975, pp. 94–95). John Richardson relates this story in his recent biography of Picasso, explaining that "Linda la Bouquetière" sold not only roses, but also her body (1991, p. 340). Jean-Claude Crespelle, describing this person in an earlier biography of the artist, added that Linda posed for a host of local painters including van Dongen and Modigliani (1969, p. 68). Richardson surmised that the model "doubtless slept with" the artist (1991, p. 340). This young girl was not unique in her visit to the Bateau-Lavoir; the res-

idence was busy with people coming and going. Much later, Picasso described the steady stream as "local types, actors, ladies, gentlemen, delinquents" (H. Parmelin, *Picasso Says*, trans. C. Trollope, London, 1969, p. 71). Fernande Olivier, Picasso's lover at the time, described one of these female visitors who, Richardson supposes, may be this same flower seller: "Bizarre-looking rather than beautiful with bright red hair and large, rather coarse but good features . . . last night I realized she must have been crawling with lice, as both of us have caught them" (F. Olivier, *Souvenirs intimes*, ed. G. Krill, Paris, 1988, p. 206). In fact, Richardson called the model in this painting the "female equivalent" of another of the Bateau-Lavoir's regulars: "p'tit Louis," Picasso's sitter for *Boy with a Pipe* (1991, p. 340; repr. Zervos I, 274; W. Rubin, 1980, p. 66). We will probably never know whether Linda la Bouquetière was the model for this picture; however, close examination of the canvas does suggest that only the head was painted from life, for the precisely rendered features and the knowing and suspicious glance of the girl suggest the portrait of an individual, while the paler tonality and the soft and generalized modeling of the body below the necklace suggest that the torso may have been drawn from Picasso's repertory of nude female forms rather than from direct study of a nude adolescent. In a large gouache and ink drawing of early 1905, *The Harlequin's Family* (Z. I. 298, pl. 130; D.-B. XII.6, p. 258),[1] the lower torso and legs of a young female figure are rendered in a very similar fashion.[2]

Pierre Daix and Georges Boudaille (1967, p. 78), as well as William Rubin (1980), place this work in a "transitional" moment, a period of transformation from blue to rose, after Picasso's visit to Holland in the summer of 1905. Linked to Symbolism, the Blue and Rose Periods get their names from Picasso's use of "a single dominating hue, which sets [the picture's] mood" (W. Rubin, *The Paley Collection*, New York, 1991, p. 98). More than simply a change in color, Rubin noted, this period of transition marks a shift in mood for the artist, from pessimism to optimism. Picasso's new, more positive outlook most probably resulted from the combination of his happy and satisfying relationship with Fernande Olivier as well as new confidence in his own work. (Picasso met Fernande in the summer of 1904; she moved in with him about one year later; their relationship lasted seven years.)

Besides the shift in hue, the transitional period is also characterized by inconsistencies in Picasso's rendering of figures. The girl's face, unlike her body, has a strong, sculptural quality that looks forward to the "sculptural turn" the artist's work would take in 1906, inspired in part by Cézanne (Rubin, 1991, p. 102). The basket held by the girl appears in Picasso's major painting of that spring, *The Family of Saltimbanques* (National Gallery of Art, Washington, D.C.; Z. I. 285; D.-B. XII.35, p. 267). Josep Palau i Fabre, concurring with Daix and Rubin, dated this painting after Picasso's return from Holland. The fact that she engages the painter's—and thus the viewer's—eyes led Palau i Fabre to associate her with the 1895 *Barefoot Girl* (1985, no. 68, p. 63), as well as a painting contemporary with the Rockefeller picture, *Portrait of Madame Canals* (D.-B. XIII.9; Rubin, 1980, p. 66), all of which show subjects staring back at the artist. The two girls and the woman "seem a little perturbed by this violation of their inmost selves by the painter's regard; and they . . . appear to be trying to penetrate as deeply into the painter's mind as he is penetrating into theirs" (1985, p. 424). Palau i Fabre described Picasso's portrayals of such intense psychological depth as something learned from Velásquez. Rubin (1980, pp. 57–58), on the other hand, detected an "air of detachment" in this *Girl with a Basket of Flowers* as well as in the *Portrait of Madame Canals* and *Woman with a Fan* (D.-B. XIII.14; Rubin, 1980, p. 67).

Leo Stein bought the painting in 1905 (probably in November; see I. Gordon, "A World Beyond the World: The Discovery of Leo Stein" in *Four Americans in Paris*, exh. cat., 1970, p. 33, n. 53). He and Gertrude Stein differed in their recollections of the acquisition of the painting, but Leo was probably correct in stating that it was the second work by Picasso

to come to the rue de Fleurus, rather than the first (L. Stein, 1950, p. 148). He recorded that the first work by Picasso he acquired was *The Acrobat's Family with a Monkey* (now Göteborgs Konstmuseum, Göteborg, Sweden; Z. I. 299, pl. 131; D.-B. XII.7, p. 258; W. Rubin, 1980, p. 62), which within a few years passed to their brother and sister-in-law, Michael and Sarah Stein. Apparently, Gertrude Stein took an immediate dislike to the painting of the girl, finding "something rather appalling in the drawing of the legs and feet, something that repelled and shocked her" (quoted in J. Richardson, 1991, p. 397). The acquisition of the painting sparked quarrels between the two siblings and to settle the arguments, the dealer Clovis Sagot suggested that the bottom part of the picture easily could be sliced off. Such mutilation was never carried out, of course, and, despite Gertrude Stein's initial negative assessment, the picture remained in the writer's collection throughout her life. (For a photograph of this painting in the Steins' apartment at 27, rue de Fleurus, ca. 1906, see Richardson, 1991, p. 399; the painting hangs next to Bonnard's *Siesta*.) In 1910–11 the painting was included in Roger Fry's Grafton Galleries show, a controversial exhibition of Post-Impressionist art, exhibited alongside works by Cézanne, van Gogh, and Gauguin (C. Nathanson, 1985, p. 3).

This work was X-rayed at The Museum of Modern Art at the time of its acquisition by Mr. and Mrs. Rockefeller. The back of the canvas is primed with gesso and contains a few isolated sketches in an unrelated style, now visible only under X ray.

PROVENANCE: Galerie Clovis Sagot, Paris, 1905; Leo and Gertrude Stein, Paris, 1905–13; Gertrude Stein, 1913–46; Estate of Gertrude Stein, 1946–68; The Museum of Modern Art syndicate, 1968; David and Peggy Rockefeller, 1968.

EXHIBITIONS: London, Grafton Galleries, *Manet and the Post-Impressionists*, Nov. 8, 1910–Jan. 15, 1911, no. 30; Paris, Galerie Georges Petit, *Picasso*, June 16–July 30, 1932, no. 37, repr. (wrongly listed as signed lower right); Zürich, Kunsthaus, *Picasso*, Sept. 11–Oct. 30, 1932, no. 26; Paris, Petit Palais, *Les Maîtres de l'art indépendant, 1893–1937*, June–Oct. 1937, no. 29; Paris, Galerie Max Kaganovitch, *Oeuvres choisies du XXᵉ siècle*, May 25–July 20, 1951, no. 36; Paris, Maison de la Pensée Française, *Picasso: Oeuvres des musées de Leningrad et de Moscou, 1900–1914*, June 1954, no. 2, exhibition continued through summer as *Picasso, deux periodes: 1900–1914 et 1950–1954*, no. 2, repr.; Marseille, Musée Cantini, *Cinquante Chefs-d'oeuvre de Picasso*, May 11–July 31, 1959, no. 7; London, Tate Gallery (organized by The Arts Council of Great Britain), *Picasso*, July 6–Sept. 18, 1960, no. 23, pl. 5c; New York, The Museum of Modern Art, *Four Americans in Paris: The Collections of Gertrude Stein and Her Family*, Dec. 19, 1970–Mar. 1, 1971, pp. 26, 166–67, fig. 32, traveled to The Baltimore Museum of Art, Apr. 4–May 30, 1971, p. 21, and to the San Francisco Museum of Art, Sept. 15–Oct. 31, 1971; Ottawa, National Gallery of Canada, *Gertrude Stein & Picasso & Juan Gris*, June 25–Aug. 15, 1971, no. 3, repr.; New York, The Museum of Modern Art, *Pablo Picasso: A Retrospective*, May 22–Sept. 16, 1980, repr. in color, p. 67.

REFERENCES: *Le Courrier français*, cover, with mention of sale at Galerie Clovis Sagot, Nov. 2, 1905 (called *Fleur de Pavé*); C. J. Holmes, *Notes on the Post-Impressionist Painters, Grafton Galleries, 1910–11*, London, 1910, p. 23; W. Sickert, in *Fortnightly Review*, Jan. 1911, reprinted in *A Free House*, London, 1947, p. 100; M. Raynal, *Picasso*, Paris, 1921, pl. 20; A. Salmon, "Dessins inédits de Cézanne," *Cahiers d'art*, vol. I, 1926, p. 264; C. Zervos, *Pablo Picasso*, vol. I: *Works from 1895 to 1906*, Paris and New York, 1932, no. 256, pl. 113; G. Stein, *The Autobiography of Alice B. Toklas*, New York, 1933, p. 52; G. Stein, *Picasso*, London, 1938, p. 7, pl. 10; J. Cassou, *Picasso*, Paris, 1940, p. 57; R. Cogniat, *Histoire de la peinture*, Paris, 1945, vol. II, repr. in color, p. 157 (wrongly dated 1906); L. Stein, *Appreciation: Painting, Poetry and Prose*, New York, 1947, p. 138; L. Stein, *Journey into the Self: Being the Letters, Papers & Journals of Leo Stein*, ed. E. Fuller, New York, 1950, p. 148; D.-H. Kahnweiler and H. Parmelin, "Petites histoires des toiles," in Vercors [Jean Bruller], *Picasso: Oeuvres des musées de Leningrad et de Moscou et de quelques collections parisiennes*, Paris, 1955, pl. 2, color; D. Sutton, *Picasso: Peintures, époques bleue et rose*, Paris, 1955, pl. XIV, color; J. Camon Aznar, *Picasso y el Cubismo*, Madrid, 1956, p. 374; G. Diehl, *Picasso*, Paris, 1960, repr. in color, p. 15; A. Blunt and P. Pool, *Picasso: The Formative Years*, London, 1962, p. 26; P. Daix, *Picasso*, New York, 1965, p. 44, repr. in color, p. 43; P. Pool, "Picasso's Neo-Classicism: First Period, 1905–06," *Apollo*, vol. LXXXI, Feb. 1965, p. 125; P. Daix and G. Boudaille, *Picasso, The Blue and Rose Periods: A Catalogue Raisonné of the Paintings, 1900–1906*, Greenwich, Conn., 1967, pp. 78, 80, no. XIII.8, repr. p. 276 [updated Neuchâtel, 1988]; J-P. Crespelle, *Picasso and His Women*, trans. Robert Baldick, New York, 1969, p. 68; E. Burns, ed., *Gertrude Stein on Picasso*, New York, 1970, pp. 13, 110, repr. in color, p. 9, in black and white, [p. 126]; F. Elgar and R. Maillard, *Picasso*, rev. and enl. ed., New York, 1972, p. 190, repr. p. 187; J. Leymarie, *Picasso: The Artist of the Century*, London, 1972, repr. p. 212; G. Laporte, *Sunshine at Midnight: Memories of Picasso and Cocteau*, trans. and annotated by D. Cooper, London and New York, 1975, pp. 94–95 (originally published as *Si tard le soir*, Paris, 1973); R. Johnson, "Picasso's Parisian Family and the 'Saltimbanques,'" *Arts* magazine, vol. LI, Jan. 1977, pp. 94, 95, n. 24; W. Rubin, ed., *Pablo Picasso: A Retrospective*, New York, 1980, p. 58, 67; E. A. Carmean, Jr., *Picasso: The Saltimbanques*, Washington, 1980, p. 52, fig. 68, no. 84; *Pablo Picasso, 1905–1908: The Rose Period*, Tokyo, 1981, no. 23; J. Palau i Fabre, *Picasso: The Early Years 1881–1907*, Barcelona, 1985, pp. 422–26, nos. 1155, 1156; C. A. Nathanson, "The American Reaction to London's First Grafton Show," *Archives of American Art Journal*, vol. 25, no. 3, 1985, pp. 3–4; F. Olivier, *Souvenirs Intimes; écrits pour Picasso*, ed., M. Décaudin, Paris, 1988, p. 209; J. Richardson with the

90

collaboration of M. McCully, *A Life of Picasso, Vol. I, 1881–1906*, New York, 1991, pp. 340, 342, 354, 397–99, 403, 514 n. 36; P. Daix, *Picasso: Life and Art*, trans. O. Emmet, New York, 1993, p. 55.

1. For the Picasso entries, abbreviations have been established in referring to various catalogues raisonnés of the artist's work. In each case the initial or initials refer to the last name of the author or authors, the Roman numeral to the volume number of the book, if applicable, and the Arabic numeral to the catalogue number within the volume. For the multivolume opus by Christian Zervos, *Pablo Picasso*, vol. I, Paris and New York, 1932, and vols. II–XXXII, Paris, 1942–77, for example, the form Z. II–2. 40 means Zervos, vol. II, part 2, cat. no. 40. The shortened forms D.-B. and D.-R. refer, respectively, to Pierre Daix and Georges Boudaille, *Picasso, The Blue and Rose Periods*, Greenwich, Conn., 1967, and to Pierre Daix and Joan Rosselet, *Picasso, The Cubist Years, 1907–1916*, London, 1979.
2. Daix and Boudaille (1967, p. 254) identified this gouache as having been displayed in an exhibition at the Galeries Serrurier in Paris from Feb. 25 to Mar. 6, 1905, on the basis of a description in a review by G. Apollinaire published in *La Plume*, May 15, 1905.

∾ Pablo Picasso
Landscape. (August or September 1908)

Oil on canvas, 39 ⅜ x 32 in. (100.5 x 81 cm.). Not signed or dated. The Museum of Modern Art, New York. Gift of David and Peggy Rockefeller.

At the end of the summer of 1908, certainly by August 14 (J. Cousins, 1989, p. 354), Picasso spent a few weeks in a small village called La Rue-des-Bois, about forty miles north of Paris in the department of the Oise. His companion, Fernande Olivier, later explained that Picasso rented a cottage away from Paris to try and "get over a nervous torpor" that he had suffered since a friend and fellow painter named Wieghels had committed suicide that spring (Cousins, 1989, p. 354; F. Olivier, *Picasso and His Friends*, New York, 1965, p. 122). Dating from this sojourn at the edge of a forest are several paintings of a strong green tonality in which schematic tree trunks, branches, and foliage are dominant motifs. The present work is the largest of three Rue-des-Bois landscapes acquired by Leo and Gertrude Stein upon their return from Italy in the fall of that year (the other two are Z. II-I. 82, D.-R. 192, W. Rubin, 1989, p. 94, private collection; and Z. II-I.86, D.-R. 186, ex-Collection Riccardo Jucker, Milan).

The date and place of execution of this work remain uncertain despite extensive research into Picasso's activities at this time. Christian Zervos believed that the present work was painted in autumn 1908 after Picasso's return to Paris, but the artist told Maurice Jardot (exh. cat., Paris, 1955) and subsequently William Rubin (1972, pp. 200–201) that he had painted it at La Rue-des-Bois. However, despite his earlier conversation with Picasso, the research for The Museum of Modern Art's 1989 exhibition *Picasso and Braque: Pioneering Cubism* and the opportunity to see the August La Rue-des-Bois pictures together with those painted the following autumn led Rubin to reconsider the possibility that the work may have been completed in Paris after all. So while volume I of the exhibition catalogue *Picasso and Braque: Pioneering Cubism* dates the work "[autumn] 1908," the post-exhibition volume II presents the more tentative "[August or September] 1908." The strongest pictorial evidence for the later date is the absence of earth tones, which seems to be more characteristic of those works painted from memory rather than on site.

While noting that the simplified houses and trees in these works, as well as the green tonality, may owe something to Le Douanier Rousseau, Rubin believes that Picasso's instinct to conceptualize ("I paint objects as I think them, not as I see them"), as well as his continuing interest in Paul Cézanne, were even more influential at this time. Rubin cited in particular the rudimentary use of the stylistic trait most characteristic of Cézanne's mature painting, *passage*, by which the eye is invited to pass freely through the picture space by means of the subtle joining of contours and planes existing at different levels of visual depth. In this work, "the way the right branch of the central tree dissolves, or melds, into the plane of the earth near the horizon line is an elementary example of *passage*" (1972, p. 51). Another such Cézannian conjunction occurs at the upper left, where another branch of the tree marks the point at which the

four different planes of the house and roof meet. As Rubin noted, at Horta de Ebro the following summer Picasso would multiply such instances of *passage* in his first fully developed Cubist paintings, like the Rockefeller *Reservoir, Horta de Ebro* (p. 61). In this *Landscape*, Yve-Alain Bois saw Picasso enacting what he calls a "double articulation" with compositional shapes. The triangular segments in this landscape can be read as either architectural surface or as ground. For Bois, the shapes in the painting reveal the beginning of the artist's growing fascination with such ambiguities—visual uncertainties that Picasso would continue to create and elaborate in his subsequent work (1992, pp. 180–83). The Rue-des-Bois landscape's wedge shapes also look forward to the schematic breakup of flesh into large planes in the artist's monumental *Three Women* (Rubin, 1989, p. 111), begun sometime in autumn 1908 and completed late the following year.

PROVENANCE: Leo and Gertrude Stein, Paris, 1908; Gertrude Stein, 1913–46; Estate of Gertrude Stein, 1946–68; The Museum of Modern Art syndicate, 1968; David and Peggy Rockefeller, 1968; The Museum of Modern Art, New York, Gift of David and Peggy Rockefeller, 1974.

EXHIBITIONS: Paris, Musée des Arts Decoratif, *Picasso, peintures 1900–1955*, June–Oct. 1955, no. 14, repr. opp. no. 15; Munich, Haus der Kunst, *Picasso, 1900–1955*, Oct. 25–Dec. 18, 1955, no. 17C, traveled to Cologne, Rheinisches Museum, Dec. 30, 1955–Feb. 29, 1956, and to Hamburg, Kunsthalle, Mar. 10–Apr. 29, 1956; New York, The Museum of Modern Art, *Four Americans in Paris: The Collections of Gertrude Stein and Her Family*, Dec. 19, 1970–Mar. 1, 1971, listed p. 170, traveled to The Baltimore Museum of Art, Apr. 4–May 30, 1971, and to the San Francisco Museum of Art, Sept. 15–Oct. 31, 1971; Ottawa, National Gallery of Canada, *Gertrude Stein & Picasso & Juan Gris*, June 25–Aug. 15, 1971, no. 21, repr.; New York, The Museum of Modern Art, *Picasso in the Collection of The Museum of Modern Art*, Jan. 23–Apr. 2, 1972, pp. 51, 200–1, repr. p. 50; Sydney, Art Gallery of New South Wales, *Modern Masters: Manet to Matisse*, Apr. 10–May 11, 1975, p. 138, repr. p. 139, traveled to Melbourne, National Gallery of Victoria, May 29–June 22, 1975, and to New York, The Museum of Modern Art, Aug. 4–Sept. 1, 1975; New York, The Museum of Modern Art, *Pablo Picasso: A Retrospective*, May 22–Sept. 16, 1980, repr. p. 111; New York, The Museum of Modern Art, *Masterworks from the Collection*, Oct. 25, 1980–Jan. 27, 1981; Melbourne, National Gallery of Victoria, *Picasso*, July 28–Sept. 23, 1984, to Sydney, Art Gallery of New South Wales, Oct. 19–Dec. 2, 1984; New York, The Museum of Modern Art, *Picasso and Braque: Pioneering Cubism*, Sept. 24, 1989–Jan. 16, 1990, p. 108; Kunstmuseum Basel, *Picasso and Braque: Die Geburt des Kubismus*, Feb. 25–June 4, 1990, no. 38; Copenhagen, Statens Museum for Kunst, *Picasso and Braque: Cubism 1907–1914*, Sept. 11–Nov. 28, 1993, pp. 46–47, pl. 7.

REFERENCES: C. Zervos, *Pablo Picasso*, vol. II-1: *Oeuvres de 1906 à 1912*, Paris, 1942, no. 83, pl. 43 (dated Paris, autumn 1908); E. Burns, ed., *Gertrude Stein on Picasso*, New York, 1970, repr. p. 101, color (wrongly listed as Collection André Meyer); W. Rubin, *Picasso in the Collection of The Museum of Modern Art*, New York, 1972, pp. 51, 200–1, repr. p. 50; P. Daix and J. Rosselet, *Picasso, The Cubist Years, 1907–1916: A Catalogue Raisonné of the Paintings and Related Works*, London, 1979, pp. 52, 225, no. 191, repr. p. 226; W. Rubin, *Pablo Picasso: A Retrospective*, New York, 1980, p. 111; Siegfried Gohr, *Kubismus: Künstler, Themen, Werke 1907–1920*, Köln, 1982, pp. 48–49; C. Altieri, "Picasso's Collages and the Force of Cubism," *Kenyon Review*, vol. VI, no. 2 (Spring 1985), p. 23; W. Rubin, *Picasso and Braque: Pioneering Cubism*, New York, 1989, p. 108; J. Palau i Fabre, *Picasso: Cubism (1907–1914)*, New York, 1991, disc. p. 98, no. 251 [title: *House Among Trees (Landscape)*];Y.-A. Bois, "The Semiology of Cubism" in L. Zelevansky, ed., *Picasso and Braque: A Symposium*, New York, 1992, p. 182, repr. p. 183; P. Daix, *Picasso: Life and Art*, trans. O. Emmet, New York, 1993, p. 89.

1. The canvas had been lined by the time of its first exhibition in 1955.

∾ Pablo Picasso
The Reservoir, Horta de Ebro (L'Abreuvoir). (Summer 1909)

Oil on canvas, 23 ¾ x 19 ¾ in. (60.3 x 50.1 cm.). Not signed or dated. The Museum of Modern Art, New York. Fractional gift of David and Peggy Rockefeller (the donors retaining a life interest in the remainder).

Picasso and Fernande Olivier spent the summer of 1909 in the isolated hill village of Horta de Ebro (now called Horta de San Juan), the birthplace of Picasso's friend Manuel Pallarés, in northeastern Spain, where Picasso had spent several months ten years earlier. The artist had recently acquired a camera, and he sent several snapshots of the village to Leo and Gertrude Stein (for a reproduction of one of Picasso's photographs, see J. Cousins, 1989, p. 361), who subsequently bought three of the six major landscapes he painted there (D.-R.275–80, repr. p. 242). Both *Reservoir, Horta de Ebro* and a second Stein acquisition, *Houses on the*

Hill, Horta de Ebro (The Museum of Modern Art, New York, Nelson A. Rockefeller Bequest; W. Rubin, 1989, p. 134; Daix 278), remained in Gertrude's collection throughout her lifetime. The Steins' third purchase, *Factory at Horta,* passed to the collection of Sergei Shchukin before World War I (now Hermitage Museum, St. Petersburg). Picasso, revealing a fascination with the American West that he shared with Georges Braque, his partner at this time in the artistic dialogue that gave birth to Cubism, wrote to the Steins: "The countryside is splendid. I love it, and the route leading here is exactly like the Overland Route to the Far West" (quoted in Cousins, 1989, p. 361). Coincidentally, the elliptical structure in the foreground of this painting was a large cistern from which only cattle drank (W. Rubin, 1972, p. 202). In addition to working on landscapes during the summer of 1909, Picasso completed over fifteen portraits of his companion, Fernande Olivier.

Picasso made a number of drawings of this motif in pencil and ink, exploring both vertical and horizontal formats (repr. Z. VI.1078, 1080, 1081, 1082, 1086); but the preliminary drawings indicate that the transformation of the observed motif into a pictorial structure was fully worked out only on the final canvas. One of Picasso's snapshots of the village reveals that he grouped the buildings in a more compact pyramidal organization than actually existed (Cousins, 1989, p. 361). Jacques Combe convincingly pointed to Paul Cézanne's landscapes of Gardanne of 1885–86 as a precedent for this tightly knit composition of buildings rising up a hillside (1936, p. 26).

William Rubin (1972, p. 56) has termed the summer at Horta de Ebro "the most crucial and productive vacation" of Picasso's career, for there he clarified previously explored formal ideas in "his first fully defined statement of Analytic Cubism." In a perceptive analysis of this work, Rubin pointed to the use of a "reverse perspective" by which shapes converge toward the spectator rather than into the distance, in conjunction with a kind of relief modeling forward from a back plane rather than the traditional illusionistic recession toward a vanishing point in space. He also noted the omnipresent technique of *passage*, by which angles and planes are made to coincide ambiguously to produce a new and prophetic unity of surface; this stylistic device ultimately derived from Cézanne. Even earlier, Gertrude Stein had found Cubism's very origins in these Horta paintings (G. Stein, *Picasso*, 1959, p. 8).

In a two-part article offering insights into Picasso's early Cubism, Leo Steinberg proposed an alternative interpretation of the formal characteristics of the landscapes painted at Horta de Ebro (1978, pp. 125–28, and 1979, p. 119); concurrently, Rubin defended his earlier analysis and terminology (1979, p. 132). Too complex for summary, the three articles offer closely reasoned arguments for two different perceptions of this work.

More recently, Rosalind Krauss, in a modification of Gertrude Stein's declaration about Cubism's origins, explained that the Horta landscapes generated an experience of space that is at the very heart of the development of Cubism. Krauss described a "radical disjunction that takes place between, on the one hand, the experience of shape—frontal, rising, parallel to picture and to plane of vision . . . and, on the other, the experience of something that imperiously, vertiginously beckons, something that excavates deep into both painting and landscape ground" (1992, p. 267). Picasso places the viewer in a position of ambivalence in which he oscillates between looking at the "plane of vision parallel to the painter's upright regard," a viewing experience that is purely optical, and the "ground that is beneath his very feet," a view that has elements of bodily experience (p. 268). In Krauss's view, this oscillation indicates a profound distrust of vision itself. And while Krauss sees the work at Horta as a turning point for Picasso apart from Braque, paving the way for paintings that display greater and greater emphasis on optical experience, for Rubin the Horta pictures remain in dialogue with those by Braque whose *Harbor* and *Large Nude* show, respectively, similar plunging depth and multiple perspectives (1992, p. 293–96).

PROVENANCE: Leo and Gertrude Stein, 1909; Gertrude Stein, Paris, 1913–46; Estate of Gertrude Stein, 1946–68; The Museum of Modern Art syndicate, 1968; David and Peggy Rockefeller, 1968, fractional gift to The Museum of Modern Art, New York (the donors retaining a life interest in the remainder).

EXHIBITIONS: Paris, Galerie Georges Petit, *Picasso*, June 16–July 30, 1932, no. 56 (as *Paysage d'Espagne*, wrongly listed as signed lower right); Zürich, Kunsthaus, *Picasso*, Sept. 11–Oct. 30, 1932, no. 50; Paris, Maison de la Pensée Française, *Picasso: Oeuvres des musées de Leningrad et de Moscou, 1900–1914*, June 1954, no. 7, exhibition continued through summer as *Picasso, deux periodes: 1900–1914 et 1950–1954*, no. 7; Paris, Musée des Arts Decoratifs, *Picasso, peintures 1900–1955*, June–Oct. 1955, no. 19, repr.; Munich, Haus der Kunst, *Picasso, 1900–1955*, Oct. 25–Dec. 18, 1955, no. 21, repr., traveled to Cologne, Rheinisches Museum, Dec. 30, 1955–Feb. 29, 1956, and to Hamburg, Kunsthalle, Mar. 10–Apr. 29, 1956; Marseille, Musée Cantini, *Cinquante Chefs-d'oeuvre de Picasso*, May 11–July 31, 1959, no. 14; London, Tate Gallery (organized by The Arts Council of Great Britain), *Picasso*, July 6–Sept. 18, 1960, no. 48, pl. 13a; Paris, Musée National d'Art Moderne, *Les Sources du XXᵉ siècle*, Nov. 4, 1960–Jan. 23, 1961, no. 556; New York, The Museum of Modern Art, *Four Americans in Paris: The Collections of Gertrude Stein and Her Family*, Dec. 19, 1970–Mar. 1, 1971, listed p. 171, repr. in color, pl. 49, traveled to The Baltimore Museum of Art, Apr. 4–May 30, 1971, and to the San Francisco Museum of Art, Sept. 15–Oct. 31, 1971; Ottawa, National Gallery of Canada, *Gertrude Stein & Picasso & Juan Gris*, June 25–Aug. 15, 1971, no. 25, repr.; New York, The Museum of Modern Art, *Picasso in the Collection of The Museum of Modern Art*, Jan. 23–Apr. 2, 1972, repr. in color, p. 57; New York, The Museum of Modern Art, *Pablo Picasso: A Retrospective*, May 22–Sept. 16, 1980, repr. p. 131; London, Tate Gallery, *The Essential Cubism*, April 27–July 9, 1983, no. 117; New York, The Museum of Modern Art, *Picasso and Braque: Pioneering Cubism*, Sept. 20, 1989–Jan. 16, 1990, repr. p. 131.

REFERENCES: M. de Zayas, "Pablo Picasso," *América* (New York), May 1911, repr. p. 364; J. des Gachons, "La Peinture d'après-demain," *Je sais tout* (Paris), Apr. 15, 1912, repr. p. 350; *Camera Work* (special no.), Aug. 1912, repr., unpaged; R. Cortissoz, "The Post-Impressionist Illusion," *The Century Magazine*, vol. LXXXV, no. 6, Apr. 1913, repr. p. 810; G. Stein, *The Autobiography of Alice B. Toklas*, New York, 1933, p. 109; J. Combe, "L'Influence de Cézanne," *La Renaissance*, May–June 1936, repr. p. 26; C. Zervos, *Histoire de l'art contemporaine*, Paris, 1938, repr. p. 204; C. Zervos, *Pablo Picasso*, vol. II-1: *Oeuvres de 1906 à 1912*, Paris, 1942, no. 157, repr.; J. Merli, *Picasso*, Buenos Aires, 1942, fig. 183; B. Dorival, *Cézanne*, Paris, 1948, pl. XXIII; E. Azcoaga, *El Cubismo*, Barcelona, 1949, pl. 3; J. Lassaigne, *La Peinture espagnol: De Velázquez à Picasso*, Geneva, 1952, repr. in color, p. 122; M. Raynal, *Picasso*, Geneva, 1953, repr. in color, p. 48; Vercors [Jean Bruller], *Picasso: Oeuvres des musées de Leningrad et de Moscou et de quelques collections parisiennes*, Paris, 1955, pl. 7; W. Boeck and J. Sabartés, *Picasso*, New York, 1955, p. 462, fig. 49; J. Camon Aznar, *Picasso y el Cubismo*, Madrid, 1956, p. 427, fig. 303; R. Rosenblum, *Cubism and Twentieth Century Art*, 2nd ed., New York, 1966, pp. 37–39, repr. fig. 21; J. Palau i Fabre, *Picasso en Cataluna*, Barcelona, 1966, repr. in color, p. 146; E. Burns, ed., *Gertrude Stein on Picasso*, New York, 1970, repr. in color, p. 49; J. Mellow, "Exhibition Preview, Four Americans in Paris," *Art in America*, Nov.–Dec. 1970, repr. p. 87; P. W. Schwartz, *Cubism*, New York, 1971, repr. in color, p. 48; W. Rubin, *Picasso in the Collection of The Museum of Modern Art*, New York, 1972, pp. 56–58, 202, repr. in color, p. 57; N. Wadley, *Cubism*, London, 1972, repr. p. 51; J. Leymarie, *Picasso: The Artist of the Century*, London, 1972, repr. in color, p. 34; J.-E. Cirlot, *Picasso: Birth of a Genius*, London, 1972, repr. p. 158; J.-L. Daval, *Journal de l'art moderne, 1884–1914*, Paris, 1973, repr. in color, p. 218; L. Steinberg, "Resisting Cézanne: Picasso's 'Three Women,'" *Art in America*, Nov.–Dec. 1978, pp. 125–28, and "The Polemical Part," *Art in America*, Mar.–Apr. 1979, p. 119; W. Rubin, "Pablo and Georges and Leo and Bill," *Art in America*, Mar.–Apr. 1979, p. 132, repr. in color, p. 138; P. Daix and J. Rosselet, *Picasso, The Cubist Years, 1907–1916: A Catalogue Raisonné of the Paintings and Related Works*, London, 1979, pp. 66–67, 241, no. 280, repr. p. 242 and in color, pl. XV; J. Palau i Fabre, *Picasso*, Barcelona, 1981, no. 94; *Pablo Picasso, 1909–1916: The Cubist Period (vol. 3)*, Tokyo, 1982, no. 13; Siegfried Gohr, *Kubismus: Künstler, Themen, Werke 1907–1920*, Köln, 1982, p. 48, repr. p. 49; D. Cooper and G. Tinterow, *The Essential Cubism: Braque, Picasso and Their Friends 1907–1920*, New York, 1983, p. 244–45, no. 117; W. Rubin, *Picasso and Braque: Pioneering Cubism*, New York, 1989, p. 131; J. Cousins, "Documentary Chronology," in W. Rubin, *Picasso and Braque: Pioneering Cubism*, New York, 1989, p. 361; J. Palau i Fabre, *Picasso: Cubism (1907–1914)*, New York, 1991, disc. p. 143, no. 403 [title: *The Horta Reservoir*]; R. Krauss, "The Motivation of the Sign" in L. Zelevansky, ed., *Picasso and Braque: A Symposium*, New York, 1992, pp. 266–69, also see in following discussion: Rubin, pp. 293–96, Krauss and Bois, p. 297; C. Poggi, *In Defiance of Painting: Cubism, Futurism, and the Invention of Collage*, New Haven, 1992, p. 32; P. Daix, *Picasso: Life and Art*, trans. O. Emmet, New York, 1993, p. 96.

ᘛ Pablo Picasso
Woman with a Guitar (*Femme à la guitare*). (Early 1914)

Oil, sand, and charcoal on canvas, 45½ x 18⅝ in. (115.5 x 47.5 cm.). Not signed or dated. The Museum of Modern Art, New York. Gift of David and Peggy Rockefeller.

A seated figure holding a musical instrument was a favorite subject for both Picasso and Georges Braque in the years preceding World War I. John Richardson first suggested that the Cubists probably found inspiration for this theme in the figure paintings of Camille Corot, twenty-four of which were exhibited at the Salon d'Automne of 1909 as part of its annual series honoring a deceased master (cited by W. Rubin, 1972,

p. 205, n. 3). Jean Leymarie wrote that the Corot exhibition, "a discovery," was admired by both Picasso and Braque (*Georges Braque*, Paris, 1973, p. vii; cited by J. Cousins, 1989, p. 364).

The date, the compositional elements, and the title of this work have generated much controversy in the Picasso literature. Several stylistic features of the painting relate it to others dating from late 1913 and 1914: the radical disjunction of head and torso, with arms and tiny stylized hands often emerging at the level of the lower torso; the "rhyming" of the shapes of musical instruments and parts of the body, as the face, ear, and lower arms relate to the guitar shape in this work (a fusion, Dawn Ades noted, that anticipates similar Surrealist imagery; 1978, p. 26); and the decorative use of stippled planes. Several shapes in this work remain ambiguous: the parallel wavy lines, used to indicate hair in other paintings, may be part of the figure's costume from which the puffed sleeves emerge below, or they may indicate the contours of the chair in which the woman sits. The rounded and shaded white shapes at the center are also difficult to read. Christian Zervos (1942, no. 448) and Pierre Daix and Joan Rosselet (1979, p. 313) dated the present work to the winter of 1913–14. In 1972, William Rubin assigned it to the spring of 1914 (1972, p. 91). In 1989, however, Rubin redated the painting to sometime in early 1914 and, in a second redating following the exhibition *Picasso and Braque: Pioneering Cubism*, *Woman with a Guitar* was placed more specifically in March 1914. This date, as explained by the author of the post-exhibition dating, Pepe Karmel, is based on the painting's relationship to a series of drawings exploring the motif of a man holding a guitar. On the verso of a sheet with two of these studies is an unrelated drawing signed and dated March 1914 (M. Richet 1987, 353, 353 bis; see Karmel, 1992, p. 337). Despite this dated page, the creation and completion of this painting cannot be placed in March with complete certainty. Therefore, we have chosen the more tentative date of early 1914, indicating a wider range of time in which Picasso could have worked on the picture.

The inclusion of Russian letters at the lower left, бол концерт, transliterated as "Bol[shoi] Konzert" or, in French, "Grand Concert," has been variously explained. Gertrude Stein, who owned this work, stated that Picasso learned the Russian alphabet from the painter Serge Férat (né Jastrebzoff) and his sister, the Baroness Hélène d'Oettingen, co-directors, with Guillaume Apollinaire, of the art and literary journal *Les Soirées de Paris* (beginning in 1913), and introduced it into some of his paintings (1933, p. 195); however, no other work by Picasso with Russian lettering is known. A more plausible account was provided by Daniel-Henry Kahnweiler after this work was exhibited in Paris in 1954 along with many works lent by Russian museums.[1] He recalled that a number of Picasso's paintings had returned from an exhibition in Moscow wrapped in Russian posters and that Picasso found the letters so appealing that he copied them (D.-H. Kahnweiler and H. Parmelin, 1955, p. 20). Larrissa Dukelskaya of the Hermitage Museum in Leningrad has stated (in conversation with the author) that the combination of Cyrillic lettering with elements from the Latin alphabet, as in the dark area in the center, was standard practice in pre-revolutionary Russia. Subsequently, Picasso offered another explanation to Rubin, saying that a Russian musical group was concertizing in Paris at that time and that Cyrillic letters were visible all around the city on their posters (Rubin, 1972, p. 212, n. 2). Also commenting on the combination of Cyrillic and Latin lettering, Robert Rosenblum has suggested that the "Fra" may refer to the price (francs) and "9 1/2" to the hour of the concert (1972, p. 268, n. 74).

Whatever the origin of the lettered elements, they indicate that Picasso took a certain interest in Russia at this time. In addition to the stimulus of friendship with Férat and d'Oettingen, Rosenblum has suggested that Picasso may also have taken note of the various international events that took place in 1913 to celebrate the three-hundredth anniversary of the Romanov dynasty (cf. his "Picasso and the Coronation of Alexander III: A Note on the Dating of Some Papiers Collés," *Burlington Magazine*, vol. CXIII, Oct. 1971, p. 604, in which he

calls attention to the inclusion of a clipping from an 1883 issue of *Le Figaro* with an account of the coronation of Czar Alexander III in Picasso's *Bottle of Vieux Marc, Glass, Guitar, and Newspaper* in the Tate Gallery; Z. II-2.335).

As for the title, scholars hold conflicting opinions as to whether the seated woman is playing a guitar or a mandolin, both of which are instruments seen throughout Picasso's oeuvre. Kahnweiler's stock book lists the title of this work as *Femme à la mandoline (au programme russe)* and this identification was repeated in the catalogues of the exhibitions *Four Americans in Paris* (1970–71), *Picasso in the Collection of The Museum of Modern Art* (1972), and *Pablo Picasso: A Retrospective* (1980). In his catalogue raisonné published in 1942, Zervos, on the other hand, called the work *Femme à la guitare*. Kirk Varnedoe and Pepe Karmel also consider that the instrument in the painting, with its combination of "B" and "reverse B" shapes, looks more like a guitar than a mandolin and resembles the other guitars that Picasso so often represents. Karmel also doubts the accuracy of Kahnweiler's record-keeping, warning that his stock books should not necessarily be accepted as the definitive guide to Picasso's titles (communicated verbally, 1993).

PROVENANCE: Galerie Kahnweiler, Paris; Gertrude Stein, 1914–46; Estate of Gertrude Stein, 1946–68; The Museum of Modern Art syndicate, 1968; David and Peggy Rockefeller, 1968; The Museum of Modern Art, New York, gift of David and Peggy Rockefeller, 1975.

EXHIBITIONS: Paris, Petit Palais, *Les Maitres de l'art indépendant, 1895–1937*, June–Oct. 1937, no. 20; Paris, Maison de la Pensée Française, *Picasso: Oeuvres des musées de Leningrad et de Moscou, 1900–1914*, June 1954, no. 10, exhibition continued through summer as *Picasso, deux periodes: 1900–1914 et 1930–1954*, no. 10, repr.; New York, The Museum of Modern Art, *Four Americans in Paris: The Collections of Gertrude Stein and Her Family*, Dec. 19, 1970–Mar. 1, 1971, p. 171, fig. 54, traveled to The Baltimore Museum of Art, Apr. 4–May 30, 1971, p. 26, and to the San Francisco Museum of Art, Sept. 15–Oct. 31, 1971; Ottawa, National Gallery of Canada, *Gertrude Stein & Picasso & Juan Gris*, June 25–Aug. 15, 1971, no. 33, repr.; New York, The Museum of Modern Art, *Picasso in the Collection of The Museum of Modern Art*, Jan. 23–Apr. 2, 1972, pp. 91, 212, repr. in color, p. 90; Greenvale, L.I., C. W. Post Center Art Gallery, *Gertrude Stein*, Apr.–May 1975, repr.; Basel, Kunstmuseum, *Picasso aus dem Museum of Modern Art, New York, und Schweizer Sammlungen*, June 15–Sept. 12, 1976, no. 31, repr. p. 69; London, Hayward Gallery, *Dada and Surrealism Reviewed*, Jan. 11–Mar. 27, 1978, no. I.31; New York, The Museum of Modern Art, *Pablo Picasso: A Retrospective*, May 22–Sept. 16, 1980, repr. p. 180; Paris, Musée d'Art Moderne de la Ville de Paris, fiftieth anniversary exhibition, June 10–Aug. 30, 1987; New York, The Museum of Modern Art, *Picasso and Braque: Pioneering Cubism*, Sept. 24, 1989–Jan. 16, 1990, p. 303; Kunstmuseum Basel, *Picasso and Braque: Die Geburt des Kubismus*, Feb. 25–June 48, 1990, no. 165; St. Petersburg, The State Hermitage Museum, Picasso exchange, Sept. 25–Nov. 13, 1990, traveled to Moscow, Pushkin Museum, Nov. 30, 1990–Jan. 6, 1991.

REFERENCES: G. Stein, *The Autobiography of Alice B. Toklas*, New York, 1933, p. 195; G. Stein, *Picasso*, London, 1938, repr. fig. 32; C. Zervos, *Pablo Picasso*, vol. II-2: *Oeuvres de 1912 à 1917*, Paris, 1942, no. 448, pl. 209; D.-H. Kahnweiler and H. Parmelin, "Petites histoires des toiles" in Vercors [Jean Bruller], *Picasso: Oeuvres des musées de Leningrad et de Moscou et de quelques collections parisiennes*, Paris, 1955, p. 20, pl. X; F. Elgar and R. Maillard, *Picasso*, Paris and London, 1955, p. 79, repr. in color, p. 94; *L'Arte Moderna: Autologia*, Milan, 1967, repr. p. 347; E. Burns, ed., *Gertrude Stein on Picasso*, New York, 1970, repr. p. 87; W. Rubin, *Picasso in the Collection of The Museum of Modern Art*, New York, 1972, pp. 91, 212, repr. in color, p. 90; R. Rosenblum, "Picasso and the Typography of Cubism" in R. Penrose and J. Golding, eds., *Picasso 1881/1972*, London, 1972, p. 73, fig. 124 (American ed., *Picasso in Retrospect*, New York, 1973); D. Ades, *Dada and Surrealism Reviewed*, London, 1978, p. 26, no. I.31; P. Daix and J. Rosselet, *Picasso, The Cubist Years, 1907–1916: A Catalogue Raisonné of the Paintings and Related Works*, London, 1979, p. 138, no. 646, repr. p. 313; M. Richet, *Musée Picasso: Catalogue sommaire des collections, II—Dessins, aquarelles, gouaches, pastels*, Paris, 1987; J. Cousins, "Documentary Chronology" in W. Rubin, *Picasso and Braque: Pioneering Cubism*, New York, 1989, p. 303; J. Palau i Fabre, *Picasso: Cubism (1907–1914)*, New York, 1991, p. 361, repr. no. 1036; P. Karmel, "Notes on the Dating of Works" in L. Zelevansky, ed., *Picasso and Braque: A Symposium*, New York, 1992, p. 337.

1. The Soviet government lent twenty-two works by Picasso, formerly in the Shchukin and Morosov collections, to this exhibition at the Maison de la Pensée Française, a cultural center sponsored by the French Communist party. To supplement this group, some French collectors were asked to participate, and Alice Toklas lent ten works from the collection of Gertrude Stein, including the present work, *Girl with a Basket of Flowers*, and *The Reservoir, Horta de Ebro* (see p. 61). Sergei Shchukin's daughter, then living in Paris, caused a public scandal shortly after the opening by claiming that her father's collection, which had been nationalized at the time of the Revolution, was rightfully her property. The exhibition was closed by the French authorities, and the Russian pictures were removed to the Soviet Embassy and subsequently returned to the Soviet Union. With the cooperation of Picasso, who lent a group of recent paintings of 1950–54, a second exhibition opened several weeks later, with a new title and a new catalogue with a preface by the French literary figure and Communist, Louis Aragon.

Alice Toklas commented on these events in two letters of the period. To Isabel Wilder, the

sister of Gertrude Stein's and Toklas's great friend, Thornton Wilder, she wrote on June 11, 1954: "The really good thing to tell you—is the stupendous retrospective of Picasso's early pictures 1900–1914. The museums of Moscow and Petersburg sent half—the rest came from private collections in Paris—ten from here—leaving large bare spots in the room and for three months. The pictures are beautifully presented—hung with great intelligence and taste." On July 12, 1954, she wrote to Donald Gallup, Curator of the Collection of American Literature, Beinecke Rare Book and Manuscript Library, Yale University: "You will have seen in your newspapers something of the excitement we have all been having with Tschoukine's daughter's claim to her father's pictures that were being shown by the Soviet government at the Pensée Française. But what you probably did not learn was that she claimed the picture no. 10 in the catalogue—which was one of the ten loaned from here. It is the long narrow one that hangs in the *petit salon* and has Russian letters in it and it is for this reason that she claims it! But there is Kahnweiler who will testify this afternoon that he sold it to Gertrude in 1914 and that it has never left her flat. And on the back of the canvas is stamped: 'This picture belongs to the estate of G. S.' which I stamped upon all the pictures . . . The Russians took the pictures of T. to their embassy to protect them—the ten from here are still at the Pensée Française—who asked me if I wished to remove them. Kahnweiler advised me not to. If a favorable decision is rendered at once which it easily may be—the show will open again. The pictures are probably well protected by two French laws—so my lawyer tells me—but the decision may drag" (both letters quoted in E. Burns, ed., *Staying on Alone: Letters of Alice B. Toklas*, New York, 1973, pp. 305–6).

∾ Juan Gris (José Victoriano González).
Spanish (died Boulogne-sur-Seine, France), 1887–1927
The Musician's Table (*La Table du musicien*). May–June 1914
Charcoal, black and colored crayons, and white paint on pasted paper and black paint on canvas, 31½ x 23¼ in. (80 x 59 cm.). Signed on back: *Juan Gris*. Not dated. David and Peggy Rockefeller Collection.

Before 1914 Gris made only occasional use of the *papier collé* and collage techniques invented in 1912 by Georges Braque and Pablo Picasso, who in their investigation of pictorial form introduced pasted elements into their compositions in order to place "an emphasis not upon the reality of the represented objects but upon the reality of the painted surface" (A. H. Barr, Jr., *Cubism and Abstract Art*, New York, 1936, p. 78). Then, in one of the most prolific years of his career, Gris produced almost fifty *papiers collés* whose geometric lucidity and sober elegance reveal the distinctive personal qualities he would contribute to Cubist painting. Gertrude Stein would write in 1933, "The only real Cubism is that of Picasso and Juan Gris. Picasso created it and Juan Gris permeated it with his clarity and his exaltation" (G. Stein, *The Autobiography of Alice B. Toklas*, New York, 1933, p. 259).

In this still life with its traditional elements of a violin, a wine bottle, a tumbler, a stemmed glass, a newspaper, and a music sheet on a wood table, Gris used four different kinds of paper to characterize his objects: the title and headlines cut from the popular Parisian daily *Le Matin*; wood-grained paper to indicate the material of the table and violin; tracing paper to suggest the shiny transparency of the bottle and glasses; and a fragment of white paper on which he drew musical staves—with three lines instead of the conventional five. Christine Poggi has pointed out that the use of transparent paper in many collages of this period reveals "Gris's continuing concern with effects of light" (*In Defiance of Painting: Cubism, Futurism, and the Invention of Collage*, New Haven, 1992, p. 120). The incorporation of naturalistically drawn volumes into a firm, flat structure of vertical, horizontal, and diagonal axes and the portrayal of objects in varied perspectives are characteristic of Gris's art at this time. There is evidence of doubling as well, with a more material representation (here a glass) next to its shadowy echo (a glass sketched in charcoal on the wood-grain paper), as if we are seeing the still life through "divergent mirrors" (Poggi, p. 120). Restoration of this work has revealed the artist's detailed charcoal drawing of the final composition on the primed canvas support.

The date of the newspaper clipping in the present work has been identified as May 10, 1914 (this information was provided through the courtesy of Mme Hélène Baltrusaitis of the American embassy, Paris, 1979, at the request of Helen Franc). This work can thus be securely dat-

ed between mid-May and the end of June, when Gris sent it to Daniel-Henry Kahnweiler and departed for Collioure on the Mediterranean coast. Its composition can be related to those of two other large *papiers collés* in which the circular rim of a glass serves as the central focal point for a complex articulation of still-life objects and musical instruments on a table: *Guitar, Glasses, and Bottle* (National Gallery of Ireland, Dublin; D. Cooper, 1977, no. 94) and *Guitar, Glasses, and Bottle* (The Museum of Modern Art, New York, Nelson A. Rockefeller Bequest; Cooper no. 91).

Gris, like Picasso, occasionally made witty references to his own life and work in the newspaper clippings he incorporated into his *papiers collés* (cf. R. Rosenblum, "Picasso and the Typography of Cubism," in *Picasso 1881/1972*, London, 1972, pp. 49–75). The subject of acrimonious rivalry in the headline of the present work, "Explorateurs en désaccord" ("Disagreement Among Explorers"), seems to have been chosen with such intent and Gris appropriated a number of headlines from a group of newspaper stories referring to charges and countercharges that arose from rival accounts of exploration in Brazil written by the British explorer A. Henry Savage Landor and by a Brazilian army colonel who had accompanied Theodore Roosevelt on an expedition. The colonel accused Landor of taking previously traveled routes, undermining his claim to have staked out new territory. Featured on the front pages of the tabloid newspaper, this story and its presentation evidently intrigued and amused the artist because he used headlines from articles on the incident in at least three collages. "Hein ces explorateurs!" ("What, these explorers!") appeared in *The Packet of Coffee* (Cooper no. 102) and part of the headline, "Un brésilien port un défi de 100.000 francs à M. Savage Landor," was included in *The Bottle of Red Wine* (Cooper no. 100). For *The Musician's Table*, in contrast to these other two works of 1914, Gris eliminated any specific references to Landor and Roosevelt. It seems probable that Gris wryly intended to draw a parallel between the mutual recriminations of the explorers and the rivalry over technical and formal innovations which marked the evolution of Cubism. Soon after his arrival in France in 1906 Gris moved into the Bateau-Lavoir, the building on the rue Ravignan where Picasso lived and worked. The studio was a kind of training ground for Gris, the slightly younger artist, who met, among others, Braque, Apollinaire, and Kahnweiler. It was from this close vantage point that Gris was able to both watch and participate in the development of Cubism (G. Tinterow, 1985, pp. 38–39).

Despite his own role within the movement, Gris was able to parody Cubism in *The Musician's Table*. In Mark Rosenthal's view, Gris seems to suggest that the artist's colleagues—and perhaps himself as well—are merely "provocateurs" without substance (1983, p. 58). Writing about *The Packet of Coffee*, Christopher Green noticed Gris's inclusion of a tiny telegraph pole that is part of *Le Matin*'s masthead, reading it as a reference to the kind of "progressive communication" among the "explorers"—Gris, Picasso, Braque—involved in the Cubist endeavor (1992, p. 15). Perhaps in *The Musician's Table*, however, Gris refers to the personal rivalry that interrupts such communication: in this work the telegraph pole is barely seen behind the charcoal edge of the violin. A fragment from a second headline, "atroce," may indicate the casualties that result from such creative fissures (Tinterow, 1985, p. 39). Patricia Leighton has pointed out that Gris's use of newspaper differs from that of Picasso in that the former would often greatly manipulate the text. Although not seen in this particular work, the process of cutting out and combining letters to create false headlines reveals Gris's strong conscious intention to make meaning with the newsprint, "leaving room for none of the doubts . . . that Picasso and Braque's collages can still inspire" (P. Leighton, "Picasso's Collages and the Threat of War, 1912–13," *The Art Bulletin*, vol. LXVII, no. 4, December 1985, p. 669).

Gris had signed a contract with the Galerie Kahnweiler in Paris for exclusive representation in 1912. Throughout World War I, Kahnweiler as a German citizen was forced to remain outside of France, and his prop-

erty was confiscated. After the war, four sales of his sequestered goods included fifty-seven works by Gris, which sold at very low prices. At these sales of his own property, Kahnweiler bought back many works by Gris, including the present example; and he continued to represent the artist until his death through the Galerie Simon, which he had formed with an associate in 1920.

PROVENANCE: Galerie Kahnweiler, Paris; second Kahnweiler sale, Paris, Hôtel Drouot, Nov. 17–18, 1921, no. 149, repr.; Galerie Simon, Paris; Sir Osbert Sitwell, Bart., London; Marlborough Fine Art, London; G. David Thompson, Pittsburgh; sale, New York, Parke Bernet, Mar. 23, 1966, no. 24, repr. in color, p. 47; David and Peggy Rockefeller, 1966.

EXHIBITIONS: London, Marlborough Fine Art, Ltd., *Juan Gris, 1887–1927: Retrospective Exhibition*, Feb.–Mar. 1958, no. 6, repr.; University Art Museum, University of California at Berkeley, *Juan Gris*, Feb. 1–Apr. 8, 1984, traveled to Washington, D.C., National Gallery of Art, Oct. 16–Dec. 31, 1983, exhibited in Washington, D.C., only, no. 23; Madrid, Ministry of Culture, Salas Pablo Ruiz Picasso, Sept. 20–Nov. 24, 1985, no. 25.

REFERENCES: C. Greenberg, "The Pasted Paper Revolution," *Art News*, vol. LVII, Sept. 1958, p. 7, repr.; D. Cooper, *Juan Gris: Catalogue raisonné des oeuvres peints*, Paris, 1977, vol. I, no. 84, p. 138, repr. p. 139; J. A. Gaya-Nuño, *Juan Gris*, Barcelona, 1974, no. 266, repr. p. 211; M. Rosenthal, *Juan Gris*, Berkeley, 1983, pp. 53, 58, repr. p. 57; G. Tinterow, ed., *Juan Gris*, Madrid, 1985, pp. 38–39, 156–57, no. 25; C. Green, *Juan Gris*, exh. cat., London, 1992.

G. David Thompson, the Pittsburgh industrialist, was a friend of Alfred Barr's and at one time a trustee of The Museum of Modern Art. Although he was a successful businessman, he was better known for his exceptional taste and acumen in buying paintings. He had a very large collection of Klees, which he tried to give to the museum in Pittsburgh. The trustees apparently did not fully appreciate his gift, and consequently he sold them to the Kunstsammlung Nordrhein-Westfalen in Düsseldorf, where at least one hundred of them remain to this day.

We became very friendly with Dave Thompson and his wife, Helene, and through that friendship they came to Seal Harbor in the summer. For several years they occupied one of the Harbor Club cottages. Subsequently, they built a rather large and handsome modern house on land along the seacoast which we sold to them. Dave Thompson died tragically in 1965. Upon his death, Helene decided to sell at auction a number of paintings which Dave owned, some of which were in Seal Harbor and others in their home in Pittsburgh. We bought several of his paintings, one of them Gris's 'Musician's Table,' a collage which I think is the finest Gris we own—even better than those we acquired subsequently from the Gertrude Stein Collection. D.R.

PHOTOGRAPH CREDITS

In this book, the photographs on pages 49 and 99 are by Kate Keller, Chief Fine Arts Photographer, and those on pages 59 and 63 are by Mali Olatunji, Fine Arts Photographer, The Museum of Modern Art. All other color plates of works in the David and Peggy Rockefeller Collection and the photograph on page 6 are by Malcolm Varon, copyright © Malcolm Varon. The photograph on page 8 is by Dan Budnik, copyright © Dan Budnik, courtesy Woodfin Camp & Associates. The photograph on page 98 is by Arthur Lavine, courtesy The Chase Manhattan Bank, N.A.

The Gertrude Stein Collection

In December of 1968, Peggy and I were given our most exciting opportunity to acquire a number of important paintings as a group since the purchase of three masterpieces from Mrs. A. Chester Beatty's collection in 1955. This opportunity arose as a result of the death in 1967 of Alice B. Toklas, the celebrated companion of Gertrude Stein. Miss Stein spent the latter years of her life in Paris, where she did much of her writing and also presided over a salon to which many of the leading artists and writers of the day were invited. Over the years she acquired, often from the artists themselves, many great paintings by Cézanne, Matisse, Picasso, Gris, and others. When Gertrude Stein died in 1946, she left her collection of forty-seven paintings and drawings by Picasso and Gris to her three great-nieces and nephews subject to a life interest for her longtime friend, Alice Toklas.

Upon the death of Miss Toklas, William S. Lieberman, then director of the Department of Painting and Sculpture at The Museum of Modern Art, learned that Gertrude Stein's three heirs wished to sell the collection. Needless to say, many people were interested in buying it, so there were offers from dealers and private individuals all over the world. Bill Lieberman knew the Stein family, and the heirs were favorably disposed toward having the Museum buy the collection if it could come up with a competitive bid. The Museum did not have sufficient acquisition funds to enable it to purchase the collection, so, as chairman of the Museum's board of trustees, I undertook to put together a syndicate to buy it.

The group which eventually agreed to participate included: William S. Paley, then president of the Museum; my brother Nelson, a prior president; John Hay Whitney, a prior chairman of the Museum; and André Meyer, a close friend of mine who, though not directly identified with the Museum, had a distinguished collection of nineteenth- and twentieth-century French paintings. William A. M. Burden, another former president of the Museum, originally expressed an interest in participating but later withdrew, at which point I agreed to take his share in the syndicate as well as my own original share.

The Stein pictures at the time of Alice Toklas's death were stored in vaults in the Chase Bank branch in Paris. No one at the Museum had seen them for a number of years and hence their condition was unknown. Thus, the first thing to do was to get a responsible expert to inspect them. Bill Lieberman obtained permission from the heirs to inspect them on behalf of the Museum and found them to be in good condition, although most of them were without frames and many of them badly needed cleaning. He brought back photographs of them which he showed to the Museum's director, Bates Lowry, the chief curator of painting and sculpture, William S. Rubin, and members of the syndicate.

The next problem was to determine how much to offer for them. For this purpose, we enlisted the assistance of Eugene V. Thaw, a well-known dealer in whom all concerned had great confidence. Mr. Thaw gave us a value for the collection as a whole which he felt would be fair to both the purchasers and the sellers, and which he believed should be competitive. The Museum and the members of the syndicate were all delighted when our bid was accepted by the heirs of the Stein estate.

Prior to submitting our bid, it was understood by the syndicate that six of the paintings we would acquire

would be identified by Bill Rubin and Bill Lieberman as of greatest interest to the Museum and would be given or left to the Museum by the members of the syndicate who bought them. This seemed reasonable enough given the key role played by Bill Lieberman and others connected with the Museum in the negotiations.

Before the transaction was concluded, the heirs had the paintings moved to London, as we insisted that they, rather than we, should get permission from the French government to have the works leave the country. From London they were shipped to New York, where the Museum's chief conservator, Jean Volkmer, cleaned and restored them. This took some months, but a date was set when the syndicate members could get together to decide on who should get which paintings. We met on the afternoon of December 14, 1968, in the old Whitney wing of the Museum, where all the paintings had been placed around a large room. Every syndicate member was present except for Jock Whitney, who was represented by Walter Thayer.

Six numbers on slips of paper were placed in an old felt hat and each syndicate member was asked to draw a number to determine the order in which the selection would be made. I was the last one to draw, but there were two slips left since I had two of the six shares. Fortunately for me the remaining slips were numbers one and three. Peggy and I had decided in advance the order in which we would make a selection. Our first choice was Picasso's *Girl with a Basket of Flowers* (p. 57), and our second choice was his *Reservoir* (p. 61). As a result of the draw, we were able to select both of these paintings. Had we not drawn number one choice, we would have lost the *Girl with a Basket of Flowers*, since it was the first choice of everyone except my brother Nelson, and he had drawn a

high number. Following the rotating order determined by lot, each syndicate member continued to make a choice until he had either exhausted his dollar quota or had drawn all the pictures he wished to choose. The syndicate members stopped drawing before all of the paintings had been selected and, therefore, several were left in our joint ownership.

It had been agreed in advance by all the syndicate members that they would lend the entire collection to the Museum for a major exhibition. This exhibition, called *Four Americans in Paris*, opened in December of 1970 and included over two hundred works, not only the ones we had bought but others as well which had once belonged to Gertrude Stein and her brothers and sister-in-law when they all lived together in Paris. The show was exceptionally popular and a great critical success. It was seen by over 200,000 people during its eleven-week stay at the Museum. Subsequently, a scaled-down version was shown in Baltimore and San Francisco.

Peggy and I acquired eight works by Picasso and two by Gris. It turned out that three of the Picassos we picked were among those the Museum had selected. The paintings which no syndicate member selected at the time of the distribution were sold two or three years later through Eugene Thaw at prices well above the originally assigned values. Thus, the cost of the paintings acquired by the syndicate members was reduced by that amount on a proportionate basis. It was a fascinating transaction which benefited The Museum of Modern Art significantly while at the same time giving great satisfaction to the syndicate participants.

DAVID ROCKEFELLER

Gifts and Promised Gifts of David and Peggy Rockefeller to The Museum of Modern Art

* GIFT
** PROMISED GIFT
*** PURCHASE THROUGH FUNDS PROVIDED BY
 DAVID AND PEGGY ROCKEFELLER

Amèrico Balán. *Un cafecito.* n.d. Woodcut.***

Romare Bearden. *The Train.* (1975). Etching, aquatint, and stencil, printed in color.***

Luis F. Benedit. *Labyrinth for White Rats.* December 1971. Watercolor, enamel, and felt-tipped pen on blueprint paper.***

Luis F. Benedit. *Labyrinth for Ants.* January 1972. Watercolor, enamel, and felt-tipped pen on blueprint paper.***

Antonio Berni. *The Dream (El sueño).* (1967). Collagraph and engraving, relief printed.***

Antonio Berni. *The Examination (El examen).* 1967. Collagraph and engraving, relief printed.***

Pierre Bonnard. *The Promenade (Promenade des nourrices, frise des fiacres).* 1894. Four-panel folding screen of distemper on unprimed canvas with carved wood frame.**

Pierre Bonnard. *Basket of Fruit Reflected in a Mirror (Corbeille de fruits se reflétant dans une glace de buffet).* (Ca. 1944–46). Oil on canvas.*

Georges Braque. *The Large Trees (Les Gros Arbres).* (Fall–Winter 1906–7). Oil on canvas mounted on composition board.**

Claudio Bravo. *Fur Coat Front and Back.* 1976. Lithograph on two sheets.***

Paul Cézanne. *Still Life with Fruit Dish (Nature morte au compotier).* (1879–80). Oil on canvas.**

Paul Cézanne. *Boy in a Red Vest (Garçon au gilet rouge).* (1888–90). Oil on canvas.**

Paul Cézanne. *Mont Sainte-Victoire.* (1902–6). Pencil and watercolor on paper.**

André Derain. *Charing Cross Bridge.* (1905–6). Oil on canvas.**

Juan Downey. Drawing for *With Energy beyond These Walls.* 1969. Crayon, pencil, charcoal, and oil on paper.***

Juan Downey. *A Clean New Race.* 1970. Pastel, pencil, and tempera on cardboard.***

Jean Dubuffet. *Group of Four Trees (Groupe de quatre arbres).* 1970–72. Polyester resin and fiberglass skin laminated over aluminum mesh, mounted on a steel framework, and finished with polyurethane paint.*

Agustín Fernández. Untitled. 1972. Graphite pencil on paper.***

Sam Francis. *Big Red.* (1953). Oil on canvas.***

Jean Dubuffet. *Group of Four Trees (Groupe de quatre arbres).* 1970–72. This sculpture is on view at One Chase Manhattan Plaza, New York.

Hugette Franco. *Scenes from a Supermarket 11.* (1976). Xerox, printed in color.***

Hugette Franco. *Scenes from a Supermarket 12.* (1976). Xerox, printed in color.***

Antonio Frasconi. *Views of Venice (Vedute di Venezia).* (1969). Portfolio of ten woodcuts, printed in color.***

Leonard French. *The Princess.* (1965). Enamel and gold leaf, copper panels, and burlap collage on burlap mounted on composition board.*

Paul Gauguin. *Portrait of Jacob Meyer de Haan.* (Autumn) 1889. Oil on wood.**

Anna Bella Geiger. *Here Is the Center.* (1973). Aquatint, photogravure, and stencil, printed in color, with embossing.***

Sam Gilliam. *Fire.* 1972. Lithograph, printed in color.***

Sam Gilliam. *Nile.* 1972. Lithograph, printed in color.***

Sam Gilliam. *Coffee Thyme.* 1977. Synthetic polymer paint and cut canvas on canvas.***

Juan Gómez-Quiroz. *Still Life #3.* 1975. Etching and aquatint, printed in color.***

Hastings. *Who? VII.* 1968. Gouache, pencil, and felt-tipped pen on paper.***

98

Wifredo Lam. *Moths and Candles.* 1946. Pencil and pen and ink on paper.***

Jacob Lawrence. *Builders No. 3.* 1974. Serigraph, printed in color.***

Jorge Guillermo Luna Ercilla. *Virtual Symbiosis* (*Symbiosis virtual*). 1967. Etching and aquatint.***

Eduardo MacEntyre. *Untitled.* 1973. Serigraph.***

Henri-Emile-Benoit Matisse. *Interior with a Young Girl/Girl Reading* (*Intérieur à la fillette/La Lecture*). (Autumn–Winter 1905–6). Oil on canvas.**

Lev Mills. *"I Do"* by Mukhtarr Mustapha. London: Cut-Chain Press, 1971. Eight aquatints and photogravures with etching or soft ground etching (one with gouache additions), printed in color.***

Ana Maria Moncalvo. *Godparents. November, 1910.* 1965. Soft ground etching and aquatint with collage, printed in color.***

Pablo Picasso. *Landscape.* (August or September 1908). Oil on canvas.*

Pablo Picasso. *The Reservoir, Horta de Ebro* (*L'Abreuvoir*). (Summer 1909). Oil on canvas.**

Pablo Picasso. *Woman with a Guitar* (*Femme à la guitare*). (Early) 1914. Oil, sand, and charcoal on canvas.*

Pablo Picasso. *Rooster* (*Le Coq*). March 23, 1938. Charcoal on paper.**

Pablo Picasso. *Woman in an Armchair* (*Femme et chien sous un arbre*). Oil on canvas. 1961–62.**

Howardena Pindell. *Kyoto: Positive/Negative.* 1980. Lithograph and etching, printed in color on two sides.***

Liliana Porter. *Wrinkle* by Emmett Williams. New York: New York Graphic Workshop, 1968. Ten photogravures.***

Liliana Porter. Untitled. 1972. Serigraph with string.***

Liliana Porter. *The Human Condition I* from the portfolio *Magritte.* 1976. Photogravure and aquatint.***

Liliana Porter. *The Masterpiece on the Mysteries of the Horizon* from the portfolio *Magritte.* 1976. Photogravure and aquatint, with gouache additions.***

Martin Puryear. *Greed's Trophy.* (1984). Steel rods and wire, wood, rattan, and leather.***

Omar Rayo. *Made in U.S.A.* 1963–64. Portfolio of fifteen inkless intaglios, one with acrylic.***

Barbara Chase Riboud. Untitled. (1971). Charcoal pencil and graphite pencil on paper.***

Carlo Rojas. Study for *Monument to Evita Peron.* (1972). Steel tubing painted black.***

Carlos Scliar. *Pear and Cherry.* 1965. Synthetic polymer paint and collage on paper over composition board.*

Antonio Segui. *Portrait.* 1970. Pencil and gouache on cardboard faced with rag paper.***

Antonio Segui. *Rower* (*Canotier*). 1970. Pencil and tempera on cardboard faced with rag paper.***

Paul Signac. *Opus 217. Against the Enamel of a Background Rhythmic with Beats and Angles, Tones, and Tints, Portrait of M. Félix Fénéon in 1890* (*Opus 217. Sur l'émail d'un fond rhythmique de mesures et d'angles, de tons et de teintes, portrait de M. Félix Fénéon en 1890*). 1890. Oil on canvas.**

Martin Puryear. *Greed's Trophy.* 1984.

Carlos Silva. *Por el puente de la palabra* by Martín Micharvegas. Buenos Aires: Sundo El Taller, 1967. Gouache, felt pen, and pen and ink.***

Jesús Rafael Soto. *Untitled B.* (1971). Embossed serigraph, printed in color.***

Francisco Toledo. *Letter to Antonio Souza.* (1960). Watercolor, wash, brush, and pen and ink on paper.***

Francisco Toledo. *Letter to an Unnamed Person.* (1960). Watercolor, wash, brush, and pen and ink on paper.***

José Urbach. *Fractions 3* from the series *Memory.* (1977). Photoengraving and aquatint, printed in color.***

Charles White. *Missouri C.* 1972. Etching, printed in color.***

Trustees of the Museum of Modern Art

David Rockefeller*
Chairman Emeritus

Mrs. Henry Ives Cobb*
Vice Chairman Emeritus

Agnes Gund
Chairman of the Board

Mrs. Frank Y. Larkin
Ronald S. Lauder
Donald B. Marron
Richard E. Salomon
Vice Chairmen

John Parkinson III
Treasurer

Lily Auchincloss
Edward Larrabee Barnes*
Celeste G. Bartos*
Sid R. Bass
H.R.H. Prinz Franz von Bayern**
Hilary P. Califano
Thomas S. Carroll*
Mrs. Gustavo Cisneros
Marshall S. Cogan
Douglas S. Cramer
Robert R. Douglass
Gianluigi Gabetti
Paul Gottlieb
Mrs. Melville Wakeman Hall
George Heard Hamilton*
Barbara Jakobson
Philip Johnson*
John L. Loeb*
Robert B. Menschel
Dorothy C. Miller**
J. Irwin Miller*
Mrs. Akio Morita
S. I. Newhouse, Jr.
Philip S. Niarchos
James G. Niven
Richard E. Oldenburg
Michael S. Ovitz
Peter G. Peterson
Gifford Phillips*
Emily Rauh Pulitzer
David Rockefeller, Jr.
Rodman C. Rockefeller
Mrs. Wolfgang Schoenborn*
Mrs. Robert F. Shapiro
Mrs. Bertram Smith*
Jerry I. Speyer
Joanne M. Stern
Mrs. Donald B. Straus*
Jeanne C. Thayer
Paul F. Walter
Richard S. Zeisler

* *Life Trustee*
** *Honorary Trustee*

Ex-Officio

Jo Carole Lauder
President of The International Council

Barbara Foshay-Miller
Chairman of The Contemporary Arts Council